CREATING

SARASOTA
COUNTY

CREATING

SARASOTA
COUNTY

FRANK A. CASSELL

THE
History
PRESS

Published by The History Press
Charleston, SC
www.historypress.com

Copyright © 2019 by Frank A. Cassell
All rights reserved

Front cover, top: by permission of Sarasota County Historical Resources; *bottom*: State Archives
of Florida.
Back cover: Coons Collection, image courtesy of Venice Museum & Archives; *insert*: by
permission of Sarasota County Historical Resources.

First published 2019

Manufactured in the United States

ISBN 9781467141802

Library of Congress Control Number: 2018963685

For my sons
David Daniel Cassell
Jonathan Frank Cassell

Gentlemen:

The object of this meeting, as I understand it, is to band together to accomplish a purpose for the benefit of the individual, the city, the county, and the state....To find out by judicious inquiry through our various committees what is the status of our relations to the northern part of the county. To get facts on the subject as to whether we are getting a square deal. To pledge ourselves to a cause made obligatory by the apparent selfishness of other sections. To a cause made just by the apparent injustices that have been done to us. To a cause of self development made necessary by the isolation which we feel we are receiving by the official action from other parts of the county. To a cause of progression that we feel is being bound and fettered by the negligence of our section by other parts of this county to our most crying need—good roads.

—Dr. Joseph Halton, keynote address, Sarasota Mass Meeting on Separation from Manatee County, June 16, 1920.

CONTENTS

Preface 11
Introduction 17

Chapter 1 The Seeds of Discontent 21
Chapter 2 A Rising Tide of Frustration 35
Chapter 3 The Struggle Begins 47
Chapter 4 A New County Is Born 61
Chapter 5 "Everything Is on the Boom in Sarasota" 79
Chapter 6 "The Million Dollar Courthouse" 107

Afterword Celebrating Sarasota County's Founding 119
Appendix A Sarasota District and County Road Projects,
 1911–1929 127
Appendix B Brief Biographies of Important Leaders in the
 Struggles for Good Roads and County Division 141
Notes 165
Bibliography 175
Index 181
About the Author 189

PREFACE

T he idea for this book emerged more than a year ago as the Sarasota County Historical Commission and the History and Preservation Coalition of Sarasota County began a conversation on how the people of Sarasota County might celebrate the one hundredth anniversary of the county's birth on July 1, 2021. There was a general consensus that this should be considered a significant event and observed appropriately by all Sarasota County citizens. Both groups wrote letters to the Sarasota Board of County Commissioners urging appointment of a planning committee for such a celebration. Manager of Sarasota County Historical Resources Robert Bendus has enthusiastically endorsed the project, and a steering committee has been named. If all goes well, we shall mount a memorable program in 2021 that involves a very large percentage of Sarasota County residents.

My contribution to these discussions as a member of both groups was to ask questions about the historical facts behind the event to be celebrated. Exactly why did the Sarasota district split from Manatee County in 1921? How was this separation achieved? What individuals and organizations were responsible for the independence movement? How did Manatee County respond to this threatened secession? Did the new county fulfill the expectations of those who founded it? Since no answers to these or other questions I posed were readily available, I undertook to find out what happened and why. And what I discovered was a story more complicated and important than I anticipated.

Through my research, I became acquainted with an interesting array of early twentieth-century men and women, most of them unknown to today's Sarasota County residents. Yet these were the individuals except for whom we would possibly still be citizens of Manatee County. I was surprised at their passion and their unflinching commitment to the creation of Sarasota County. As I learned more, it became clear that the fight to separate from Manatee County was but a part of a larger struggle to secure the Sarasota district's economic future by building a system of roads and bridges that would link the area internally as well as to the rest of Florida and the nation. The founders of Sarasota County absolutely believed that the advent of the automobile and the long-haul truck represented the future. Communities with good roads and bridges tied to expanding state and federal road systems would succeed in that future. Other communities, they thought, would likely wither and die, for roads and bridges brought commerce, tourists, and investors.

My admiration for the founders of Sarasota County continued to grow as I came to appreciate the challenges they faced. The Sarasota district was more than a third of Manatee County, but it had only one representative on the five-man board of county commissioners. As a result, the citizens of the Sarasota district paid far more in taxes than they received in benefits. Moreover, the businessmen of Bradentown (now called Bradenton) and other northern Manatee County communities found it easy to manipulate county policies to the detriment of their southern neighbors. Sarasota district tax dollars disproportionately funded roads and schools in the northern two-thirds of Manatee County. What made the situation worse was that the Sarasota district was in a period of economic expansion and population growth after 1910. Inadequate schools and the lack of a modern road system placed the hopes of the district's residents for continued prosperity in jeopardy.

Faced with these dilemmas, the people of the Sarasota district might well have felt a tinge of fear about their future prospects. Yet, in a relatively short period of time, the situation changed. The story of how and why this rapid transformation of circumstances took place is the theme of this book. What I found, in brief, was that the Sarasota district and later Sarasota County produced five major achievements between 1910 and 1928. These were

1. Formation of a political leadership from all parts of the district united in fighting for good roads and bridges before Manatee County and state officials.

2. The development of an informed and politically aware citizenry in the Sarasota district that supported the leadership and their pro-growth and development agenda.
3. The creation of Sarasota County as a necessary step in the fight for good roads and bridges. Faced with what they perceived as the ineptitude and downright bias of Manatee County authorities, the Sarasotans felt there was no alternative to separation.
4. The establishment of an effective and competent Sarasota County government.
5. The building of the Sarasota County Courthouse and the successful completion of Sarasota County's basic road system, including the Tamiami Trail and the cross-state highway.

Each of these achievements significantly affected Sarasota County's history. The fact that the same group of leaders was responsible for all of them is quite remarkable and worthy of study. Today's Sarasotans owe a great debt of gratitude to Arthur B. Edwards, Frank Walpole, Joseph H. Lord, Bertha Palmer, Adrian C. Honoré, Rose Phillips Wilson, Harry Higel, Peter Buchan, Thomas Albritton, William M. Tuttle, George Prime, and many other early leaders who gave the Sarasota district a modern road system, a working county government, and so much more.

I have arranged the book in six chapters that put the story of road building and county independence in chronological order. The intent is to discuss how these issues interacted within the context of the automobile revolution, rapid population growth in Florida, and the impact of World War I. I have added an afterword that summarizes the history of previous efforts to celebrate Sarasota County's birth. Here, I argue that there should be a major civic event or events in 2021 to mark the anniversary. Such a celebration should be inclusive of all parts of the county and have a strong historical education program as part of the festivities. I have also included two appendices.

Appendix A lays out the somewhat complicated sequence of actions related to road and bridge building in the Sarasota district and Sarasota County from 1911 to 1929. Readers may find it useful to consult this chronology occasionally to see where things stood at a particular time or in regard to a specific project.

Appendix B contains a series of short biographies of the men and women most responsible for Sarasota's success in becoming a county and building its basic road system. I have tried to relate key facts about these

individuals throughout the text, but such references are scattered across many pages. Since I wanted readers to have as coherent a sense of these people as possible, I decided on the format of this appendix as the best way to accomplish my goal. I also wanted readers to get an idea of the social geography of this leadership group; though they were diverse, they were not entirely representative of all groups living in the area. Farmers, laborers, and African American citizens of the Sarasota district were not a part of the leadership. And while some women appear among those I write about, they too were not typical of the general female population. Even a cursory examination of the lives of these twenty-six people shows that all were white, that many were well educated, and that most were town dwellers working as doctors, lawyers, shopkeepers, and real estate developers. Bertha Honoré Palmer was one of the richest women in America; most of the others appear to have been reasonably well off although not wealthy. A few were native Floridians, but a large number came from the lower South or the Midwest. Nearly all of them had compiled impressive records of public service. Among the women, all were members of the Sarasota Woman's Club. A large number of the men were not just Freemasons but past grand masters or secretaries of Sarasota Lodge no. 147. Some of the men were members of the powerful county Democratic Party Executive Committee at a time when there was no Republican Party functioning in the area. Two of the women and most of the men served as directors of the Sarasota Board of Trade or its successor organizations. The thing that united them all was a very optimistic vision of Sarasota's future. They deeply believed that if they did the right things, the Sarasota area would continue to grow and prosper and become culturally attractive into the indefinite future. In the long term and even for the first few years after Sarasota became a county, that vision seemed to be fulfilled, as the area benefited from the great Florida land boom. But the boom inevitably burst, and the Great Depression was not far behind. Nonetheless, the 1910–28 era left an inheritance of a solid transportation infrastructure, a reasonable school system, an expanded population, and, above all, a county government able to pursue policies responsive to the needs and hopes of the majority of its citizens.

It is certainly my hope that there will be a successful and meaningful centennial celebration of Sarasota County's formation and that this volume will prove useful to Sarasota County residents who wish to understand how, why, and by whose actions the county came into existence. In any case, the story of Sarasota County's origins remains a good tale about how a small

group of committed people overcame numerous challenges to give their home area a shot at greatness.

Every scholar relies on the help of professional librarians and archivists to identify primary sources. I owe a debt of gratitude to Lindsay Ogles and Larry Kelleher at the Sarasota County Department of Historical Resources, as well as staff members at the Venice Museum & Archives, the Chicago History Museum, the Manatee County Historical Records Library, the Elizabeth Eaton Florida History Collection of the Manatee County Public Library System, the Office of the Sarasota County Clerk, State Library & Archives of Florida, and the Sarasota County Library System: Selby and Fruitville Libraries. I also benefited greatly from a close reading of the manuscript by my colleagues Dorothy Korwek and Ruthmary Williams as well as by Mr. Robert Bendus, manager of Sarasota County Historical Resources. Betty Nugent, another associate, provided me with useful information on the early history of Englewood, Florida. Mr. Nathan Clary of the Sarasota Car Museum helped identify one of the early automobiles I encountered in my research. Elizabeth Weber Cassell, my spouse of fifty-eight years, contributed greatly to making this project a reality and participated in each stage of preparing the manuscript. I have dedicated this volume to my two sons, David and Jonathan Cassell, of whom I am very proud. They have accomplished much in their lives both personally and professionally.

INTRODUCTION

The year 2021 will mark the centennial of the founding of Sarasota County, Florida. To some, perhaps to many, this may not seem like such a "big deal." After all, that event took place a very long time ago, and it may be hard to see its relevance to modern-day Sarasota. In fact, things might have turned out very differently for the county—now fourteenth among Florida's sixty-seven counties in population, thirteenth in median household income and ninth in real property value—had the movement to separate from Manatee County failed in 1921.

In that year, a remarkable group of men and women concluded that unless something was done to free what was then called "the Sarasota district" from its attachment to Manatee County, their future would likely be anything but bright. They believed they were overtaxed and underserved by a Manatee County Commission dominated by business interests situated in and around the county seat, then called Bradentown. These leaders had many grievances, including underfunded schools and inadequate law enforcement. They also felt that county government was generally insensitive to their needs and located too far away to provide adequate services. But transportation issues, particularly the need for good roads and bridges, primarily fueled their discontent with Manatee County authorities.

In the years leading up to 1921, the influential businessmen, farmers, ranchers, land dealers, lawyers, and doctors of the Sarasota district were increasingly concerned about their deficient and poorly maintained transportation infrastructure. With the advent of mass-produced automobiles,

good roads became essential. At first, local residents desired well-built roads that linked up communities and allowed people to drive to church, to visit friends and family or to take in a movie. But soon the truly revolutionary potential of the automobile became clear. Even before America entered World War I, plans were made to build nation-spanning roads like the Lincoln Highway from Maryland to San Francisco and the complicated Dixie Highway project from Sault Ste. Marie in Michigan to Miami, Florida. The originally proposed western branch of the Dixie Highway in Florida later became the famous Tamiami Trail that still winds its way from Tampa through Bradenton, Sarasota, Fort Myers, Naples, and then across the Everglades to Miami.

This expanding grid of interconnected highways, together with the rapid growth of privately owned automobiles, profoundly affected states and counties. Leaders began to realize that convenient railroad service was no longer enough to guarantee growth and development. The new key to prosperity was proximity to state and, within a few years, federal road systems. The next best choice was to build a road from your community to the nearest major highway. Not to be attached to the road grid likely meant a community would sink into obscurity.

Given the stakes, it should be no surprise that by 1913 roads and road maintenance had become major issues in counties throughout Florida, a state that relied on attracting tourists as well as importing manufactured goods while sending citrus and vegetables north to urban markets. And within Florida, some counties sought not only to expand their road-building programs but also to influence state and federal road-building plans in ways that would disadvantage nearby counties viewed as competitors.

The leaders of the Sarasota district recognized the importance of good roads and bridges early. In 1914, they worked hard to float a bond issue allowing district citizens to tax themselves to finance a well-conceived plan for a road system. Mismanagement and miscalculations in the road-building program infuriated the Sarasotans as time slipped by with little progress. It was at this point that they came to blame the Manatee County Board of Commissioners for dragging its feet and causing the delays. Some Sarasota district leaders believed the commissioners were more interested in supporting road projects that benefited Bradentown or that helped the development of Anna Maria Island than in addressing Sarasota district transportation needs.

The growing suspicion as to the motives of the Manatee County commissioners in the 1914–15 period had the effect of creating a sense of shared purpose among the scattered communities of the Sarasota district.

Thanks to leadership from the government of the City of Sarasota and the Sarasota Board of Trade, a Good Roads Committee was established. With representatives from most of the Sarasota district communities and the support of the main—and for most of the time the only—newspaper in Sarasota, the *Sarasota Times*, the Good Roads Committee in conjunction with the Sarasota Board of Trade soon emerged as a powerful advocacy group that rallied the district's citizens behind an agenda of good roads and bridges and economic prosperity. However, global events soon pushed local concerns into the background. After America entered World War I, military needs severely curtailed road construction as manpower and building supplies were redirected to the war effort.

Once the war ended late in 1918, disagreements over transportation issues reappeared with even greater acrimony in the Sarasota district, as did friction with the Manatee County commissioners regarding taxes and schools. The most corrosive dispute arose over the efforts by business interests in Bradentown to seek changes in the routes of the Tamiami Trail and the cross-state highway. Had those changes been made, both roads would have run through Bradentown but bypassed the Sarasota district, thus likely blighting its economic future. These mounting controversies spawned a movement for independence in the Sarasota district beginning in 1920. It had become evident that the battle for good roads and bridges could not be won without first achieving political separation from Manatee County. The members of the Sarasota Board of Trade, soon renamed the Sarasota Chamber of Commerce, and the Good Roads Committee slipped smoothly into leadership of the campaign to establish a new Sarasota County. The techniques they had developed to hold together the coalition of Sarasota district communities fighting for good roads and bridges now were used to mobilize those same communities in the struggle for independence from Manatee County and the establishment of a new local government structure. Final victory was not easily won, but in the end, the superior political organization of the Sarasotans proved decisive not only in gaining legislative approval but also in winning a critical election in the Sarasota district, where 80 percent voted in favor of county division.

After Governor Cary Hardee authorized the formation of Sarasota County on July 1, 1921, those who had forged the political consensus inside the Sarasota district and then led the successful fight for independence now took up the reins of power in the new county. Forming a new government proved no easy task. The county leaders suffered because of their inexperience as well as plain bad luck, such as the enormous damage inflicted by the

hurricane of 1921. Moreover, they were stymied in the first six months of their administration by Manatee County's utter failure to cooperate in providing records essential to Sarasota County's functioning. The new government, however, did act decisively on many fronts, particularly road building and maintenance. By the end of the great boom period of the 1920s, Sarasota County had much of the transportation infrastructure it needed to compete for tourists, settlers, investors, businesses, and northern markets for its agricultural products.

The Florida land boom of the 1920s remade Sarasota County and most of Florida as people and money flooded into one of the nation's last frontiers. Although this great era of prosperity ended badly with the collapse of the Florida boom followed by the Great Depression in the early 1930s, Sarasota County emerged with an expanded population and significant additions to its building stock as well as many new bridges and miles of high-quality roads. Many recently arrived men and women of wealth and influence came to dominate the county's economy and society and lead Sarasota into a new era.

With the opening of the magnificent "million dollar" courthouse in the City of Sarasota early in 1927 and the completion of the cross-state highway and the Tamiami Trail shortly thereafter, the story of the founding of Sarasota County concludes. But that pioneer generation of men and women who organized and led the fights for a comprehensive road and bridge system, the formation of Sarasota County, and the establishment of a new government deserve far greater recognition for what they accomplished on behalf of future generations of Sarasotans.

THE SEEDS OF DISCONTENT

I n the spring and early summer of 1921, the citizens of what was then called the Sarasota district of Manatee County had much to celebrate. After years of growing frustration with what they saw as an uncaring and insensitive county government located in Bradentown to the north, they launched a campaign to win their independence and become a county in their own right. On May 11, they learned the state legislature in Tallahassee had approved enabling legislation, and just days later Governor Cary Hardee signed the measure. The City of Sarasota erupted into a scene of impromptu parades, endless honking of hundreds of automobile horns, the wail of fire truck sirens, and an informal gathering of leaders from most of the small communities in the Sarasota district who congratulated one another on the success of their campaign. A month later, the people of the Sarasota district voted overwhelmingly to ratify county division, and once more there was exuberant jubilation. By terms of the legislation, Sarasota County, Florida's sixtieth county, would come into existence on July 1, 1921.[1]

The fight for county division in the Sarasota district had gone on for about a year as general feelings of discontent with the county government in Bradentown intensified. At a series of public meetings throughout the district, leaders of the movement laid out in detail the anti-Sarasota district bias of the Manatee County Board of Commissioners, the county school board, and other government agencies in their treatment of the people living in the southern third of Manatee County. Only county division, they had argued, could right the balance and allow the Sarasota district to prosper.[2]

How had all this come to pass? Originally, Manatee County including the Sarasota district had been part of Hillsborough County, home of the metropolis of Tampa. In 1855, Manatee County became a county in its own right. Then, in 1887, DeSoto County broke off from Manatee County, forcing the removal of the county seat at Pine Level—now located in DeSoto County—to the town of Manatee just east of Bradentown. This relocation for the most part benefited the few residents living in the Sarasota district, since they now traveled a shorter distance to handle tax and legal matters at the new center of county government. For the next twenty-five years or so, this arrangement seemed to work well enough. In part, it was accepted by the Sarasota district simply because of its small population, estimated at 600 in 1900 compared to the 4,100 people living in the other four districts of the county.[3]

The Sarasota district inhabitants were not only small in number but also scattered thinly over a very large area. The largest community was the town of Sarasota, an outgrowth of the failed Ormiston Colony. In 1885, the largely Scottish settlers arrived on the shores of Sarasota Bay, where the Florida Mortgage and Investment Company had promised houses and a functioning town. Alas, all they found was a jungle. Thanks to nearby neighbors, the colonists did not starve, but most left the area within a few months, never to return. Despite this failure, the Florida Mortgage and Investment Company still owned thousands of acres it intended to develop and sell. To head the operation, the company's leader dispatched his son, John Hamilton Gillespie, to America. A soldier by trade, Gillespie brought energy, order, and purpose to the company's struggling efforts in the settlement of Sarasota.[4]

In short order, Gillespie began advertising lands for sale, built the DeSoto Hotel to attract wealthy tourists, and laid out Gulf Stream Avenue along Sarasota Bay. He established a community cemetery named Rosemary and even laid out what has been described as one of the earliest golf courses in America. Like many Scots, he was passionate about the sport. By 1903, Gillespie had created a solid base for the new community and arranged for the state legislature to legally define Sarasota as a town. Predictably, he became the first mayor. About the same time, the Seaboard Air Line Railway, through one of its subsidiaries, extended its tracks to the town of Sarasota, thus giving the area direct rail access to Bradentown, Tampa, and the great cities of the north. With its superb weather and bountiful fishing, Sarasota soon attracted well-to-do sportsmen as well as people with health problems who needed to escape northern winters. But before the town of

Sarasota could fully exploit its assets, a depression in 1907 brought economic expansion nationally and locally to a halt.[5]

Despite its problems, the town of Sarasota—with a population of 842, according to the census of 1910—easily outpaced any other community in the Sarasota district. But each of these small settlements was growing in size and would be important a decade later in the fight for county separation. Among these little villages were Englewood, Venice, and Osprey to the south of the town of the Sarasota. To the east and southeast stood Miakka, Bee Ridge, Fruitville, and Tatum Ridge. Populated areas along the shores of the bay could be reached by primitive roads and by water transportation in 1910. Inland communities, located primarily on the few low ridges in the area, could support small-scale vegetable and citrus farming, but they were often isolated during the six-month wet season, when rain and flooding rivers and creeks made travel nearly impossible.[6]

In fact, almost 70 percent of the land in the Sarasota district was underwater all or part of the year. Vast sloughs dominated the western portion of the district, while large stretches of saw grass marshes spread out near Bee Ridge and Fruitville. Moreover, periodic flooding along the Myakka River and Philippi Creek severely restricted settlement and agricultural development along their banks. Unless something dramatic happened, the Sarasota district had very limited prospects for the future, and the town of Sarasota would likely remain nothing more than a fishing village.

Then in February 1910, an event of immense significance occurred: Mrs. Potter Palmer of Chicago stepped off her private Pullman coach at the Seaboard Railway station in the town of Sarasota. Bertha Honoré Palmer was one of the most extraordinary and wealthy women of the age. Born in Louisville, Kentucky, in 1849, she moved with her family to the boomtown of Chicago, where she grew up, attending private schools both there and in the Georgetown area of Washington, D.C. Her father became a successful real estate investor, which meant that Bertha and her siblings moved in the city's best social circles. In 1870, at age twenty-one, she married Potter Palmer, who was forty-four at the time. Palmer had made one fortune running a Chicago department store and was busily accumulating another in real estate. His focus was the State Street area near Lake Michigan in what is now known as the Loop. To promote his plan to make this area the city's new business center, Palmer built the city's greatest hotel, the Palmer House. Unfortunately for Potter and his new bride, all of Potter's real estate assets were lost in the Chicago Fire of 1871. Encouraged by Bertha, Potter soon recovered his wealth and rebuilt the Palmer House, where the

couple lived for a few years. Later, Potter built a $1 million mansion on north Lake Shore Drive, where he was developing another project later called the Gold Coast because of the rich people who bought property there.[7]

Blessed with beauty, intelligence, education, and good taste in all things, Bertha quickly established herself as the social arbiter of Chicago. At her mansion, usually referred to as "the Castle," she threw lavish parties. The guest lists defined who was—and who was not—part of Chicago's elite. She also had political reach through her sister, Ida, who married Frederick Grant, eldest son of President Ulysses S. Grant. She was often seen at the White House attending functions and even standing in reception lines with the president and the First Lady.[8]

Bertha had other interests besides her role as society queen. She belonged to the Chicago Women's Club, supported social worker Jane Addams and Hull House, and even held a meeting at the Castle where a group of women workers formed a union. She became a significant art collector, accumulating a large number of works by the French Impressionists. These works now hang in the Bertha and Potter Palmer Gallery of the Art Institute of Chicago.[9]

In 1891, Bertha Palmer was appointed to the Board of Lady Managers of Chicago's World's Columbian Exposition and then won election as the group's president. It was the first time the

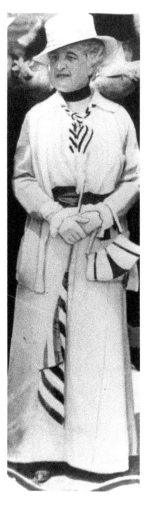

Bertha Honoré Palmer. *By permission of Sarasota County Historical Resources.*

U.S. government had ever granted such official recognition to a group of women. The challenges Bertha faced were enormous. She had to fight for resources to build a Women's Building as well as a Children's Building and a dormitory for unattached females. She had to organize a vast effort to mobilize the women of the United States to send exhibits to Chicago that would illustrate all of the accomplishments of American women in industry, the arts, education, invention, agriculture, horticulture, and many other fields. She traveled to Europe to meet queens, princesses, noblewomen as

well as professional women to persuade them to organize national displays of women's work for the Women's Building in Chicago's Jackson Park. Those leading women she could not meet personally she wrote to seek their support. The Empress of Japan, for example, assumed a leadership role and organized a world's fair committee to gather a display of women's work in that faraway nation.[10]

The Chicago World's Fair was a grand success, and Palmer earned praise in America and around the world for what she and the Board of Lady Managers achieved. Following the fair, Palmer continued her social activities in Chicago, Bar Harbor in Maine, and Newport in Rhode Island. In 1902, her husband, Potter, died, leaving his spouse a very rich widow. Until 1910, she spent time each year in Paris and London, where she maintained homes. In England, she became part of an elite social group that King Edward VII gathered around himself. But Edward died in 1910, and his successor had no interest in socializing with rich American widows. At age sixty-one, Bertha Palmer was still the undisputed leader of Chicago society, but she seemed to yearn for other challenges.[11]

Her journey to Sarasota began when she read an ad in the January 23, 1910 *Chicago Sunday Tribune* promoting land sales in and around the town of Sarasota, Florida. Those interested were invited to contact Joseph H. Lord at his office in the Marquette Building in Chicago's Loop area. Intrigued, Bertha checked into Lord's reputation and then invited him to the Castle for a visit. If the campaign for county division had a precise beginning, it was at that meeting, for it led to a partnership of two powerful and energetic people who came to share a common vision of Sarasota's future.[12]

Lord had been born in Wells Depot, Maine, in 1859 and graduated from Brown University. He married Fran Mabel Webber, herself a college graduate from Boston University. The family immigrated in 1885 to Florida, where Lord passed the state bar examination and set up a practice in the Orlando area. Then, in 1889, he relocated to the Sarasota district, where, over the next twenty years, he purchased 100,000 acres, mostly from Gillespie and the Florida Mortgage and Investment Company. Because his investments in land would increase in value only if many new settlers came to the Sarasota district, he necessarily became one of the great boosters for the region. He promoted any idea that promise to improve the area and attract tourists and potential residents.[13]

There is no record of what was said when Lord first met Bertha Palmer, but within days, she boarded a train bound for the town of Sarasota along with her father, H.H. Honoré, her brother Adrian, and her son Honoré

Joseph H. Lord. *By permission of Sarasota County Historical Resources.*

Palmer. Save for H.H. Honoré, who died within a few years, the other members of the Palmer party would all play significant roles in the creation of Sarasota County. When they reached the town of Sarasota, the group found Arthur Britton Edwards waiting for them at the station. Edwards was Lord's partner in a real estate firm. Because Lord had continuing business obligations in Chicago, it fell to Edwards to take care of the Palmer party until his partner's return. Since Sarasota lacked a first-class hotel, Edwards arranged to lease the Halton Sanatorium, which was better equipped to handle distinguished guests.[14]

Edwards spent a great deal of time talking to Bertha Palmer about the history of the Sarasota district and his own personal experiences. The two became friendly as, bit by bit, Edwards divulged his life story. Born in 1874 just north of where the town and then city of Sarasota would develop, he grew up in grinding poverty with little education. Both his parents had died by his fifteenth birthday. To support his three younger siblings, he went to work for local cattlemen. In every way, he was a self-made man. In 1898, at the start of the Spanish-American War, he joined the U.S. Quartermaster's Department. He then became part of the American occupation force in Cuba after fighting ended. By 1903, the year the railroad reached the town of Sarasota, he had opened a real estate office. Like Lord, Edwards avidly promoted the Sarasota district and supported progressive ideas. He, too, would be a major leader in the battles for good roads and county division.[15]

Within a very short period of time, Bertha Palmer purchased tens of thousands of acres from Lord and other landholders. Eventually, she controlled 140,000 acres, or nearly 220 square miles, in Manatee and Hillsborough Counties. To manage these vast holdings, Palmer created two corporate structures, the Sarasota-Venice Company and the Palmer Florida Company. She named her brother Adrian president of both corporations while making Lord and her two sons, Honoré and Potter Jr., company officers. She, however, directly managed her great Osprey Point estate and her 15,000-acre ranch along the Myakka River known as Meadowsweet Pastures.[16]

Bertha Palmer's arrival and news of her massive real estate purchases galvanized the Sarasota district. Suddenly, there was activity everywhere. It took many workers to build her mansion, The Oaks, and to operate her ranch and her estate. She arranged for the Seaboard Air Line Railway Company to extend its rails from Sarasota south to Venice, thus connecting her lands along the shore of Sarasota Bay and opening the door to new agricultural development. Before long, Bertha Palmer was not only the biggest landowner in Manatee County but also the largest employer. Moreover, her international fame guaranteed publicity for the Sarasota district, which soon became a destination for other wealthy individuals, some of whom built winter homes and began to invest in local development. Success begat success. By 1913, the town of Sarasota had grown to the point that its leaders successfully petitioned the legislature for incorporation as a city. In early 1914, Bertha Palmer's friend A.B. Edwards took office as Sarasota's first city mayor.[17]

Another sign of escalating growth and prosperity was the reinvigoration of the Sarasota Board of Trade in 1910, shortly after Bertha Palmer's initial visit. The organization underwent a number of reorganizations in the next few years, sometimes calling itself a board of trade or the Commercial Club or the chamber of commerce. Whatever its name, the organization represented the businessmen, doctors, lawyers, and real estate sellers not only of the City of Sarasota but also of the Sarasota district. It had close ties to city government officials, to the Masons, and to the local Democratic Party Executive Committee. The list of the directors of the board of trade was a "who's who" of leading citizens. Since the Sarasota district was a part of Manatee County, it had no government of its own. The board of trade helped fill that void.[18]

From the beginning, the board of trade relied heavily on the Palmer family, which helped fund its activities and even allowed it at times to meet in its Sarasota headquarters facility. Palmer allies Lord and Edwards both served as presidents, while Palmer corporate executives held board positions. This level of cooperation was possible because the strategic interests of the Palmers and other wealthy landowners in the Sarasota district neatly aligned with those of the Sarasota Board of Trade membership. Growth in population, wealth, agricultural productivity, and business activity were the goals they all sought.[19]

Transportation issues commanded the attention of the board of trade as well as of the Palmers and the City of Sarasota government. A swelling tide of immigrants from the north as well as escalating economic activity due mainly to the effect of Bertha Palmer's investments increased pressure to

expand railroad service, build utilities, improve water access to communities along the gulf, and construct roads that served everybody living in the Sarasota district.[20]

Another area of cooperation involved advertising to attract tourists, settlers, and investors. As an international celebrity, Bertha Honoré Palmer generated a great deal of free publicity for Sarasota that helped make the area a popular destination for other wealthy people. But to compete with other areas of Florida for middle-class tourists, the Sarasota district needed a professional, sustained advertising campaign that reached millions of Americans. The board of trade took the lead in organizing such a campaign. It printed thousands of brochures to be mailed across the United States. Bertha Palmer, her family, and the Palmer corporations supplied professional writers from Chicago to write the pamphlet and donated much of the funding needed to publish and distribute the piece.[21]

Both the Palmers and the Sarasota Board of Trade soon recognized that roads represented a new frontier for Florida communities competing for a brighter economic future. In 1910, there were no well-developed hard-top roads in the Sarasota district, including in the town of Sarasota. What roads existed were little more than cleared paths. There were few bridges; most waterways had to be forded. Those living along the Sarasota Bay shoreline relied on small schooners to carry on commerce and obtain the necessities of life. But all of this was about to change.

By 1913, relatively sizeable numbers of automobiles had appeared in Florida and Manatee County. There were around three hundred companies building automobiles in this period, but more than half of the vehicles in service in the United States were Ford Motor Company Model Ts. Ford launched the Model T in October 1908, and the company's revolutionary assembly line processes churned out fifteen million of the cars by 1927. Cheap (as low as $260), made for use on rough roads, and relatively easy to maintain, the Model T meant people of modest means could now afford to own and drive a car—even though the only color choice was black. But people with cars wanted to go places both locally and nationally. Public demand for more and better roads exploded as local and state governments as well as the U.S. Congress struggled to respond. Joyriding and vacation travel were some of the motives behind the growing call for new roads. Commerce was another. Bad roads dramatically increased the cost of moving crops, cattle, and hogs to railway facilities in states like Florida, thus putting agricultural products at a comparative price disadvantage.[22]

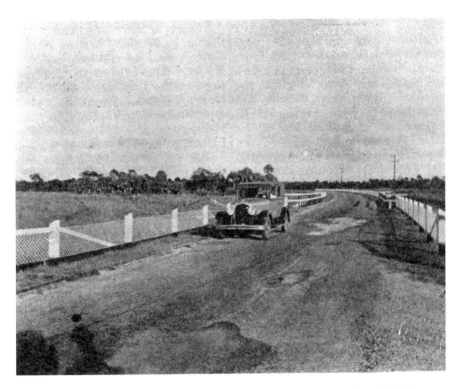

Tamiami Trail. Although unpaved, this road was far better than most before 1920. *By permission of Sarasota County Historical Resources.*

The deplorable state of American rural roads gave rise to a Good Roads Movement beginning as early as the 1880s. Originally led by bicycling organizations whose members wanted to explore beyond the boundaries of cities and large towns, the Good Roads Movement pressed county and state officials to build smoother and better-paved highways. In the early twentieth century, as the number of automobiles grew, national groups such as the American Automobile Association lobbied for roads able to carry this rapidly expanding automobile traffic. They were supported by regional and state Good Roads Associations. It became clear that cars and, after World War I, trucks soon wore out inadequately paved roads and bridges. It was also clear that counties alone could not fund the construction of better, more durable roads. Nor could they on their own plan out a rational system of roads serving the needs of large sections of a state. The automobile revolution involved in part a revolution in how state governments and the federal government conceived their roles in building and managing a vast interconnected system of county, state, and federal highways.[23]

Before the creation of the Florida Highway Department in 1915 and passage of the Bankhead Act of 1916 that first authorized federal aid for highways, Florida counties were entirely responsible for rural roads, which they funded by poll taxes, property taxes, and bond issues. In other words, roads were a local matter, and the boards of county commissioners were responsible for creating and maintaining roads outside of cities and towns. In Manatee County, for example, the taxes applicable to road construction and repairs were distributed among the five county commissioners, each of whom decided how to spend those funds within their districts. With the permission of the state legislature, counties could establish special bonding districts where property owners could vote to pay the interest on bonds sold to fund road and bridge projects in their area. At the time, these were the only options.[24]

The problem of roads became increasingly acute for Bertha Honoré Palmer as she developed more and more of her vast landholdings. In 1913, she marketed properties in the Boulevard Addition, a subdivision she established just north of the town of Sarasota. One of the chief assets of the location, besides being on the shoreline of Sarasota Bay, was that the Sarasota-Bradentown "hard road" built the year before ran right past the development, theoretically allowing easy access to either Bradentown or the town of Sarasota. But the road to Bradentown had been badly paved by the Manatee County government, which then did little to repair the inevitable damage. Drivers complained of frequent tire blowouts due to road deterioration. What made this situation worse was the fact that the Sarasota-Bradentown road was expected to become part of a Bayshore Road stretching from the Tampa/St. Petersburg area to Venice at the southern end of the Sarasota district. Bertha Palmer supported this concept because the proposed road would unite all of her bay shore properties.[25]

About the same time, Bertha Palmer opened work on the first of two grand agricultural planned communities, this one called Bee Ridge Farms. She envisioned an eight-thousand-acre development centered on the Palmer company town of Bee Ridge, which straddled the Venice Extension rail line she had insisted be built as part of her initial land purchases in 1910. Roads played an important role in her planning of this unique agricultural experiment. Across the eight thousand acres, she built roads every half mile so that a road ran in front of every farm site. She had built a community of farmers rather than lonely isolated farms, as in the north. Residents in Bee Ridge Farms could easily reach their neighbors by car or move their vegetable and citrus crops to the rail station in the town of Bee Ridge.

Palmer also used her political clout with the Manatee Board of County Commissioners to arrange for the building of Bee Ridge Road and the extension of Fruitville Road to reach her properties east and southeast of the City of Sarasota. In this, she was supported by other large landowners such as Joseph H. Lord, who still served as vice-president of her Sarasota-Venice Company. But the quality of these roads was often poor and maintenance proved a continuing challenge. Moreover, the all-important Bayshore Road was far from complete. To put it differently, Bertha Palmer had built the best planned road system in all of Manatee County at Bee Ridge Farms, but there were no well-built roads connecting that system to other parts of the county or the state, let alone the nation. She and other land developers understood that land values were closely tied to good roads.[26]

In October 1913, the Manatee Board of County Commissioners issued what it described as a master plan for road and bridge development in the county, to be paid for by selling bonds. The commissioners' plan did not have the benefit of public input. Even a cursory look at the plan showed that it favored the interests of the northern part of the county. The clear emphasis was on building or improving roads that connected Bradentown with Tampa and with Anna Maria Island, a fast-developing tourist attraction

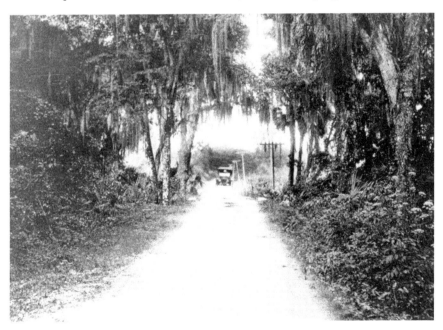

Fruitville Road before 1920. *By permission of Sarasota County Historical Resources.*

west of Bradentown. The Bayshore Road so much desired by Sarasota district leaders was the only major project included that directly benefited southern Manatee County residents. There were, however, vague references to extending the Bayshore Road to Venice and Fruitville Road east to the village of Miakka near the Myakka River. The plan did not set priorities on which roads would be built first. Moreover, there were pressing road needs in the Sarasota district not addressed by the plan, including those in the southernmost areas and on the offshore keys. Even more troubling to Sarasota district leaders was that the bonding plan made the landowners of the entire county responsible for paying off the interest and principle of the bonds. This meant the Palmers, Lord, and other large landowners would be taxed to finance northern Manatee County projects of little interest to them or the Sarasota district. This prospect so distressed the southerners that the Sarasota Board of Trade urged the one representative for the Sarasota district on the Manatee Board of County Commissioners to oppose any countywide road-bonding proposal.[27]

The 1913 road and bridges bond proposal passed despite the displeasure of the citizens in the Sarasota district. It was a forceful reminder that the northern part of Manatee County had the votes and the political power and that its interests had priority. The chief benefit to Sarasota was the extension of the Bayshore Road south to the town limits of Sarasota. The road began again on the south side of the city and ran a short distance past Philippi Creek. But the terms of the bonding issue did not provide for road maintenance, and within a year, the Sarasota district portion of the Bayshore Road was nearly impassable. The Sarasota district now had reason to doubt the managerial competence of the Manatee Board of County Commissioners as well as its political evenhandedness.

Another problem with the 1913 road and bridge bond proposal was that the board of county commissioners' master plan proved sadly deficient in identifying Manatee County's real needs. As the numbers of people, automobiles, vegetable farms, and citrus groves increased, it soon became apparent that besides the other weaknesses of the commissioners' plan, it substantially underestimated the immediate requirements for new roads and bridges. Moreover, existing paved roads in all parts of the county were poorly built and infrequently repaired. Many of them were so narrow that two automobiles could not pass each other in opposite directions without one pulling off the road entirely.[28]

To address growing public unhappiness with the roads situation, the county board in late 1913 proposed a larger and more expensive roads and bridges

bonding program. This time, the Sarasota Board of Trade demanded and received a concession from the commissioners that, should the public vote to implement the program, all tax funds raised in the Sarasota district to pay interest on the bonds would be devoted to road and bridge projects in the district. Clearly, the people of the Sarasota district now realized that their interests had diverged from those of their northern neighbors. But things did not go well in the referendum vote held in February 1914. A new state election law proved so confusing that local election officials improperly disqualified many voters. In the end, the county commissioners threw out the results and chose not to schedule another election. This decision was never explained but may have been due to the fact that the votes actually counted in the election suggested a strong possibility of defeat. By March 1914, the Good Roads Movement in Manatee County appeared to go into hibernation. However, the roads issue would not disappear as the need for durable bridges and roads continued to grow.[29]

The failed 1914 vote held important lessons for the Sarasota district. For one, the inability of the Manatee County commissioners to organize and manage the election seemed again to demonstrate governmental incompetence. Secondly, the strong opposition to the proposal throughout the county showed the weakness of relying on roads and bridges master plans developed by the county government without consulting local communities. Even within the Sarasota district, significant conflicts grew over future transportation issues. Inland residents supported the building of new roads, but they were far less interested in funding expensive bridges to the keys, which they saw as of little benefit to themselves. Joseph Lord, the quintessential Sarasota booster, spoke against the bill, arguing that Manatee County had already taken on more bonded debt than he judged prudent. The Sarasota district began to realize that its future lay in a different direction from that of northern Manatee County, but there were no mechanisms in place to allow district residents to identify, articulate, and advocate their needs and ambitions. Before there could be a Sarasota County, a sense of civic, economic, and political unity as well as an agreement on common goals had to evolve in the district. The struggle for good roads and bridges and the continuing ineptitude of the Manatee County commissioners eventually forced Sarasota-area residents to mute their own differences and embrace cohesive political action as the best path to securing prosperity.[30]

A Rising Tide of Frustration

The initiative for preparing a plan for bridges and roads in the Sarasota district now passed from the Manatee County commissioners to Bertha Palmer and her family and associates. By 1915, Palmer operations in the City of Sarasota and at Bertha's agricultural planned community at Bee Ridge were swiftly developing. The need for roads and bridges to connect up her properties, to move agricultural crops to market, and to link up investors with land she wanted to sell grew with each passing month. Like many in the Sarasota district, she was appalled by the inability of the county board to address effectively the roads issue. In this judgment, she was joined by her able brother Adrian C. Honoré, who served as president of the Sarasota-Venice Company and the Palmer Florida Company, as well as by her two sons, Honoré and Potter Jr.[31]

The first hint that something was afoot came from the August 13, 1914 issue of the *Sarasota Times*, in which a story revealed that an unnamed group of businessmen had determined to develop a plan for roads and bridges in the Sarasota district and employed an engineer to advise them. Their idea was to present the plan to the Manatee Board of County Commissioners and begin the process of holding an election to establish a roads and bridges special bonding district. In other words, these leaders intended to "go it alone," with the Sarasota district planning its own roads and bridges and then taxing themselves to pay for it. Bertha Palmer, as the largest landholder, would be responsible for 50 percent of any tax to pay off a bond issue. The men behind the proposal were Lamar Rankin, City of Sarasota mayor A.B.

Edwards, and former mayor Harry Higel, all of whom had ties to Palmer. Edwards had known Bertha Palmer since she arrived in 1910 and had sold her land. Lamar Rankin, an executive with the Palmers' Sarasota-Venice Company, was the chief land salesman at Bertha Palmer's Bee Ridge Farms operation. Harry Higel had his fingers in many economic enterprises but was best known for developing Sarasota Key, later renamed Siesta Key. He had also sold land to Bertha Palmer in the Venice area. Adrian Honoré was not an official member of the committee, but records show that little happened without his direction and knowledge.[32]

Besides planning a new road and bridge system, the committee studied road-building techniques, particularly the relative costs and durability of different types of paving materials. They even organized a car caravan that took nineteen Sarasotans to the town of Eustis in the center of the state to examine the utility of what were called oil/sand roads, a relatively cheap and allegedly strong paving substance. In the meantime, Rose Phillips Wilson, editor of the *Sarasota Times* and indefatigable supporter of good roads and bridges, published articles not only detailing the committee's activities but also warning that other counties were outpacing Manatee County in transportation planning and could win the competition for tourists and economic development.[33]

By early October 1914, the committee's work had advanced to the point that the members needed to identify the next steps in the process. While closely tied to the Sarasota Board of Trade and the Sarasota City Council as well as the Palmers, the committee was entirely self-created. The members had no standing other than as citizens of Manatee County to bring their plan to the county commissioners. Moreover, they could present no evidence that the citizens of the Sarasota district had any knowledge of or input into the plan, although the plan itself showed that considerable negotiations with many communities had taken place behind the scenes. By law, any application for a special bonding district required a petition signed by at least 25 percent of the eligible voters in the proposed district before the county commissioners could take action and seek the approval of the state legislature. Who was to circulate the petition? Somehow, the committee had to find a way to gain legitimacy and engage as many people as possible from all the communities of the Sarasota district in the process.

Harry Higel seems to have conceived the idea of calling a "mass meeting" to review and hopefully approve the committee's plan. It was he who made the public announcement of the meeting in the *Sarasota Times* of October 22, 1914. The concept of mass meetings, where citizens of a community

assembled to discuss matters of common concern, had its roots in English parliamentary law. In this case, the mass meeting was intended to overcome the problem that the Sarasota district had no government of its own. Much as the American Revolution leaders had done in the early 1770s, the Sarasotans advanced their goals by appealing to the original source of political power: the people themselves. And the people of the City of Sarasota responded enthusiastically in early December, as more than 150 of them gathered at the Hover Arcade Building, where city government was housed. They listened to the plan, asked questions about what roads and bridges would be built and considered the estimated costs. Mayor A.B. Edwards gave the principal address, and attorney Cary B. Fish then stood and moved for the vote.[34]

The crowd overwhelmingly voted for the proposal to create the Sarasota/Venice Special Roads and Bridges Bond District that encompassed areas located in the western half of the Sarasota district. The plan called for the building of an eighteen-mile, hard-topped "trunk" road from the City of Sarasota to Venice, a road to Bee Ridge ending at the Friendship Baptist Church in the Fruitville community, extension of the Fruitville hard road, a new road from Tallavast Station to Lockwood Ridge Road, a hard-surface road north from Sarasota to Indian Beach, and a bridge over Philippi Creek. Various other bridges, including one to Sarasota Key (later renamed Siesta Key), were also included. Costs were estimated at $165,000 (later increased to $250,000). Edwards told the crowd that Adrian Honoré had already found a Chicago firm that would buy all the bonds at 5 percent interest.[35]

The mass meeting gave one other direction to Mayor Edwards: appoint a broadly representative Good Roads Committee to help get the petition drive organized and gain county and state legislative approval. This new committee gave the organizers of the bond proposal the chance they needed to make good roads a unifying issue for all of the Sarasota district. Edwards named influential leaders from all parts of the district, including William B. Webb from Osprey; Charles T. Curry from Venice; Thomas A. Albritton from Bee Ridge; Franklin P. Dean of Indian Beach; as well as himself, Dr. F. William Schultz, and Lamar Rankin, all of Sarasota.[36]

The committee members were an interesting group, some of whom were destined to become important figures in the struggle for county division and then in the governance of the new Sarasota County. A.B. Edwards, chair of the Organization Committee, would continue to battle for roads and bridges in the Sarasota district, but he also emerged as a prime mover in the campaign for independence from Manatee County. With the launching

Left: Arthur Britton Edwards as a young man. *By permission of Sarasota County Historical Resources.*

Right: George Higel of Venice, around 1907. *Image courtesy of Venice Museum & Archives.*

of Sarasota County in 1921, Edwards became the tax assessor. Thomas Albritton, a citrus grower from Bce Ridge, served as a Sarasota County commissioner from 1922 to 1924, while his son Paul C. Albritton became the Sarasota County judge in 1924. Franklin P. Dean from the settlement of Indian Beach, located just north of the City of Sarasota, later served as a member of the General Committee on County Division chaired by Edwards in 1920. This was the group that orchestrated the drive for independence. These connections show how closely the roads and county separation issues became intertwined.[37]

The new Good Roads Committee quickly gathered the necessary petition signatures, and the state legislature soon approved holding a referendum within the Sarasota district. In the meantime, Edwards gathered information vital to the success of the bond vote, even employing engineers to study and report to him on the suitability of local sand in laying oil/sand roads, the paving material selected by the mass meeting after hearing assertions that it was both durable and economic. On March 11, 1915, the roads cause was helped by the reorganization of the Sarasota Board of Trade into a new group called the Commercial Club. The old association had played an important role in the continuing struggle for more and better roads and bridges in the

Sarasota district but had fallen on hard times just as the special bonding district vote was about to take place. Supported by this new and energized Commercial Club and the Palmers as well as the relentlessly positive stories in Rose Wilson's *Sarasota Times*, Edwards and the Good Roads Committee waged a vigorous campaign for the bond district proposal in all parts of the Sarasota region. By March 4, two weeks before the election, Edwards was so confident of victory that he scheduled a "Day of General Rejoicing" and invited other towns in the district to send representatives to participate. On March 18, the *Sarasota Times* reported the voting results. By a four-to-one ratio the referendum passed, winning in every part of the area included in the Sarasota/Venice Special Roads and Bridges Bonding District. Here was more evidence that a political consciousness had emerged in the Sarasota district. Many of its citizens were beginning to see themselves as a polity separate and distinct from Manatee County. A mass meeting in the City of Sarasota held as part of Edwards's "Day of General Rejoicing" celebrated the outcome. The jubilant audience heard from W.J. Adams, president of the Commercial Club, and Joseph Lord from the Sarasota-Venice Company, who once again praised the virtues of oil/sand for road paving.[38]

But celebration proved premature. In mid-August 1915, the Manatee County Board of Commissioners rejected all bids submitted to purchase the bonds for the special roads and bridges district. A.B. Edwards, Harry Higel, C.E. Hitchings of the Bank of Sarasota, Ellwood Moore of the First National Bank of Sarasota, and attorney John Burket representing the city government and the Commercial Club traveled to Manatee to witness the opening of the bids. The Sarasotans reported back that the Manatee County Board of Commissioners had determined the bond issue had not been properly advertised and therefore the bidding process had to be repeated. They hoped the commissioners would be able to open a new set of bids on August 28 and that work on the roads would begin in November. It had already been five months since the election and nothing had been done to construct the roads and bridges the district so desperately desired. And there would be other delays.[39]

August 28 came and went with no action taken by the Manatee County Board of Commissioners. More bad news arrived on November 4, 1915, when Sarasotans learned to their dismay that the county commissioners not only had not solicited more bids for the bonds but also had decided to call another election to ask the voters of the Sarasota district to allow the commission to make material changes in the roads and bridges plan so that it would not cost more than the $250,000 approved in the March vote. J.W.

Ponder, the county commissioner representing the Sarasota district, told the *Sarasota Times* that the roads and bridges plan as approved in March was too "elaborate" and the bonding money would not come close to covering the costs. In a private letter to Bertha Palmer, Ponder asserted that federal government road engineers brought in by the county commissioners had made the assessment. He did not explain why it had taken nine months for the Manatee Board of County Commissioners to decide that the entire process was flawed and everything must be done again. Ponder suggested that, in a retooled plan, the width of proposed roads needed to be reduced from fifteen feet to nine feet and that other cost-saving measures must be adopted. It is no wonder that in this period a frustrated Bertha Palmer contacted her attorney in Tampa about ways to create a Sarasota County separate from Manatee. She did not, however, press the issue.[40]

The Sarasota Commercial Club met to discuss the proposed changes to the road and bridge plan. With no palatable alternative before them, the group endorsed the amended proposal put forth by Commissioner Ponder. The club's subcommittee on roads began circulating a petition to the commissioners supporting a new election. As this was happening, Edwards and Bertha Palmer received yet more negative news. Perhaps the government road engineers had said something in their report to the county commissioners about the utility of oil/sand roads; but whatever the cause, Joseph Lord and Lamar Rankin, both executives in the Palmer corporate structure and members of the Commercial Club, suddenly took off on a car trip around Florida to study other communities' experience with this type of paving. On December 1, 1915, Lord reported their findings to his old friend and sometime business partner Mayor A.B. Edwards. They had looked at every brick and asphalt road from Tampa to Eustis. He reminded Edwards that he and Adrian Honoré had agreed to the roads and bridges special bond district only because of assurances that oil/sand roads had been tested successfully in Lake County. In fact, he and Rankin had now learned that roads of that type had failed. As a result, Lake County had been forced to change from sand to a clay base for the roads. "I want to say to you," wrote Lord, "that I believe it would be a terrible mistake to go ahead with the scheme as outlined, to build the roads on sand." Lord admitted that the whole episode "is very embarrassing." There is some evidence that Lord's judgment had an immediate effect at least on the Sarasota-Venice Road, where concrete was used as a paving substance on part of the route. Lord's startling findings also caused Bertha Palmer and her brother Adrian to temporarily withdraw their support for the revised plan. Besides the sand

base issue, the two of them became concerned that the county commissioners might choose to save money by eliminating roads the Palmers considered essential from the roads and bridge project list. Commissioner James Ponder apparently saved the day by persuading them that their concerns would be addressed. Despite all the difficulties, the coalition of Sarasota district leaders pushed forward on the road and bridges plan.[41]

On November 10, 1915, the Sarasota Commercial Club had appointed a new committee "to cooperate with the County Commissioners on roads and bridges." The chair of this group was the now-former Sarasota mayor, A.B. Edwards, and the members were Franklin P. Dean from Indian Beach, H.W. Mackintosh from Bee Ridge, Howard Elliott, Vic Saunders of Osprey, and Albert Blackburn of Venice. If broadly representative geographically of the Sarasota district, the committee was also filled with people close to Bertha Palmer, such as Mackintosh, Edwards, and Blackburn. Not surprisingly, she agreed to pay all expenses related to the campaign to win passage of the revised road plan. The first task of the group was to define precisely the changes to the original roads and bridges plan, including reducing the width of the roads and changing the location of one bridge to lessen costs of construction.

The committee then called a mass meeting in the City of Sarasota and secured broad support for these changes. By late November, the committee launched a petition drive and soon had enough signatures to ask formally that the county commissioners hold an election on the modified roads and bridges plan. Two weeks later, on December 8, 1915, the commissioners set January 22, 1916, as the date for the election.[42]

With the help of editor Rose Phillips Wilson, the committee waged a spirited campaign, urging people to vote "yes." Wilson constantly reiterated in the *Sarasota Times* the benefits of good roads and bridges, pointing out that the revised plan would create thirty-four miles of well-paved roads connecting Sarasota to northern Manatee County as well as to Venice in the south, Miakka in the east, and Bee Ridge to the southeast. She noted that when the proposed Sarasota-Venice hard road was linked to a road being planned by another special road and bridge bond district in the Englewood area, the Sarasota district would be integrated into the most likely route of the Tamiami Trail. This massive project had first been proposed by a Miami businessman, James Franklin Jaudon, in 1915 and was seen as a critical loop highway allowing tourists to drive between Tampa and Miami across the Everglades. The roads committee also sponsored a mass meeting in Osprey. There, county commissioner James Ponder and A.B. Edwards addressed

"any misunderstanding in regard to the selection of the roads to be built." This statement suggested there was still work to be done to convince smaller communities that the modified roads and bridges plan did not sacrifice their interests. A final mass meeting was held on January 3 in the City of Sarasota to whip up public enthusiasm for the revised plan.[43]

The affirmative voters easily carried the day on January 11, 1916, although the Venice precinct recorded a slight majority of "no" votes. At a meeting called by the Sarasota Commercial Club, President Adams noted that companies submitting bids to construct roads would need to include the different costs for rock, clay, and sand base. This appears to show that Joseph Lord's report on the inferior quality of oil/sand roads was not ignored. Within weeks of the vote, Bertha Palmer's Sarasota-Venice Company began advertising properties it owned along the as-yet-unbuilt Tamiami Trail in the Sarasota district, asserting that the inevitable flood of tourists along the road would drive up land prices.[44]

In May 1916, almost five months after the vote, the Manatee County commissioners met and finally accepted a bid on the bonds of the Sarasota/Venice Special Roads and Bridges Bond District. This long and continuing delay irritated Rose Wilson, who complained that the money for the bonds had been approved in March 1915 and no construction had yet commenced. She noted that a recent judicial restraining order had temporarily blocked any road building but work should begin in thirty-five days "if no further legal technicalities hold up the works." Three weeks later, the contract to build the roads and bridges was signed with the Continental Public Works Company of New York, which agreed to complete the project by May 1, 1917. Engineer William M. Tuttle assumed leadership of the work. A local man, Tuttle also served as vice-president and treasurer of the West Coast Realty Company, located in the City of Sarasota. A Pennsylvania firm, the Luten Bridge Company, won the contract to erect the bridges in the plan.[45]

For a time, things proceeded smoothly. Reports in the newspapers detailed progress on all the road and bridge projects. The county commissioners in January 1917 let contracts in the new Englewood Roads and Bridges Special Bond District. The people in that district had voted to extend the still uncompleted Sarasota-Venice Road to Englewood, thus bringing the dream for the Tamiami Trail closer to reality. The Sarasota district leaders also took heart from what would prove to be revolutionary changes in road policy at the federal and state levels of government. In 1915, Florida established a state road commission that by 1917 began allocating funds to counties to build and maintain a state road system. The federal government

enacted the Bankhead Act, officially known as the Federal Aid Road Act, in 1916 to allocate federal appropriations to counties through state highway commissions for roads that would meet national standards for design and construction and be part of a national highway system. The government had concluded that the old system of leaving road building and maintenance to the counties funded entirely by local taxes and bonded debt was no longer adequate. The objective had to be a system of interconnected national roads, a system of state roads linking all parts of each state to the national roads, and a system of county roads serving local needs and connecting people to state and federal road systems.[46]

Despite the good news, there were growing challenges to the Sarasota district's roads and bridges program. On April 6, 1917, the United States joined the Allies in fighting World War I. Before long, the U.S. government took over the railroads to maximize their contribution to the war effort. Since Florida needed to import most building materials, including those needed in road construction, the state was deeply affected by severe cutbacks in the numbers of railcars available for this purpose.[47]

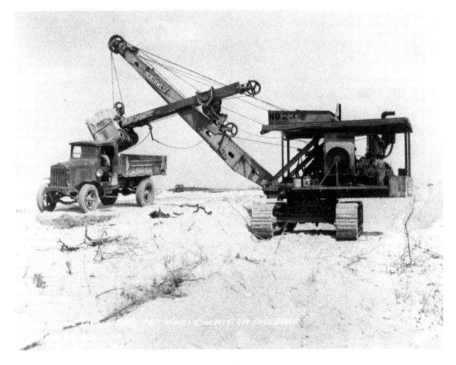

Power shovel loading shell for concrete in the Venice area. *Image courtesy of Venice Museum & Archives.*

Two months after the nation went to war, the Continental Public Works Company went bankrupt. Since the company had the contract to build the roads authorized by the special bonding district, work ceased on these projects. The fleets of trucks, road graders, and pavers ground to a halt. Not until three months later, on September 1, 1917, did the county commissioners finally declare the contract with the company to be forfeit because of major noncompliance. At the same time, the commissioners entered into a contract with the Fidelity and Deposit Company of Maryland to complete the work. Work on the roads then resumed, although the railroad problems often forced contractors to rely on local sources of building materials. City of Sarasota mayor Harry Higel, an avid advocate of good roads, managed to make a personal profit by hauling five thousand cubic yards of sand and shell from his land on Sarasota Key up Philippi Creek to the crews building the Sarasota-Venice Road. By Thanksgiving 1917, some progress on the roads and bridges had been made. However, these projects were supposed to have been completed by May 1, some six months before. Worse, the vote authorizing the roads and bridges special district had been held two and a half years earlier. The county commissioners were hardly responsible for all the delays and missteps that bedeviled the roads and bridges project, but they certainly had contributed through general indolence and incompetence.[48]

Just before Thanksgiving, the Fidelity and Deposit Company said it could not continue construction on the roads—save for the Sarasota-Venice Road—that it had pledged to finish. The company blamed government wartime restrictions that affected the availability of labor and the shipping of raw building materials by rail. The company asked that its contract be modified to allow it to finish the work after the war ended. The Sarasota-Venice Road—or "Velvet Road," as some called it—was indeed completed in 1918, but it was only nine feet wide and suffered from other design deficiencies. Its shortcomings would soon force major reconstruction. In fact, the general quality of all the roads and bridges that had been built or partially built as part of the Sarasota/Venice Special Roads and Bridges Bond District was not good. The road north to Bradentown, for example, continued to suffer from terrible potholes that the Manatee County commissioners were slow to fix. At one point, Sarasota entrepreneur Owen Burns personally provided materials to repair the road, asking only to be repaid when the county had sufficient funds. Perhaps the worst example of shoddy workmanship was the bridge to Sarasota (Siesta) Key, which showed signs of deterioration almost as soon as it opened. Cement began falling off the structure in large pieces. A new Sarasota Board of Trade, which replaced the Commercial Club,

Owen Burns, Sarasota leader and businessman. *By permission of Sarasota County Historical Resources.*

traveled to Bradentown to plead with the county commissioners to repair the bridge. The board received little encouragement.[49]

The end of the war came on November 11, 1918, and work soon resumed on the remaining Sarasota district road and bridge projects. By August 1919, Manatee County learned that it would receive $150,000 in federal road funds. About the same time, an important bridge opened over the Manatee River between Bradentown and Palmetto, thus establishing a valuable route north to Tampa. Feeling that momentum was with them, the businessmen of Bradentown resuscitated an old road-building idea they believed would lead to big profits. They relaunched the plan for constructing a cross-state road from Manatee County to the Dixie Highway on Florida's east coast. It was announced that serious discussions were underway among leaders of affected counties to participate in building a highway from Fort Pierce to Okeechobee City and then to Arcadia, Bradentown, and perhaps Sarasota. But A.B. Edwards and other City of Sarasota leaders now had long experience with the county commissioners and the Bradentown business community. They had little confidence that the northern Manatee County leaders would take Sarasota district interests into consideration when planning the cross-state road. In fact, the Sarasotans feared that the northerners would try to keep the Sarasota district from access to this cross-state road and thereby monopolize the benefits of the anticipated tourist traffic. Edwards therefore proposed a plan to the Sarasota Board of Trade to pave the Myakka road from the City of Sarasota to the eastern border of the county. He believed this action would insure that Sarasota could easily be connected to the cross-state road if it was actually built. And there were other problems for the district. The Bayshore Road had not yet been completed to Tampa, and the Tamiami Trail still had a gap between Venice and Englewood. The board of trade agreed to press the Manatee County Commission for action on all these projects, although the commission's record of ignoring or rejecting similar requests from the Sarasota district suggested that nothing would be done.[50]

By the end of 1919, the citizens of the Sarasota District were fed up with the county commissioners and, for that matter, with the entire population of the northern two-thirds of Manatee County. Since 1913, the Sarasotans had struggled with the Manatee County government over the building of roads and bridges. They came to see the county commissioners as both inept and biased in favor of Bradentown and the northern sector of the county. Over the past seven years, the Sarasota district had grown in population and wealth. Moreover, a political union had been forged between the Palmers, Joseph Lord, and other wealthy landowners and an ambitious and able group of lawyers, doctors, real estate investors, merchants, and businessmen representing not only the City of Sarasota but also all the small communities of the district. This union was based on common aspirations for rapid economic expansion, which in turn was entirely dependent on a modern and sophisticated transportation infrastructure emphasizing good roads and bridges. It was also based on their shared belief that the current political system was stacked against them and that only through their own united efforts could they remake it in their favor. As veterans of the road and bridge conflicts, men like A.B. Edwards and Harry Higel knew that changes in federal and state road policies meant that counties were no longer entirely responsible for funding roads. There was now a new system emerging in which the federal and state governments shared funding responsibility with the counties as well as planning and maintenance. But county governments were the units that higher government levels dealt with and through which resources were dispensed. Since the Sarasota district was not a county, it had meager influence on key decisions about where bridges and roads would be built and funds for maintenance spent. The obvious answer to all of this was for the Sarasota district to cut loose from Manatee County, become a county in its own right, and seek a destiny uniquely its own. And, in fact, that is exactly what happened.[51]

THE STRUGGLE BEGINS

By June 1920, the level of grievances and frustration among the citizens of the Sarasota district reached the point where the political and commercial leadership determined to seek independence from Manatee County. Sometime in the spring, the movement for county division began to take shape, particularly in the City of Sarasota and specifically among city officials and business leaders involved in the good roads effort.[52]

The Sarasota district was not the only area of Florida where discontent fueled efforts to form new counties. The context for creating a large number of new counties in Florida at this time was rapid population growth. In 1910, Florida's population was 752,619. Twenty years later, 1,468,211 people called Florida home, an increase of 95 percent. Not surprisingly, twenty of Florida's sixty-seven counties came into existence in this period. The year 1921 proved to be a banner one for new counties, with seven, including Sarasota, winning approval from the state legislature. Counties are part of state government. In 1920, their organization and functions were defined in the Florida Constitution of 1885. Article VIII provided considerable detail on the establishment of a new county, an action that required both legislative and gubernatorial approval. In 1921, with so many applications for county division arriving in Tallahassee, both legislative houses appointed standing committees to review the paperwork and make recommendations.[53]

Little is known about the preliminary work behind the meeting that publicly kicked off the campaign to establish Sarasota County. However, it became evident that considerable thought and preparation had taken place

Left: Honoré Palmer, Bertha Palmer's elder son. *By permission of Sarasota County Historical Resources.*

Right: Potter Palmer Jr., Bertha Palmer's younger son. *By permission of Sarasota County Historical Resources.*

before thirty-five people assembled in a publicly announced mass meeting on June 16, 1920, at the offices of the Palmer Trust in the City of Sarasota. Bertha Palmer had died in May 1918, but her sons, Honoré and Potter Jr., and her brother Adrian C. Honoré remained very much in charge of the Palmer empire in Florida. Like Bertha, they had all strongly advocated more and better-built roads and bridges. Now they were convinced their economic interests would best be served by political independence from Manatee County. The man presiding over this initial meeting on county division was none other than Sarasota mayor Arthur Britten Edwards, who continued to be one of the principal leaders of the Good Roads Movement in the Sarasota district as well as a friend of the Palmers. Edwards opened the session saying that "an agitation had been started for county division" and that the purpose of the meeting was to consider breaking away from Manatee County and forming a new county.[54]

Edwards then introduced Dr. Joseph Halton as the main speaker for the evening. Halton, born in England, had joined his brother Jack, also a doctor, in Sarasota sometime before 1910. He ran a hospital and had been actively engaged in civic affairs, including a term on the Sarasota town

council in 1910–11. His task at the mass meeting was challenging: define the Sarasota district's grievances, justify county division as an appropriate response, and mobilize people for action. Halton began by charging that the government of Manatee County sought to isolate the Sarasota district by its official actions as well as by negligence regarding "our most crying need—good roads." As a result, he said, communications among the neighboring towns have been obstructed. Moreover, he claimed that all existing roads leading north from the Sarasota district were so poorly maintained that they were "almost impassable since the time of the passing of our first bond issue for the building of hard roads." He was referring to the bond election of 1915 some five years earlier. Halton further alleged that the county government had purposely scheduled its inadequate program of road repairs during the tourist season, presumably to inhibit tourist traffic to the Sarasota district. Halton also charged that "we are likely to be robbed of the logical road from the west coast of Florida to Arcadia." Here he alluded to efforts by Manatee County leaders to make sure that the proposed cross-state road from the City of Fort Pierce on the Atlantic Ocean to the Gulf of Mexico would end in Bradentown rather than Sarasota. But Halton said the City of Sarasota was not alone in suffering from bias and negligence at the county seat in Bradentown. He also complained of the uncompleted road to Manasota Key south of the town of Venice, where the Manasota Lumber Company had a million-dollar investment in the timber industry.

By now, Halton had warmed to his topic. "We in the south district," he warned, "can expect to be milked until we are dry. The northern part will seize the profits of our labors, for example our district bonded roads. They are used by the northern districts but make no contribution to help with maintenance." At this point, Halton wandered into a discussion of the motives of those seeking county division. He defined these leaders, including himself, as men "in the prime of our productive years. The effective moving, vitalizing work of this community must be done by us in the next fifteen golden years." He said the group wanted "our community to grow, we want to grow with it. We want to move and not stagnate." The problem, he reiterated, is "we feel we are being held back by some of our old ties." Joseph Halton was no Thomas Paine in terms of revolutionary rhetoric, but in his rambling speech he had made the key points: Manatee County continued to mistreat the citizens of the Sarasota district, their prosperity and future progress were threatened, and the only alternative was separation and the creation of a new county.[55]

In Halton's keynote address, the widespread frustration of citizens of the Sarasota district with the lack of progress on roads and bridges became painfully evident. They now realized that economic progress required a major political change. They also recognized that the Manatee County government and the businessmen of Bradentown must be viewed as economic competitors who were using their political and budgetary control over the building of roads and bridges as a way to retard the Sarasota district's development. After Halton sat down, the meeting proceeded with Joseph E. Battle, a director of the Sarasota Board of Trade, in the chair. Following some debate and a passionate pro-separation speech by influential businessman Owen Burns, the mass meeting passed a resolution to establish an Organization Committee to plan the independence campaign and directed it to report to a second mass meeting a few weeks later. Once again, as they had done in 1914 at the beginning of the good roads effort, the Sarasota district leaders used the device of the mass meeting to give their political agenda legitimacy.[56]

On June 23, a much larger group of citizens assembled at the mass meeting held in the offices of the Palmer Trust. Rose Phillips Wilson of the *Sarasota Times* described the crowd as representative of most areas of the Sarasota district. The report of the Organization Committee was the chief item of business. Once again, Joseph Battle presided. Dr. Halton, who chaired the committee, delivered the report on behalf of the members: Arthur L. Joiner, cashier of the first National Bank of Sarasota; attorney John F. Burket; Owen Burns; and Lawrence L. May, head of the Palmers' operations in Sarasota. The report reflected considerable thought about the problems that would confront a campaign for county division. It called for the selection of a twenty-five-member Executive Committee, soon dubbed the General Committee on County Division, to lead the movement. The members were to be "representative of the entire district." Each of them would be assigned to a working subcommittee. The Organizational Committee report then proposed the names of those individuals it thought should be members of the General Committee on County Division.[57]

Following the precedent of 1914, when the Sarasota Board of Trade put together a committee to push the idea of a roads and bridges special district, the Organization Committee nominated representatives from all the affected communities in the Sarasota district. These included Augustus M. Wilson (Miakka), W.L. Dunn (Nokomis), W.E. Stephens (Venice), J.R. Mason (Manasota), Peter Buchan (Englewood), Vic Saunders (Osprey), Bryant Taylor (Bee Ridge), Ernest Tucker (Fruitville), William Hancock

(Miakka), and F.P. Dean (Indian Beach). John Graham of Bradentown, a large landowner in the Sarasota district, was also nominated. The organizers of the county division movement clearly understood that to be successful their political effort needed both the appearance and the reality of unity among the citizens of the district.[58]

The remainder of the nominees were closely associated with the City of Sarasota, although some also had significant connections to other communities in the district. Almost all of them had extensive records of civic service, including membership on the board of trade. Among these were Mayor A.B. Edwards, businessman and real estate developer Owen Burns, banker Arthur L. Joiner, attorney John F. Burket, Palmer executive Lawrence L. May, steamship owner John Savarese, attorney William Y. Perry, businessman George B. Prime, engineer William M. Tuttle, attorney Frank Redd, Clarence Hitchings, Dr. Joseph Halton, Bertha Palmer's brother Adrian C. Honoré, Frank Pearce, and E.O. Burns. Taken as a group, the General Committee on County Division constituted a formidable political force. The members represented every part of the future Sarasota County, were all well-respected men who had long been leaders in their communities, and counted among their number some of the wealthiest men in all of Manatee County. Many were veterans of the campaigns for good roads and bridges. They were the "movers and shakers" who promoted causes that encouraged economic growth and prosperity in the region. Rose Phillips Wilson was not a member—although by all rights she should have been among the first to be named. A relatively short time later, she would be selected as one of the first female directors of the Sarasota Board of Trade. Wilson and the *Sarasota Times* would prove indispensable to the county division campaign, as they had been and continued to be to the Good Roads Movement.[59]

The Organization Committee further proposed that the members of the General Committee on County Division be assigned to one of six subcommittees: finance, data, legislation, territorial lines, publicity, and general information. Those attending the second mass meeting then discussed the committee's proposals. There were no voices opposing county division. However, some asserted that certain nominees to the committee were, in fact, not friendly to the idea. The response was to allow the committee at its discretion to add additional proponents of county division to its membership. With that action, the second mass meeting adjourned.[60]

A quorum of the General Committee on County Division chaired by lawyer John Burket met on July 7 in the city council chambers at the Hover

Arcade Building on the City of Sarasota bay front. The group swiftly approved all parts of the Organization Committee report made at the second mass meeting. A.B. Edwards chaired the subcommittee on data. He reported that he had studied the effect of county division on millage rates. He concluded that Sarasotans could expect a tax surplus for several years following separation, leading to a decrease in taxes. This was a key point, since in other county division controversies fear of higher taxes often sparked opposition to independence movements. Other subcommittees were not yet ready to report, and the mass meeting adjourned. While occasional mass meetings would be called in the future as needed, the power to act had now passed to the General Committee on County Division, which essentially was an arm of the Sarasota Board of Trade. The mass meeting device had accomplished its primary task by giving a patina of democratic legitimacy to a process that was hardly democratic at all. African Americans, women, and those of small means were largely left out of the process. And at this time, the general population was not given an opportunity to debate and vote on the wisdom and desirability of seceding from Manatee County. Later, the proponents would be forced to persuade a broader electorate to support their initiative. But by then they had achieved such superior political organization and command of the public debate that their scattered opponents had no real chance to defeat county division.[61]

On July 22, the General Committee heard from the subcommittee on territorial lines, charged with defining the geographical boundaries of the new Sarasota County. Chair William Tuttle, who was responsible for overseeing the building of roads planned for in the Sarasota/Venice Roads and Bridges Special Bond District, gave the report. The northern boundary, he said, should continue to be a straight line running between Townships 35 and 36 from the Gulf of Mexico to the DeSoto County line. Other boundaries would also be the same as the present Sarasota district. There was little discussion and no opposition to Tuttle's proposed county limits, although later the northern boundary line became a central issue in the battle for county division. For the moment, however, Tuttle's report allowed Edwards and the data subcommittee to make a more accurate assessment of the tax implications of county separation.[62]

Even as the General Committee on County Division systematically went about the business of gathering information and shaping the proposal for the new county, Manatee County continued to take actions that the Sarasota district saw as threatening. The *Manatee River Journal*, published in Bradentown, reported in early August 1920 that an election had been

scheduled for September 7 to approve a new roads and bridges special bonding district that would raise $200,000 to build a hard-topped road from the town of Manatee to the town of Miakka. All citizens of the Sarasota district not living within the Sarasota/Venice or Englewood special bonding districts would be included in the new district and taxed to pay off the bonds. The news came as a shock to the General Committee and to the board of trade. As William Tuttle pointed out, such a road with needed bridges and feeder roads would cost much more than $200,000. Moreover, the road would not benefit the people in the eastern portion of the Sarasota district who would be taxed to build it. They, he said, would be better served by a hard road to Sarasota, which would likely never be built if this special bond district was approved. He might have added that part of the tax base of the proposed Sarasota County was in the process of being coopted by the Manatee County government.[63]

As if this were not enough, Tuttle went on to claim that people he did not name living in Bradentown were once again scheming to change the route of the Tamiami Trail. At present, he reminded everyone, the planned route would carry the road south from Tampa through Bradentown, Sarasota, Punta Gorda, Fort Myers, and then southeast from Naples to Miami. The Bradentown forces, he said, wanted the road to turn sharply east at Bradentown and follow the route of the planned cross-state highway to Arcadia and on to Fort Pierce, where it would join the Dixie Highway to Miami. The dream of a cross-state highway running to and through Bradentown to the Gulf of Mexico had long been in the minds of Bradentown leaders. Designating such a highway as part of the Tamiami Trail would multiply the economic benefits to the Bradentown business community. The effect of such a change would be to cut off Sarasota and areas to the south from the bulk of north–south automobile tourist traffic. The Sarasota Board of Trade certainly did not want the route of the Tamiami Trail altered, but it did like the idea of the cross-state road as long as Sarasota was on the road's route as well as Bradentown. Tuttle's intelligence regarding the ambitions of the Bradentown political and economic leaders proved to be accurate, and the issues around the routes of the Tamiami Trail and the cross-state highway soon moved to the very center of the growing conflict between the Sarasotans and the rest of Manatee County.[64]

The most pressing problem for the Sarasota Board of Trade in the late summer was to defeat the Manatee County Commission's proposed roads and bridges plan at the bond district election scheduled for September 15, 1920. Although heavily involved in planning for county division, the board

now had to organize an effort to defend an essential interest of the Sarasota district. By September 2, former state senator Augustus Wilson of Miakka had joined the debate in opposition to the Manatee County Board of Commissioners' initiative. Wilson claimed that the proposed bonding district was really a charade and that the planned highway would never be entirely completed along the route publicly proclaimed by the commissioners. He predicted that the county government would actually build the road from Bradentown to the Waterbury tract in eastern Manatee County and then extend it in a more easterly direction toward Arcadia in DeSoto County so that it became part of the cross-state highway. As a result, the Sarasota district inhabitants living in the bonding district would receive no benefits from the road while being taxed to pay off a huge bonded debt. Indeed, they would be taxed to build a road that would bar the future Sarasota County from the benefits of access to the cross-state highway. In the end, the $200,000 bond issue was defeated at the polls, much to the relief of the Sarasotans. The episode dramatically increased the distrust of the citizens of the Sarasota district toward the county commissioners and accelerated support for separation. And the larger battle between the Manatee County government and the Sarasota district over roads was far from over.[65]

On Wednesday, September 7, 1920, one week before the controversial bond election, the General Committee on County Division chose to call for a third mass meeting in the City of Sarasota. Significantly, the group told Rose Wilson for publication that the purpose of the public meeting was to lay out the case for county separation and make a decision whether to proceed. Presumably, the timing of the meeting was meant to accomplish two things: first, to whip up opposition to the new bond district proposal; and second, to channel growing hostility toward Manatee County into the movement for independence. John Burket, chair of the General Committee on County Division, gaveled the mass meeting to order. He then called on A.B. Edwards, chair of the data subcommittee, to speak. Despite all his accomplishments, Edwards was but forty-six years old. He was not a physically imposing man, but he projected a strong presence. He spoke well and had honed his political skills during his years in public office. Above all, he had credibility as a native-born Sarasotan who always supported civic and economic progress. When Edwards spoke, people paid attention.[66]

Edwards's argument for county division repeated earlier assertions that the Sarasota district paid more in taxes to Manatee County than it got back in services. He cited as an example that the county had accumulated $350,000 in school indebtedness, of which the district bore liability for

$100,000. But for that $100,000, the Sarasota district had received only $35,000 in support of its schools. The rest had gone to the northern districts of the county. Such unfairness, said Edwards, resulted from inadequate representation on the county board. The Sarasota district covered between one-third and one-half of Manatee County and paid one-third of the taxes but had only one representative on the five-member board of county commissioners. Augustus Wilson followed Edwards to the podium to discuss once more the charge made by the opponents of separation that taxes would rise. Although this matter had been addressed by Edwards at an earlier mass meeting, the General Committee felt more needed to be said. Wilson described research he had conducted on counties that had recently won their independence. In every case, he said, the millage rate had gone down in the new counties and the people paid lower taxes, at least for a few years. Other speakers reiterated Sarasota district grievances regarding roads and bridges.[67]

At this point, the question was called on whether the Sarasota district should seek legislative approval for separation from Manatee County. The vote in favor was unanimous. Rose Wilson's headline on September 9 claimed that the "Executive Committee Now Has Official Endorsement of the People and Will Proceed with Active Efforts." Of course, the people at large had not yet been asked how they felt about the matter. The third mass meeting also passed motions that there should be created a committee on a constitution and bylaws for the organization as well as a finance committee to raise funds to sustain the campaign for separation.[68]

Having now publicly proclaimed their intention to seek independence, members of the General Committee on County Division moved quickly to organize a political campaign to win legislative approval. The publicity subcommittee began arranging mass meetings in other communities in the Sarasota district, where delegations from the General Committee laid out why independence was necessary and rallied support for the separation campaign. The subcommittee also began work on a pamphlet for broad distribution making the case for leaving Manatee County.[69]

Ironically, in the midst of all this activity, many of the most ardent advocates for county separation serving on the general committee left Sarasota to be part of a Manatee County delegation that was to address the Tampa Wholesale Grocers Association. Edwards, Tuttle, Frank Walpole, Harry Higel, George B. Pearce, M.L. Wread, Lawrence May, and Augustus M. Wilson joined delegations from the northern part of Manatee County in asking the Tampa businessmen's group to lobby the Hillsborough Board of

Man changing a tire, an all-too-common scene on early Sarasota roads. *Steinmetz collection, State Archives of Florida.*

County Commissioners to repair the Hillsborough portion of the Bayshore Road, which they said was in such bad shape that it was close to unusable. They claimed that three of the thirty-seven bridges on that stretch of highway were "in dangerous condition." As a result, vehicles traveling the Bayshore Road suffered damage, particularly from blown tires, and commercial and tourist traffic was threatened. The grocers agreed to help, sensing their own interests were imperiled should they be deprived of markets and sources of vegetables to the south.[70]

The episode demonstrated that good roads always stood at the top of the agendas of the General Committee on County Division and the Sarasota Board of Trade, even if it meant cooperating with people they distrusted and from whom they were seeking independence. In addition, the Tampa trip showed something else of importance: the role of women in politics was changing. Rose Wilson and Mrs. Lawrence May had been part of the Sarasota delegation in Tampa, a major breakthrough for women seeking greater equality. Within days of the delegation returning from Tampa, the *Sarasota Times* announced that Congress had declared the Nineteenth Amendment to the U.S. Constitution passed. Women now had the right to vote, and the presidential election of 1920 would be their first opportunity.[71]

Women had been an active and influential force in the Sarasota district for years. The Sarasota Woman's Club and predecessor groups had spearheaded efforts to beautify the bay front and lower Main Street. They created the town's first library, fought for compulsory school laws, and, with Bertha Palmer's help, built a children's park in the downtown area. During and after World War I, new groups such as the League of Women Voters and the Daughters of the American Revolution also began to channel women's energies into civic activities. Similar developments took place in other Sarasota district communities. In Englewood, women founded the Lemon Bay Mother's Club in 1918, a forerunner of the Lemon Bay Woman's Club, while the slightly older Bee Ridge Woman's Club also started a library. Many women owned substantial property or managed businesses and thus wielded economic power. The emergence of women in the political process was not lost on the male leaders of the General Committee on County Division or the Sarasota Board of Trade. They knew that at some point there would likely be a referendum on county separation. Wisely, they recognized that the women of the Sarasota district could not be ignored and, indeed, needed to be brought into the process. This became evident in November 1920, when the board of

trade elected new officers and new board members. For the first time, two women were included. Alice Guenther, spouse of a Palmer corporation executive, served as president of the Sarasota Woman's Club. Rose Wilson, of course, had long been a powerful voice for progressive change through her newspaper. For reasons not entirely clear, the Sarasota Board of Trade was reorganized in late November as the Sarasota Chamber of Commerce and legally incorporated. Most of the old board of trade officers and board members, including the two women, moved smoothly into the new organization.[72]

The change of the board of trade to the chamber of commerce may reflect problems in the county division campaign. From November 1920 to April 1921, the county division issue seemed to drop out of sight. After months of detailed reports on plans and progress in the local paper, the flow of information significantly abated. There were certainly distractions, such as the Bayshore Road matter and continuing concerns about Bradentown's efforts to control the cross-state highway and to change the route of the Tamiami Trail. The election of 1920 undoubtedly took up the energies of many of the leaders of the county separation movement, almost all of whom were avid Democrats.

Another major distraction took place in January 1921, when a father and his son walking in the road along Siesta Beach found a badly beaten and unconscious Harry Higel. He was lying in a pool of blood with his head split open. He was taken to Dr. Joseph Halton, who did what he could and sent him on to Tampa, but Higel died along the way. Halton, who had long known Higel, later said that the former mayor's head and face were so deformed by the assault that he did not recognize him. Only a ring Higel was wearing tipped the doctor as to his identity. At first, suspicion fell on one of Higel's African American employees, with whom he had an argument. But news soon broke that the local deputy sheriff had arrested Rube Allyn, who ran a newspaper called the *Florida Fisherman*. He was, in fact, quite a well-known figure who had previously published a newspaper in Sarasota for a brief time and had been active in the Good Roads Movement. He and Higel had even been part of a Sarasota district delegation examining road paving in eastern Florida. Not long before the murder, Allyn had agreed to address a Sarasota Board of Trade dinner. Rose Wilson described him as a popular and witty speaker.[73]

As word spread of Higel's death and Allyn's arrest, an angry mob began to form, forcing the authorities to whisk Allyn out of Sarasota and into a jail

cell in Bradentown. Although circumstantial evidence implicated Allyn in the crime, he remained silent. The Higel family even hired a lawyer and a detective to aid the prosecution. In the end, however, a jury felt there was insufficient evidence to convict. Allyn never returned to Sarasota and lived the remainder of his life out of public view in a small community east of Bradentown. To the present day, the Higel murder is likely the most famous Sarasota murder for which no conviction was ever obtained.[74]

Harry Higel, Sarasota mayor and a murder victim. *By permission of Sarasota County Historical Resources.*

The spectacular circumstances of his demise obscure Higel's role in Sarasota history. Born in Philadelphia in 1867, Higel came with his family to the Venice area in 1884. He soon relocated to the new town of Sarasota. He succeeded in several lines of business but, in 1907, shifted his attention to developing Sarasota Key, later renamed Siesta after Higel's first major real estate development on the island. He served five terms as a member of the Sarasota town and city council and three terms as mayor. Besides developing Siesta Key, Higel became a bank director and a director of the Seaboard Air Line Railway Company. He was almost universally well liked, and his friends were nearly at a loss to explain Rube Allyn's motive, if he in fact he was the murderer. The only suggestion of a motive is that Allyn harbored ambitions to be the City of Sarasota mayor and hated Higel for beating him in the 1916 election. However, five years is a long time to wait for revenge. Higel's many friends placed a plaque honoring his memory on the Siesta Key Bridge, a structure Higel had successfully fought to have included as a project in the Sarasota/Venice Special Roads and Bridges Bond District.[75]

Higel was undoubtedly a loss both to the Good Roads Movement and the campaign for county separation, and his death and Allyn's trial transfixed the local political scene. But none of this convincingly explains the long hiatus in the General Committee on County Division's operations on behalf of county separation. It may be that one relatively simple answer is that the bill to create Sarasota County could not be introduced before April 1921, when the next session of the legislature assembled.

HAMDEN S. SMITH
1911

Hamden S. Smith, Sarasota
mayor and later head of the
Sarasota Chamber of Commerce.
*By permission of Sarasota County
Historical Resources.*

As the bill was already drafted, it may be there was little to be done before that time. Another possibility might be that the scope and complexity of the struggle for independence had overwhelmed an organizations made up entirely of volunteers. The members of the general committee and the board of trade were mainly successful and busy businessmen and women, many of whom had families to raise and commitments to other community causes. This may help explain why the recently established Sarasota Board of Trade suddenly morphed into the Sarasota Chamber of Commerce and then incorporated. Although made up of the same members as the old board of trade, the new structure set the stage for employing a full-time staff member.

On March 4, 1921, the new chamber of commerce, under the leadership of former Sarasota town mayor Hamden S. Smith, hired E.S. Delbert, manager of the local office of the Western Union Telegraph Company, as its secretary. Delbert proved to be an energetic asset as the county division contest entered its final phases.[76]

A NEW COUNTY IS BORN

S ecretary Delbert could not assume his chamber of commerce duties prior to the end of March pending the successful search for his replacement at the Western Union office. Once installed, however, the dynamic chamber secretary soon tackled a variety of projects. He fought to have mail delivered to all parts of the City of Sarasota and organized a publicity campaign to make Sarasota a summer resort as well as a winter resort. He also contacted the Florida legislative delegation in Washington as well as appropriate federal authorities to urge quicker action on a dredging project to connect Tampa Bay with Sarasota Bay.[77]

Delbert and the reorganized Sarasota Chamber of Commerce also jumped back into the county division fray. On April 7, 1921, the chamber's board of governors met in the director's room of the Bank of Sarasota. They moved immediately to the reading of a proposed legislative bill creating Sarasota County and its new government. The board approved the draft, which incorporated all of the points developed by the old General Committee on County Division, including the boundaries. It then authorized former state senator Augustus Wilson of Miakka to introduce the bill into the legislature. Wilson traveled to Tallahassee immediately and then sent the chamber board a telegram reporting that the Sarasota County bill would be submitted to the legislature on April 14. He later informed the board that prospects were bright for passage and that "there would be no great objection" from the northern end of Manatee County. Wilson would soon regret these words, for he had totally miscalculated the reaction in Bradentown.[78]

"County Division Question Occupies the Spotlight" read the headline in the April 21 edition of the *Manatee River Journal.* The story reported that the boards of trade in Bradentown, Manatee, and Palmetto agreed to "take action against the formation of Sarasota County." It also claimed that a large number of people in the Sarasota district had telegraphed state senator Frank M. Cooper and state representative J.J. Stewart expressing strong protest against the idea. The newspaper said that prior to the submission of the county separation bill there had been little discussion about the possibility. But when people learned of the pending legislative action, "opposition at once developed in almost all sections of the county." The Bradentown Board of Trade immediately held a well-attended meeting in which a committee was selected and dispatched to Tallahassee to fight the county division bill "to the limit." The board also sent a telegram of opposition to the state legislature, as did the boards of trade in Manatee and Palmetto.[79]

The *Manatee River Journal* also included in its story the names of Sarasota district citizens who had wired their legislative representatives urging defeat of the bill. The list included W.S. Harris and L.R. Duggins of Bee Ridge; H.V. White, C.N. Chapman, J.W. Keene, M. O'Brien, and H.H. Lettly of the City of Sarasota; Gary M. Ragan, Clem Phillips, B.F. Blackburn, John S. Tyler, and Lee H. Tyler of Laurel; Thomas Reed Martin of Nokomis; and J.M. Johnson of Osprey. Several of these men are of interest. Thomas Reed Martin had come from Chicago to design Bertha Palmer's mansion, the Oaks. She later fired him for what she called "disloyalty." Despite this setback, Martin went on to become one of Sarasota's most prolific architects. In 1921, he was associated with Dr. Fred Albee in designing and building a planned town in Nokomis. Gary Ragan, despite his opposition, ended up on the Sarasota County Board of Public Instruction. Benjamin Franklin "Frank" Blackburn was an early homesteader in the Osprey area and part of a large and influential family. The *Manatee River Journal* never said why these men and the others protesting to the legislature felt so strongly against county separation. Indeed, no coherent public statement of why northern Manatee County opposed separation ever appeared.[80]

The chamber of commerce wasted no time responding to the Bradentown challenge. Two cars full of board members left for Tallahassee to support former senator Wilsons's efforts with the legislature. Rose Wilson editorialized about the hostility of Bradentown, reminding her northern neighbors that Manatee County had itself broken off from Hillsborough in 1855. In a clear warning to Bradentown, she wrote in her editorial, "Sure, we want a county of our own and we are going to work with that in view until we get it."[81]

The special committee sent to Tallahassee from Sarasota boasted some high-powered individuals. The leader was Sarasota mayor A.B. Edwards. His fellow delegates included E.S. Delbridge, secretary of the chamber; Lawrence May, manager of the Palmer interests; Arthur. L. Joiner of the First National Bank of Sarasota; and businessman T.F. Arnold. They testified in front of the Senate Committee on County Organization, as did the group from Bradentown.[82]

The results were not heartening. The Sarasota district delegation lacked the support of their local senator, Frank Cooper. As a result, the committee merely reported the bill back to the floor of the Senate without recommendation, effectively tabling it. The Sarasotans complained that the Bradentown committee had advanced no

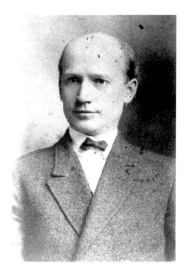

Thomas Reed Martin, one of Sarasota's most important early architects. *By permission of Sarasota County Historical Resources.*

serious arguments against separation save "sentimental" ones. The Sarasota committee, on the other hand, presented a petition for separation signed by a majority of voters in the Sarasota district. The committee members also cited facts and figures on population, property values, taxing capacity, and many other matters. Moreover, they discussed the representativeness of their organization and the educational mass meetings held throughout the district. They very likely pointed out to the Senate Committee on County Organization that it had already approved bills for six new counties in the past few weeks. Why should they be treated differently? All of this was true, but the political realities were against Mayor Edwards and his colleagues. Unless something dramatic happened, the campaign for Sarasota County appeared to have foundered. And given scheduling deadlines, it would likely be two years before the Sarasotans could again raise the issue in the Florida Legislature.

In reaction, the Sarasota Chamber of Commerce called another mass meeting in the City of Sarasota to discuss the situation. Edwards and the others who had testified before the state senate committee reported on their experience in Tallahassee. In their opinion, the bill to create Sarasota County might get through the senate but faced a dim future in the house. With few options to choose from, those attending the mass meeting decided

to give diplomacy a chance. They agreed to place the future of the county division campaign in the hands of a ten-member committee that was given the power to "act in all matters pertaining to success of the movement." Further, they instructed this new committee (which eventually ended up with eleven members) to arrange a meeting with the Bradentown committee "to secure an end of opposition." If this effort failed, they were directed to plan a new fight for independence two years hence.[83]

There was no question that only one man could possibly organize this effort: Mayor Arthur Britton Edwards. Edwards had led the fight for good roads and bridges and helped carry the county movement as far as it had come. Although mayor of the City of Sarasota, Edwards was well known throughout the district. He had spoken frequently at most if not all of the mass meetings held in the smaller communities on behalf of county separation. He was skilled at defining issues such as road and bridge development and independence from Manatee County in ways that showed he fought for everyone's interests, not just those living in the City of Sarasota. If anyone could pull off a reversal of political fortunes, it was Edwards. And his fellow committee members also brought considerable talent, experience, and commitment to the hoped-for negotiations with the northern Manatee County representatives. The veteran group included lawyers John Burket and William Perry, Peter Buchan of Englewood, hardware store owner George

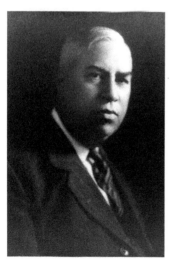

John Burket, attorney and advocate for county division. *By permission of Sarasota County Historical Resources.*

B. Prime, druggist T.F. Arnold, businessmen Joseph E. Battle and Ira G. Archibald, newsman Otis F. Landers, Palmer executive Lawrence May, and Dr. Joseph Halton, who first gave public voice to the desire for a new county.[84]

The negotiation team assembled on the evening of April 28 at the Palmer Trust offices, where a great deal of public business had been transacted over the years. What was said or what strategies were decided on are not known. But within hours, the Bradentown Board of Trade agreed to sponsor a mass meeting the next day and to invite the Sarasota committee to attend and make the case for separation. That meeting apparently took place in a constructive atmosphere. As the *Manatee River Journal* put

it, there was "a frank and friendly discussion." Top leaders of Bradentown were in attendance, including county judge O.K. Reaves; Mayor Stephens; large landowner John. A. Graham, who had attended one early mass meeting in Sarasota; H.F. Tabor; and other businessmen in the city. There were also representatives present from the communities of Manatee and Palmetto. Discussion ranged over several issues, with at least some of the northern Manatee County people uncomfortable at accepting the Sarasota district representatives' assertion that its people paid far more in taxes than they received in benefits. There were also questions about how to apportion the bonded debt between Manatee and Sarasota Counties and to split county assets. Among the Sarasota delegation, Edwards took the lead in setting out why the Sarasota district wanted a separation. William Perry, who had been the primary author of the senate bill, also made a forceful case for the Sarasota district. He asserted that the people of the Sarasota district had made their choice "and felt they were only asking for justice." He challenged the northerners "to show any cause why the new county should not be created."[85]

Before the meeting ended, the northerners agreed to appoint a committee to negotiate a settlement with the Sarasotans if possible. The two groups met the next morning, a Saturday, in Bradentown. In private, the Bradentown committee revealed that it had one nonnegotiable demand: the members wanted a change in the proposed northern border of the new Sarasota County. Specifically, they required the surrender of four townships or 144 square miles of land in the northeast corner of the Sarasota district. This amounted to 16 percent of the proposed Sarasota County. As a result, the new county would cover 725 square miles rather than 869 square miles. Faced with the unpalatable alternative of waiting two years for another chance to become a county, the Sarasotans soon conceded the area. Other agreements were quickly concluded on less important issues. With that, the northern Manatee County committee agreed to recommend to the Bradentown mass meeting that the deal be approved and support given to the passage of a revised county division bill in the legislature. It was further agreed that three members from each committee would travel together to Tallahassee to present the bill to the legislature. On Monday night, May 1, the two committees met once more to study and then approve the new piece of legislation. One day later, the mass meeting reconvened at the Manatee County Courthouse and, despite some unhappiness, voted in favor of the committees' proposal. The three northern delegates selected for the Tallahassee trip were former state senator and newspaper editor J.H. Humphries, O.L Stuart, and George

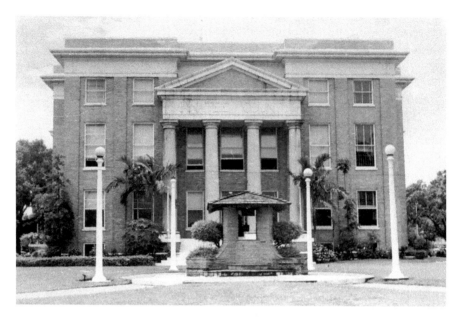

Manatee County Courthouse, where the Sarasota district's fate was determined. *By permission of Sarasota County Historical Resources.*

F. Harmer. Edwards, Burket, and Perry made up the Sarasota contingent; Augustus Wilson was already in Tallahassee.[86]

Reactions to this sudden turn of events differed greatly between the newspapers in Bradentown and Sarasota. J.H. Humphries, editor of the *Manatee River Journal* as well as one of the northern Manatee County delegates to Tallahassee, professed some ambiguity. He certainly had been a strong opponent of separation, but in an editorial he admitted that "active opposition is at an end" and that the bill would likely pass. He expressed relief that there had been no drawn-out confrontation as in other county divisions. When the bill passes, Humphries asserted, Manatee County will say "God bless you, go in peace, and may prosperity always attend you." He remained mute on the question of why the northern Manatee leaders were so anxious to obtain the four townships.[87]

There was no ambiguity in Rose Phillips Wilson's response to the news. "All Obstacles to Creation of Sarasota County Are Overcome" was her principal headline on May 5, 1921. Her story gave more information on the revised bill. The City of Sarasota would be the temporary county seat until county voters selected a permanent one. She also praised the wisdom of the two committees. By making a compromise, they had avoided two

years of fighting that would have stifled the progress in both sections. But, like Humphries, Wilson said nothing at this point about the loss of four townships and the substantial reduction in size of the new Sarasota County. She did caution that the legislature had yet to pass the bill or the governor to sign it. Even then, the bill called for a referendum among the voters of the Sarasota district on whether they chose to separate.[88]

The joint committee went immediately to Tallahassee and introduced the bill. On Wednesday, May 11, both houses of the legislature unanimously voted for creating the new county. Governor Cary Hardee signed the bill into law on May 12. He promptly handed one of the pens he used in the ceremony to an old political friend, Frank Walpole of Sarasota. Although not an official member of the Committee of Ten, Walpole had been privately lobbying in support of the separation bill. Despite positive action on the Sarasota County bill by the governor and legislature, nothing would be final until the referendum was held. The governor soon set June 15 as the date for the election. If approved by the voters, the new county would officially begin operations on July 1, 1921. Rose Wilson was perhaps the first person in Sarasota to learn of events in Tallahassee, as Sarasotans on the scene such as Robert Burket and Frank Walpole telegraphed news of each development to her directly. As one of Sarasota's biggest boosters, Wilson could take a great deal of the credit for bringing the county independence movement close to final victory.[89]

Even if the campaign for independence was not quite over, the Sarasota district exploded in celebration. By 9:00 p.m. on May 12, the City of Sarasota was rocked by the screams of factory whistles and fire engine sirens. Sarasota's biggest fire truck, driven by the chief himself, cruised slowly about the city followed by a large crowd. Secretary Delbridge of the Sarasota Chamber of Commerce sat next to him, operating the siren. Hundreds of people and an untold number of cars flooded into the Five Points area of downtown. Speeches were planned at Five Points, but the noise and general chaos made this impossible. Rose Wilson singled out E.S. Delbridge for praise in

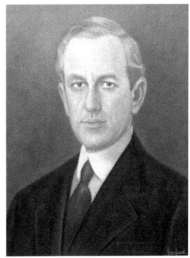

Governor Cary Hardee signed the act creating Sarasota County. *State Archives of Florida.*

Sarasota Times headline of May 12, 1921. *By permission of Sarasota County Historical Resources.*

the *Sarasota Times* as the person who raised the necessary funds to support the travel and expenses of the various committees and organized the petition drive that documented local support for county separation. She added that he also handled the telephones and answered telegrams of congratulations. Above all, Delbridge had supplied steady competence and endless energy to drive the county division campaign to the brink of ultimate success.[90]

Even as the celebration went on late into the night, supporters of county division began contemplating the next challenge: the election on June 15, only a month away. Rose Wilson immediately began lobbying women to learn about the issues and register to vote. She warned that women "have a short time to register and pay the poll tax." Wilson summarized the qualifications to vote in Florida. Every voter had to be a Florida resident for at least one year and possess a poll tax receipt for the past two years. Since women had received the right to vote in 1919, they only needed a poll tax receipt for 1920. All poll taxes had to be paid by the second Saturday the month before the election. Since the time they were first decreed, these somewhat arcane rules had led to many citizens being banned from voting booths. At least one road and bridge bond election had been lost because of strict enforcement of the regulations by electoral officials. Wilson clearly meant to avoid this happening again by publicizing the requirements especially for the benefit of women who had little experience with the electoral process.[91]

While mobilizing to defend the county separation bill from attacks during the coming campaign, the board of governors of the Sarasota Chamber of Commerce found it politically necessary to come up with an explanation for the loss of the four townships. This was not an easy task, since no one in Bradentown had ever explained why the boundary issue was so important that it imperiled the entire separation campaign. The area in question was certainly large although lightly settled and with significant portions subject to flooding. Historians have by and large been baffled. One speculated that

Rose Phillips Wilson, an effective progressive voice in early Sarasota history. *By permission of Sarasota County Historical Resources.*

Manatee County may have anticipated a growth of the cattle industry in the area that might have resulted in enhanced land values. Others simply pass over the topic.[92]

To understand why Manatee County desired to keep the four townships, it is necessary to ask what the business and political leaders, particularly in Bradentown, thought they would gain or lose depending on which county controlled the area. Scattered references in the Sarasota and Bradentown newspapers suggest that one of Manatee County's top concerns was the route of the proposed cross-state highway. Northern Manatee County wanted the western portion of that road to run from Arcadia to Myakka City to Bradentown, where it would hook up with the Tamiami Trail as well as roads leading to the beaches on Anna Marie Island. Vague promises had been made to the Sarasotans in earlier years that the cross-state road would also have a connection to the City of Sarasota. But as the Sarasota district as well as the City of Sarasota grew in wealth and population, northern Manatee County's leaders came to view their southern neighbors as competitors for tourists and investment dollars.[93]

If Sarasota County secured the four townships, a key section of the proposed cross-state highway would be under the new county's authority.

There was concern among business leaders in the Bradentown area that, since the cross-state highway was designated as a state road, the state highway authorities would listen to Sarasota County and perhaps adopt the idea of making Sarasota rather than Bradentown the terminus. On the other hand, if Manatee County retained the four townships, it might be able to completely block Sarasota from access to the highway. In that case, Manatee County would reap most of the expected benefits from the new road. The cross-state highway soon cropped up as an issue during the referendum election campaign in May and June 1921, thereby forcing the chamber of commerce to come up with assurances that Sarasota would be part of the project.[94]

Yet another motive likely explained why Manatee County so badly wanted to keep the four townships. While few people lived in the area and only a portion of the land was suited to agriculture, one enormous economic enterprise being developed gave promise of attracting more population, increasing citrus production, and encouraging new investment. The Waterbury tract covered some ten thousand acres. James Waterbury of Minneapolis, Minnesota, had made his money and reputation building heating systems for school buildings. He purchased the Waterbury tract in the late 1910s and established the town of Waterbury. His landholdings ran between what are now State Roads 64 and 70. On the north, his land bordered the Manatee River, and the eastern border was close to the Myakka River and included the districts around Myakka City. On the south side of Waterbury's land ran the East and West Railway tracks, offering easy access to northern markets.

By 1920, Waterbury had real estate sales offices operating in northern cities and announced big plans for developing his property. He offered people a chance to own ten acres of land as an investment. They could pay in installments over ten years and live on the lot or not as they chose. In any case, the entire ten thousand acres would be managed as one giant corporate operation. Lot owners had nothing to do with the trees or crops of grapefruit, but they did receive a portion of the market price paid for fruit gathered on their land. A magazine for medical doctors examined the business plan of the Waterbury tract and pronounced it a scam in which only James Waterbury was likely to make any money. But in 1921, the businessmen of Bradentown might reasonably have believed that Waterbury could well transform the eastern part of the county economically and thus make it worth holding on to the four townships. Their great interest in the fortunes of the Waterbury Company's plan was demonstrated by Manatee County's efforts in previous

years to build a road from Bradentown to the Waterbury tract. But the tract never fulfilled its promise, and nothing significant now remains of the planned towns of Waterbury and Pomelo that James Waterbury had hoped would attract settlers and investors.[95]

The Sarasota Chamber of Commerce and Rose Wilson tried to leave nothing to chance in the campaign to win the June 15 referendum vote. She regularly restated the reasons for separation: unfair taxes, inadequate roads, underrepresentation on the county board of commissioners, and underdeveloped schools. It was far better, she said, to keep our taxes in our own county for the benefit of our citizens. She regularly quoted Augustus Wilson and A.B. Edwards that the record showed taxes went down, not up, in newly established counties. She hammered the point that 31 percent of the assets of Manatee County would come to Sarasota County. She did not ignore but also did not stress that Sarasota County would have to pay 31 percent of the bonded debt of Manatee County. Wilson's oft-repeated argument was that a vote for creating Sarasota County was a vote for better roads and schools, control of finances, and an independent county government run by five commissioners elected by Sarasota County citizens. The chamber announced that it was organizing a new round of mass meetings throughout the Sarasota district to explain the county division law and to answer questions.[96]

One of the first of these meetings was set up at the Sarasota Woman's Club for 3:00 p.m. on May 23, and all women were invited to attend. Katherine McClellan, chair of the Committee on Legislation and Citizenship, organized the event. Katherine, along with her sister Daisetta, had developed the upscale community of McClellan Park south of downtown Sarasota beginning in the summer of 1915. She introduced to the women each of the delegates from the chamber of commerce. Attorney William Perry, who had distinguished himself in the pivotal mass meeting in Bradentown, talked about the history of the county division movement beginning with the first mass meeting in Sarasota held almost a year before. He stressed that the organizers of that event desired and got a unanimous vote at that time to ensure that the new Sarasota County would be "the best and most progressive county on the west coast." Perry was followed by A.B. Edwards, who presented a map of the boundaries of the new county and the roads that had been built and were still under construction as well as those that were planned when funding became available. Edwards also repeated the familiar argument that the taxes of newly created counties went down. Frank Walpole, still the Manatee County commissioner representing the

Sarasota district, told of being in Governor Cary Hardee's office when he signed the bill and then sending a telegram to Rose Wilson announcing the event. He went on to explain the exact provisions of the law. He then talked about new state policies that created state-aided roads that were partially funded with state dollars and maintained by the state. As a county, Sarasota would greatly benefit from these policies as it continued to fight for a modern system of roads. Walpole summarized by saying that no one can "develop key property without decent roads." Chamber secretary E.J. Delbridge then told the women that the chamber would pay the poll taxes for the women attending the meeting so that they could vote in the June 15 referendum. Nobody raised any questions about this unusual proposal, and twenty women accepted the offer.[97]

Those opposing county division lacked the organization of those in favor but certainly made their voices and opinions heard. They repeatedly stoked fear of higher taxes to fund the new county, criticized the loss of the four townships, and insisted that county division meant Sarasota would not be connected to the cross-state highway. The critics claimed that making the City of Sarasota the permanent county seat was part of a secret plan that also included appointments to new government offices for those supporting separation. Another line of attack challenged the veracity of the tax data used by the chamber.[98]

Perhaps the most serious challenge to the referendum supporters came from former City of Sarasota mayor G.W. Franklin. Franklin sent his letter of opposition to editor Rose Wilson, who printed it despite her passionate commitment to separation. The ex-mayor wrote that, whatever supporters said, costs and taxes would rise. The maintenance of two county governments where there had only been one necessarily demanded more people, more buildings, and certainly more money. But Franklin was only warming up. He attacked the chamber and the General Committee on County Division as well as the device of using mass meetings as a source of power and authority. The entire process was undemocratic, he claimed. What should have happened was a district-wide vote at the beginning of the process to determine if a majority of the people wished to pursue independence. Instead, the proponents took it upon themselves to make the decision to proceed. Franklin agreed that there was not a fair distribution of tax money, "but this could be overcome by redistricting" rather than county division. He even attacked the Palmer family, claiming that they wanted a new county that taxed the developed areas along the bay to build infrastructure in the underdeveloped areas inland, where they owned enormous amounts of land.[99]

Franklin could not be taken lightly. He had a following in the City of Sarasota, and his arguments posed a challenge. The former mayor's most dangerous assertion related to the Palmers and the development of the backcountry. This was an appeal to the citizens of the City of Sarasota to think carefully before voting for a separation that would in his opinion not benefit them particularly and certainly cost them tax revenue to help rich investors like the Palmers make their lands more valuable. The communities along the Gulf of Mexico and the people living inland had clashed before over roads and bridges as well the issue of fencing in cattle herds. If Franklin could reopen these old wounds, there was certainly a chance the county division referendum might be defeated.

The chamber of commerce and Rose Wilson's newspaper vigorously contested every criticism of county division, especially Franklin's assertions. William Perry, the rising star of the separation movement, took on the task of rebutting Franklin in the *Sarasota Times*. He concentrated on the issue of Sarasota versus the backcountry. He flatly denied Franklin's claim that the City of Sarasota would pay the bulk of the taxes raised by the new county. He pointed out that 80 percent of the property taxes in the new county would be paid by the five biggest landowners: the Palmer brothers, Adrian C. Honoré, Joseph H. Lord, John A. Graham, and the Manatee Lumber Company. Only 20 percent of the property taxes would be paid by the citizens of the City of Sarasota and the remainder of the district.[100]

Former state senator Augustus Wilson, who had worked so hard to secure passage of the county division bill, sent a letter to the *Sarasota Times* on the issue of losing the four townships. He argued, interestingly, that including the townships in the new Sarasota County would be "more a liability than an asset." Those 144 square miles, Wilson argued, had few residents, and land values were low. As a result, that area generated little in tax revenue. Moreover, the area needed more roads and bridges. Therefore, other areas of the new county would be forced to shift tax revenue to meet the legitimate requirements of citizens living in those four townships. It would be better, he implied, to let Manatee County pick up the tab for infrastructure improvements. He emphasized that loss of the four townships would not keep the new Sarasota County from connecting up with the cross-state highway as some had alleged. The chamber of commerce had assurances from Adrian C. Honoré and other landowners in the eastern part of the Sarasota district that they would donate the land needed to build the Verna Road from Fruitville Road to intersect with the cross-state highway (now State Road 70). As a result, the new county would not be deprived of the

fiscal benefits of the tourists expected to seek out the attractions of southwest Florida. These were interesting, perhaps even plausible arguments, but the fact remained that the Sarasotans had lost 144 square miles of land from their proposed county.[101]

Week after week, stories appeared in the *Sarasota Times* boosting creation of Sarasota County. On June 9, one week before the election, a subcommittee of the Sarasota Chamber of Commerce placed an ad in the *Sarasota Times*. The lead headline revealed the main thrust of the independence movement: "Do You Want Your Taxes to Benefit You? Then Vote for Sarasota County." The ad continued along this line, noting, "We could have our own county and use tax revenues for our own needs or we could continue to contribute to other sections and have our development hindered by an unequal representation in the affairs affecting us."[102]

The authors of the ad then turned to specific issues, starting with roads. The Sarasota district roads were in terrible shape, and many areas simply did not have the roads they needed. Yet the Manatee County taxing system continued to transfer tax revenues raised in the Sarasota district to road projects in the northern areas. The same pattern of inequitable distribution of taxes was evident in school financing; in just the previous year, $9,900 of Sarasota district tax revenues were assigned to the northern section of Manatee County. These facts alone, said the ad, justified a unanimous vote for separation in the upcoming election.[103]

An adjacent news story discussed some of the mechanics involved in getting a Sarasota County government up and running. The state constitution directed the chief judge in the new county to work with his peer in Manatee County to obtain transcripts of records pertinent to Sarasota. The county division law had a provision setting the days when the Sarasota County circuit court spring and fall terms were to begin. Another provision of the law abolished the Sarasota/Venice and the Englewood special bonding districts. Henceforth, Sarasota County would be responsible for paying off interest on the bonds and managing a sinking fund to retire the bonds themselves. This presumably was very good news for those areas of the county that had burdened themselves with debt to build roads and bridges that served the general public.[104]

In the last issue of the *Sarasota Times* to appear before the June 15 vote, Rose Phillips Wilson printed the entire bill passed by the legislature that authorized the establishment of Sarasota County. Among other things, the law made Sarasota County part of the Twenty-Seventh State Senatorial District and the First Congressional District as well as the Sixth Federal

Circuit Court. The new county was assigned one seat in the lower house of the Florida Legislature. Once the law was ratified in the referendum and Governor Cary Hardee certified the result, he would then appoint all the initial county officers, who would serve until the general elections in 1922. The Sarasota Board of County Commissioners was told to hold its first meeting on or after July 1, 1921. That day, the Sarasota Board of Public Instruction was directed to conduct its initial meeting. The legislation also created the judicial system and ordered the clerk of the county court in Manatee County to transfer all ongoing cases affecting the new county to the clerk of the Sarasota County Court. The Manatee County tax assessor was directed to perform his duties for 1921 for both counties and be proportionately compensated by both. As it turned out, these seemingly specific directions sometimes proved little more than guidelines.[105]

Rose Wilson had done everything in her power to support the movement for Sarasota County. Always upbeat and optimistic, supremely confident in Sarasota's boundless future, and impatient with those urging caution, she had been a giant in the yearlong battles leading up to the referendum. Her last editorial before the election showed her confidence that the people of the Sarasota district would vote the right way—her way. "Wednesday will be a great day. Voters will ratify the law creating Sarasota County by a safe majority." She went on to say that "the new community will have more money for schools and roads without additional taxation." The new Sarasota government would, in her judgment, do a better job than its predecessor in promoting development and maintaining a "more economical and representative county government." She praised the wisdom of the chamber of commerce in negotiating a settlement with its peers in Manatee County, thus sparing the people of the Sarasota district years of conflict to obtain their rights. She made reference to those in the Sarasota district who opposed county division but denied the validity of their concerns. With that, Wilson and her paper fell silent and, like everyone else, awaited the election results.[106]

The news on the election was a total vindication for all those who had spent a year striving to create Sarasota County. When readers opened the Thursday, June 16 edition of Rose Wilson's paper, they immediately noticed that she had renamed the newspaper she and her husband had founded in 1899. It was no longer the *Sarasota Times* but the *Sarasota County Times*. The headline below, set in the biggest type she owned, read, "Hurrah for Sarasota County!" The election results then followed. The county division bill was ratified 518 to 154, roughly a four-to-one margin. The six precincts reported

THE SARASOTA COUNTY TIMES

ESTABLISHED 1890—SUCCESSOR TO THE MANATEE COUNTY ADVOCATE AND THE SARASOTA TIMES

DEVOTED TO THE INTERESTS OF A SECTION OF BEAUTIFUL BAYS, PERFECT CLIMATE, UNEXCELLED SHORE LINE, AND UNLIMITED POSSIBILITIES

VOL. XXIII, No. 2 SARASOTA, FLORIDA, THURSDAY, JUNE 16, 1921 $3.00 A YEAR

Hurrah For Sarasota County!

Sarasota County Times banner headline of June 16, 1921. Note the change in the name of the paper. *By permission of Sarasota County Historical Resources.*

the following tallies: Sarasota, 406 to 118; Osprey, 37 to 2; Venice/Nokomis, 22 to 30; Englewood, 25 to 0; Miakka, 7 to 0; and Manasota, 11 to 4. All areas of the new county except for the Venice/Nokomis district decisively backed the split from Manatee County. Wilson reported that at City of Sarasota voting stations, balloting started early and with great enthusiasm. When the polls closed, large crowds clustered around the stations awaiting the results. She asserted that throughout the new county nearly 80 percent of those eligible cast their ballots.

Why a majority voted negatively in the Venice/Nokomis area is not well understood. But almost from the beginning of the contest for county division, an influential group of leaders in that region did express opposition. Earlier in June, George Higel, brother of the slain Harry Higel and the clever and witty local correspondent for the *Sarasota Times* for Venice and Nokomis (and a future county commissioner), reported on a mass meeting on the question of county separation held at the Polly Anna Inn in Nokomis. Architect Thomas Reed Martin, who had very early spoken out against separation, presided at what Higel called the largest political meeting in the area's history. A.B. Edwards, William Perry, Otis F. Landers, and John Burket made the usual presentations on why separation was a good idea. They were opposed by George Blackburn, who had been one of those who sent a telegram to the legislature attacking the county separation bill and thereby helping to temporarily stall its progress. Higel admitted that Blackburn made some interesting arguments based on the economic effects he anticipated if a new county was created, although Higel himself remained a firm supporter.[107]

At the celebration in downtown Sarasota, which began at 10:00 p.m. on June 15, 1921, prominent citizens came from around the district to join in the merrymaking. Even a few Bradentown residents and Manatee County officials showed up and distributed cigars. Rose Wilson claimed that she saw well-known opponents of the county separation bill cheering Sarasota County with everybody else and vowing to "work as hard for it as they

had against its creation." A few days later, Frank Walpole and chamber of commerce secretary Delbridge drove north along the Bradentown hard road to the new border between Manatee and Sarasota Counties. There they erected a "Welcome to Sarasota County" sign above the road.[108]

The battle was now over. A savvy band of politicians, businessmen, wealthy landowners, and one lady newspaper editor had overcome all obstacles. Generally, the election campaign and the election results did not leave any bad feelings or produce a rift in Sarasota politics. But during the campaign, many promises had been made about roads and bridges, and about schools, lower taxes, and greater representation in setting policy. Creating a Sarasota County government was no mere intellectual exercise. The people behind the movement and those who supported them expected tangible benefits in the form of economic progress spurred by a vastly improved transportation infrastructure. Establishing Sarasota County's independence was a great achievement, but it would mean far less if the ambitions of the movement failed to be realized. Independence, after all, was never seen as an end in itself. Rather, it became a strategic necessity in order to position the Sarasota district for economic success in a new world where good roads and bridges were essential. Like their American Revolutionary forbearers, those who successfully fought for Sarasota County's existence had demonstrated they could tear down oppressive or inadequate political structures. But just as their predecessors in 1789 were challenged to run the nation they created, these latter-day revolutionaries had to show that they could govern as effectively as they could agitate for change.

"EVERYTHING IS ON THE BOOM
IN SARASOTA"

T he Florida State Constitution directed the governor to appoint
the initial officeholders of a newly approved county. In Sarasota
County, these appointments would last only until the next election
in 1922. Governor Cary Hardee, a Democrat, had only been in office since
January 1921. In carrying out this duty, the governor asked for nominations
from the Committee on County Division that had been established by the
Sarasota Chamber of Commerce. After all, the members of this group had
participated in the movement for separation and thereby demonstrated their
commitment to making the new Sarasota County successful.[109]

Those chosen to found the government of Sarasota County would face
a daunting task. There was no courthouse, no jail, no records, no courts,
no system of taxation, no school administration, no clerks or deputy
sheriffs, and—above all—no money to pay salaries and bills. Few of the
new appointees had any practical experience in county administration. Yet
the public had high expectations of their new government, particularly in
regard to building new roads and bridges and repairing existing ones—and
doing all of this while reducing taxes.[110]

On June 21, less than a week after the referendum vote, Governor Hardee
made his appointments known. The most important ones dealt with the
membership of the Sarasota Board of County Commissioners. For District
One, the governor picked Frank Walpole. Walpole was a good choice in that
he was serving as the Sarasota district representative on the Manatee Board
of County Commissioners and as chair of the Manatee County Democratic

Party. As a former newspaperman and current Democratic Party official, he had developed close ties with Democratic politicians in Tallahassee. It was Walpole who sat in the governor's office when Hardee signed the legislative act opening the door to the establishment of Sarasota County. Governor Hardee had even given him a pen he used on that occasion. No one, other than A.B. Edwards, had better credentials to lead the new county.[111]

Walpole was joined on the county commission by Lawrence L. May, who represented the Second District, also located in the City of Sarasota. May administered the Palmer brothers' corporate operations in the Sarasota area. It was he who had thrown open the Palmer Trust offices for meetings of groups supporting the Good Roads Movement and county separation. Frank J. Hayden of Nokomis represented the Third District. A former traveling salesman, Hayden had purchased land in Nokomis a few years earlier. He had no prominent role in either the roads movement or the campaign for Sarasota County. Peter Buchan of Englewood, the commissioner for the Fourth District, was a loyal soldier in both efforts. An active Democrat, Buchan had come to Englewood eight years earlier, bought land, and managed a general store for several years. He had been involved in some of the most dramatic episodes of the Sarasota district's recent history. Edwards tapped him in 1913 to be on the Good Roads Committee, which sponsored the original Sarasota/ Venice Special Roads and Bridges Bonding District. He was an early supporter of county separation and a member of the committee sent to Tallahassee to present the bill to the legislature. When Bradentown's opposition threatened to end the fight for independence, Buchan stepped forward to help find funds to continue the struggle. As a result, he was named to the ten-man Sarasota Chamber of Commerce Committee sent to negotiate a settlement with the Bradentown Chamber of Commerce.[112]

The governor named Henry Hancock of Miakka to the Fifth District post. While the Hancock family was prominent in Miakka history, Henry Hancock had played no public role in the big issues leading to Sarasota County. He may have been selected because the more

Peter Buchan of Englewood.
By permission of Sarasota County Historical Resources.

obvious choice from Miakka, Augustus Wilson, had been named tax collector for the new county. As a group, the new Sarasota County Board of Commissioners represented the goals and aspirations of the majority of Sarasotans, who believed the board should work for economic development and a vastly improved transportation infrastructure.[113]

The members of the county school board, like the board of county commissioners, represented specific districts. Governor Hardee named Arthur Joiner to the First District seat. A businessman and cashier of the First National Bank of Sarasota, Joiner had been a stalwart in the battle for county independence. He had been chosen as a member of the original committee on county division in June 1920. In April 1921, he was part of the Sarasota delegation that testified before the state legislature on the question of separation. Among the other school board appointees were Thomas L. Livermore of Bee Ridge, a Yale University graduate, for the Second District, and Mrs. Wesley Higel of Venice for the Third District. Higel was described as well educated and especially interested in the rural schools of the county. She was the only woman chosen by Governor Hardee as a member of the Sarasota County administration. However, she failed to complete all the state requirements for office holders and never formally assumed her post.[114]

For the critical role of county superintendent of schools, the governor named Professor Thomas W. Yarborough, former principal of Sarasota High School. Yarborough had also been an active member and officer of the Sarasota Board of Trade. In 1913, he had chaired a meeting of that group on the building of the Bayshore Road. Yarborough served continuously as superintendent until January 1, 1945.[115]

William Y. Perry became Sarasota County's first county judge. Perry had been born in northern Florida but later relocated to Sarasota, where he established a law practice. He had served as a member of the Sarasota Board of Trade and then as attorney for the Sarasota Chamber of Commerce. He had been deeply involved in every step of the county separation drama, beginning with service on the original county division committee. He had raised money for the movement, spoken at mass meetings, helped draft the county separation bill, and, as a member of the Sarasota Chamber of Commerce committee, was sent to negotiate a settlement in Bradentown. His presentation at a mass meeting held there significantly contributed to ending the crisis. Perry held the chief judge position until his death in 1924. O.E. Roesch was named as the first clerk of the county court. He had served as assistant clerk in the Manatee County administration.[116]

Thomas W. Yarborough, Sarasota County's first superintendent of schools. *By permission of Sarasota County Historical Resources.*

Augustus M. Wilson became the county's first tax collector. Another veteran of the road and county division battles, he had once served in the Florida state senate as well as three terms in the lower house. He had experience as the tax assessor of Manatee County and as a member of the Manatee County school board. Wilson had been active in the fight for roads and bridges and later became a major leader of the county division effort when he served as a lobbyist for the separation bill. He wrote and spoke repeatedly on the question of whether Sarasota district taxes would go up if it became a county. Wilson said that he had studied the pattern of taxation in newly created counties and found that taxes actually went down for the first few years. His strong statements helped blunt one of the major criticisms of county separation.[117]

Other appointments included Frank Redd as the county prosecuting attorney. Redd also had been a member of the board of trade and selected

for service on the original General Committee on County Division. Charles Strohmeyer, a real estate developer, became county tax assessor but was soon replaced by A.B. Edwards, who had recently completed his term as mayor of the City of Sarasota. Much has already been said of Edwards as a towering figure of both the roads and bridges campaigns and the struggle for independence from Manatee County. B.D. Levi, a former deputy sheriff in Manatee County as well as a former employee of the Palmer family, was named sheriff of Sarasota County.[118]

The final significant appointment by the governor designated Joseph H. Lord as the first state representative from Sarasota County. One of the major landowners in the new county and once a top executive of the Palmer family's Sarasota-Venice Company, Lord was very well connected. Like his sometime business partner, A.B. Edwards, he was a passionate booster of all things Sarasota. He had been a principal leader in the Good Roads Movement in the Sarasota district and strongly supported county division, but his business activities in Chicago often kept him from directly participating in the political struggle. These, then, were the men and one woman charged with building and managing Sarasota County's government while also responding to growing public demand for less taxes and more government services.[119]

Hover Arcade, site of the first meeting of the Sarasota Board of County Commissioners on June 23, 1921. *By permission of Sarasota County Historical Resources.*

Although the county government structure was not to begin functioning until July 1, 1921, many matters needed to be addressed before that date. Therefore, the first meeting of the Sarasota Board of County Commissioners actually took place in the City of Sarasota on June 23 in the Hover Arcade Building, which also served as city hall. The commissioners described the session inaccurately as informal. Those present included Commissioners Walpole, May, Hayden, and Buchan as well as O.E. Roesch, clerk of the county court. Their first action was to elect Frank Walpole as board chairman. The commissioners then agreed to rent space in the Hover Arcade Building for $100 a month from the City of Sarasota, which also had its offices in the structure, until a new courthouse was constructed. In other business, the commission purchased record books for county offices and three business machines for the clerk's office. Perhaps the commission's most important action was to establish the size of financial bonds many appointees had to provide prior to assuming office. By the time of their first official meeting a week later, the commissioners had received the bonds of most of the officers, thus allowing them to begin work. However, other officers were sidelined for months as their bonds were processed.[120]

There was little drama in running a county when measured against the sometimes bitter struggles over roads and county division. But there were a

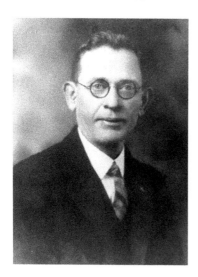

few moments worth noting. The clerk of the county court, O.E. Roesch, provided one early example. After the first meeting of the Board of County Commissioners, he simply dropped out. At meeting after meeting, he failed to attend and carry out his duties. Chairman Walpole finally asked chamber of commerce secretary E.S. Delbridge to fill in for the missing Roesch. Eventually, the county board in frustration sent a letter to Governor Hardee asking him to dismiss Roesch and appoint Delbridge in his place. At the last minute, Roesch finally turned up and apologized for his absence. He gave as an excuse that his new job required him to live in Sarasota County, which meant relocating from Bradentown. He had found it difficult to find suitable

Frank A. Walpole, first chair of the Sarasota Board of County Commissioners. *By permission of Sarasota County Historical Resources.*

housing for his family but now had solved the problem. The Sarasota Board of County Commissioners then withdrew its letter to Hardee, and Roesch returned to his post.[121]

The inexperienced commissioners did make mistakes. In October 1921, they voted to call a countywide election to determine the permanent county seat after receiving petitions signed suspiciously by many of their spouses as well as officers of the Sarasota Chamber of Commerce. The vote was slated for November 1921. Two weeks later, the commissioners cancelled the election amid a public outcry. Many citizens pointed out that during the campaign to ratify the state law creating Sarasota County they were told the decision on a permanent seat would be at least five years in the future. This widespread opposition forced a rapid retreat by the commissioners, who then claimed they had reviewed the petitions and found they lacked sufficient signatures.[122]

An even more serious problem for the Sarasota political leadership was its inability to work smoothly with Manatee County in carrying out the relevant provisions of the state constitution and the law creating Sarasota County. For example, Manatee County was to implement the tax collection of 1921 even in the new Sarasota County, since it possessed the staff and the pertinent records. However, when the tax bills reached Sarasota County residents, many found that their taxes had gone up substantially rather than down as they had been promised. It appeared for a time that the opponents of county division had been right when they predicted higher taxes. It turned out, however, that the Manatee tax officials had failed to deduct from the Sarasota tax bills assessments for projects entirely located in Manatee. The Sarasotans were being billed for public expenditures their own government had not approved and that did not benefit them in any way. The Sarasota County Board of Commissioners was soon flooded with tax protests and appeals. It took weeks to straighten out the mess. In the end, Sarasota taxes actually went down just as Augustus Wilson and A.B. Edwards had predicted they would before the ratification election in June. There appears to have been no malicious intent by the Mantee tax authorities, but the episode did not reflect well on the competence of the new county government.[123]

Generally, relations were not cordial between Sarasota and Manatee Counties, despite the gestures of goodwill made after the ratification election. The outstanding issue was negotiating an equitable distribution of assets and debts between the two counties. Sarasota paid one-third of the taxes of the old Manatee County and was therefore responsible for one-third of the debts and entitled to one-third of the assets. The two boards of commissioners met

repeatedly but made little progress in agreeing on the final figures. Manatee County took the position that it would not release any funds to Sarasota County, including recently collected tax income, until it agreed to Manatee County's terms. Sarasota County even hired an accountant at one point to review Manatee County's financial records in a failed effort to determine who owed what to whom.[124]

The situation became so serious that Sarasota County was forced to lay off some of its newly hired staff and slash salaries for those who remained. The commissioners floated one loan after another to finance continued government operations. Eventually, Sarasota County brought a court case against Manatee County that led to a judge making many of the critical financial decisions. In December 1921, nearly six months after Sarasota County was established, Manatee County authorities finally delivered the Sarasota tax books to Sarasota County tax collector Augustus Wilson, who could then actually collect taxes to fund the government. The last fiscal issue dividing the two counties went unresolved until 1924.[125]

And there were other challenges. Judge Perry could not run his court without copies of records and transcripts of cases affecting Sarasota County residents. The Manatee County Court delayed carrying out this constitutionally mandated responsibility as long as it could, thus creating great confusion. Sarasota County sheriff B.D. Levi complained of his treatment by the Manatee County jail officials. Because Sarasota had no county jail, the commissioners made arrangements with the City of Sarasota and Manatee County to house Sarasota prisoners. When Levi showed up in Bradentown to deliver prisoners, the local jailers made it clear they considered him a bother and the whole arrangement unpleasant. Levi understandably felt that Sarasota County needed to build its own jail. So, too, did the Sarasota County Grand Jury that undertook its own investigation of the situation. But the jail could not be built until the site of the permanent county seat had been determined.[126]

Even nature challenged the Sarasota County commissioners. In October 1921, a hurricane ravaged the Sarasota County coastline, badly damaging or washing away miles of roadway and damaging railroad tracks. The storm partly destroyed the municipal pier and swept away fish processing plants near the water. City and county offices in the Hover Arcade Building located on the waterfront were partially flooded. The Sarasota County Board of Commissioners later honored Clerk of the Circuit Court O.E. Roesch and his deputy for taking quick action to save government records by moving them inland several blocks to Mayor A.B. Edwards's real estate office at

some risk to themselves. But the commissioners still faced a public outcry over the ruined roads, and they had very limited resources with which to address the problem.[127]

From the beginning, the new county commissioners spent much of their effort on building, repairing, and extending the county's road system. They were abetted and sometimes prodded by the Sarasota County Chamber of Commerce. The board of governors of the chamber was filled with strong advocates of the Good Roads Movement such as George Prime and A.B. Edwards. Once Edwards completed his term as mayor of the City of Sarasota at the end of 1921, he took over as president of the chamber as well as serving as county tax assessor. But it was Frank Walpole who best epitomized the intimate connections between the chamber and the Sarasota County Commission. He was both chair of the commission and chair of the chamber's Good Roads Committee. Walpole and his fellow commissioners understood that the main reason there was a Sarasota County at all was the public demand for good roads and bridges. It was the one issue they absolutely had to address effectively.[128]

The commissioners set the tone at their first official meeting on July 5, 1921, when they authorized Chairman Walpole to send a telegram to the State Road Department asking that state convicts be used to speed the building of the Venice-Englewood Road. In the afternoon session, John A. Graham, the wealthy landowner from Bradentown who owned considerable property in eastern Sarasota County, complained that the Myakka Bridge was "almost impossible to cross over." He asked for an appropriation of $200 for bridge and road repair. The commissioners immediately agreed. In August, a joint chamber-commission committee made up of Edwards and Walpole met in Tallahassee with the State Highway Commission, asking for improvements to State Road 5, the Tamiami Trail. Their chief request was once again convict labor. The State Highway Commission agreed only to give Sarasota County surplus war equipment that included two Ford and two Dodge trucks, two motorcycles (but only one sidecar), a one-ton cement mixer, and a Caterpillar tractor. Edwards and Walpole promptly arranged to send the equipment to the City of Sarasota by rail. Now, Sarasota County possessed some capacity to build hard-paved roads on its own. A few days later, that capacity increased when the county commissioners bought a road grader from the Palmers for $250. So concerned were the commissioners about the slow progress of Tamiami Trail construction that they lent their new heavy-duty tractor to Charlotte County in September. They hoped the machine would help

their neighboring county to the south accelerate completion of its portion of the Tamiami Trail.[129]

The so-called missing link of the Tamiami Trail inside Sarasota County between Venice and Englewood continued to frustrate the county commissioners. Once more, they turned to the Palmers for assistance. Since the Palmer family owned most of the land in the Venice area, they had strong economic reasons for the completion of this stretch of road. The Palmers offered the county a deal. The Palmer Florida Corporation owned a shell pit in Venice. The company would supply the county with the shell it needed for road building at 40 cents per cubic yard. In return, the Palmers asked the county to physically clear and then legally grant them a right-of-way from the shell pit to the Venice rail station that Bertha Palmer had built years before. The Palmers would also pay the costs of hauling and spreading shell on the Venice-Englewood road right-of-way. The county agreed and issued a contract immediately to E.S. Ellis to build the missing section of the Tamiami Trail.[130]

In this same period of time, the Sarasotans enjoyed another victory by blocking yet again the plan of Bradentown businessmen and politicians to change the routes of both the Tamiami Trail and the cross-state highway so as to deny Sarasota direct access to either road. It was one of the issues that had spurred the Sarasota district to become a county in its own

Venice rail station, built by Bertha Palmer. *Courtesy of Gulf Coast Heritage, Inc.*

right. The Manatee County plan specifically called for the Florida State Highway Department to help fund a road running from Bradentown to the Waterbury tract in the eastern part of the county and thence to Arcadia in DeSoto County, Okeechobee City, and then on to the east coast of Florida, where it would connect up with the Dixie Highway running to Miami. Their plan also called for designating this cross-state highway as part of the Tamiami Trail. This scheme would have had the effect of abandoning plans to build the Tamiami Trail through the Everglades, thus deflecting tourists away from Sarasota, Venice, Punta Gorda, Fort Myers, and points south. Then, by building their section of the cross-state road directly from Bradentown to the Waterbury tract, the Manatee County commissioners hoped to keep Sarasota County from paving a connector road from Fruitville Road to the proposed cross-state highway/Tamiami Trail at the village of Verna. Sarasota County would as a result be severed from the two roads most important to its future. It was certainly a clever ploy to disadvantage communities Bradentown saw as competitors, but it required the approval of the State Highway Commission.[131]

To argue against the Bradentown advocates, Sarasota County and Punta Gorda in Charlotte County both dispatched representatives to a meeting of state highway officials in Fort Myers. The Sarasota delegation members were veterans of years of conflicts over roads and bridges. Among them were Augustus Wilson, Sarasota County tax collector; Lawrence May, Sarasota County commissioner and Palmer employee; and William Tuttle, engineer and good roads advocate. When they finished their presentations,

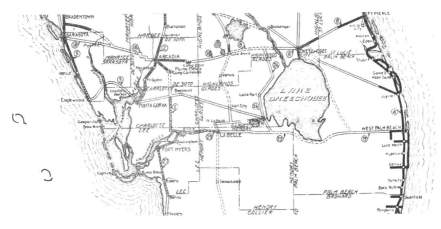

Portion of a 1923 Florida road map showing actual and projected road projects in central Florida. *By permission of Sarasota County Historical Resources.*

the State Highway Commission rebuffed the Bradentown delegation on all points. The commission refused to change the route of the cross-state road, thus killing the Bradentown–Waterbury tract road proposal, for it could not be built without state funds. The Tamiami Trail scheme also evaporated. State Road 5 would continue to be built as originally planned and be known as the Tamiami Trail, much to the relief of people in southwest Florida. The whole episode underlined the importance of Sarasota becoming a county. As representatives of a county, the Sarasota delegation spoke with a much more powerful voice than if they had represented merely a portion of Manatee County. They had legal rights backed up by representation in the state legislature. The Manatee County people found they could neither ignore nor bully their former neighbors.[132]

As the year 1922 began, the Sarasota Chamber of Commerce and the Sarasota Board of County Commissioners stepped up their efforts to finish construction of the roads linking Sarasota north and east. The chamber of commerce made "Completion of the Tamiami Trail" its slogan for the year and pledged to work closely with the county commissioners. This was not difficult, since Frank Walpole continued to be chairman of both the commission and the chamber's Good Roads Committee. In February, Walpole arranged with the State Highway Commission for a large delivery of additional war surplus vehicles and machines suitable for work on the Tamiami Trail and other road projects. The commissioners authorized erecting a storage shed to house the growing array of equipment now owned by the county. In March, the chamber welcomed the Tamiami Trail Blazers, who arrived in a grand procession of touring cars driving north from Fort Myers to publicize the need to finish the trail. The chamber recruited local cars and drivers to join the procession as it pushed on to Tampa.[133]

Despite all the talk in Sarasota and other communities about the importance of the Tamiami Trail, the project made very slow progress. The key section of the road across the Everglades proved much tougher and more expensive than anticipated. Farther north, there were gaps in the road as yet unpaved. Critics pointed out that the existing sections of the Tamiami Trail were inadequate to handle the expected volume of cars and trucks. Even current traffic usage was rapidly wearing out completed parts of the highway. A great deal more money was required to build a truly modern road.

The progress on building the cross-state road was no better. On May 1, 1922, the Sarasota County Chamber of Commerce chastised the county commissioners for not pushing the project hard enough. Its petition pointed out that the State Highway Commission had declared that the road leading

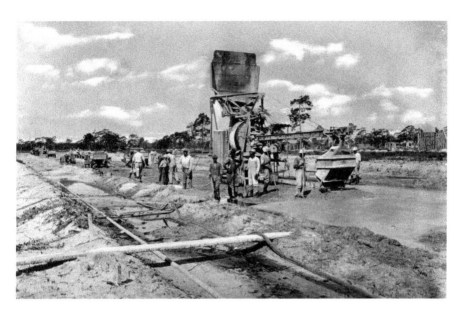

African American workers constructing a concrete road, Venice, Florida, 1920s. *State Archives of Florida.*

Men and an excavator during the construction of the Tamiami Trail, Florida, 1927. *State Archives of Florida.*

east from Sarasota (Fruitville Road) was to be part of the cross-state highway and pledged to pay half the cost for its extension eastward. But nothing had happened. The chamber appointed a committee to meet with the boards of county commissioners in both Sarasota and DeSoto Counties. Walpole responded that the road had indeed been designated a state road and a state engineer was coming to chart a precise route. Progress would be made over the next few years, but the cross-state road would not be completed until 1927 and the Tamiami Trail until 1928.[134]

As the first year of Sarasota County's history wound down and preparations were made for the first election of county officers in June 1922, much of the public elation after the ratification vote the previous June had dissipated. It did not help that the county grand jury in April issued a negative report on the performance of the county board. The grand jury criticized the commissioners for poor record keeping, for paying bills not properly itemized and for failing to place dates on payrolls and other disbursements. It claimed that a delegation sent to Tallahassee by the county commissioners had been overpaid. Coming on top of several well-publicized mistakes by the commissioners, the grand jury report was a disheartening blow to the new government.[135]

To limit damage, Walpole wrote a public letter answering the grand jury's charges and generally explaining what had been accomplished by the government. He pointed out the enormous task of creating a government out of almost nothing. Just ten months earlier, the county commissioners had commenced operations. He noted that the state requirement that all appointed officials post bonds took a great deal of time to implement, as did equipping facilities for the sheriff, clerk, assessor, tax collector, judges' chambers, a courtroom, and offices for the board of county commissioners. He reviewed the multiple time-consuming fights with Manatee County officials over assessments, tax collections, and the transcription of records. Walpole observed, "We have had ups and downs…until it seemed our hair would turn gray."[136]

He also talked of the great hurricane of October 21 and the damage it did to roads, bridges, and even the Hover Arcade, as well as the stress it created for undermanned county offices. Walpole emphasized the progress made on new road and bridge construction and his success in obtaining large amounts of surplus road equipment from the State Highway Department. As for the grand jury report, Walpole simply observed that the state government had recently conducted a thorough audit of Sarasota County's fiscal policies and practices and praised both. He concluded that the county commissioners

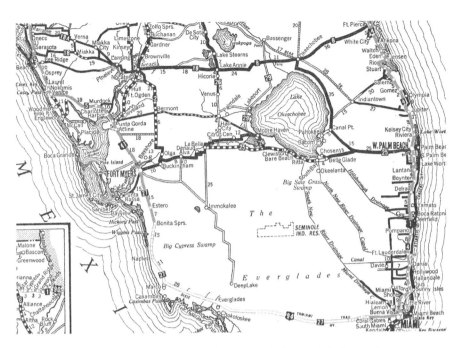

Portion of 1925 Florida Census map showing routes of Tamiami Trail and other cross-state highways. *By permission of Sarasota County Historical Resources.*

had made mistakes, "not being infallible, but always well intentioned." With insight born of hard experience, Walpole summed up his months as the head of Sarasota County government: "Setting up house-keeping for a new county is a big job." Yet, he said, the county's officers "have made good, but only after the hardest kind of work, fighting every inch of the way, with one obstacle after another to overcome."[137]

Walpole's letter was as much campaign manifesto as it was a rebuttal of the grand jury report. The campaign to elect new county officers was in full swing when his letter was published, and many of the current county officials had challengers running against them. Organizing the first major election in Sarasota County was itself another test of the competence of the county commissioners. They had earlier defined the boundaries of the five commission districts and established nine precincts where voting would take place: City of Sarasota north of Main Street, Fruitville, City of Sarasota south of Main Street, Bee Ridge, Miakka, Osprey, Nokomis/Venice, Manasota, and Englewood. The various officers responsible for collecting poll taxes and checking voter registration were facing their first practical test, but they seem to have carried out their duties in a proficient manner.[138]

The election of June 6, 1922, was, in fact, the Democratic Party primary and open only to white voters. As there was no Republican Party apparatus in Sarasota or for that matter in Florida and most other former Confederate states, whoever emerged victorious in the primary was deemed elected to office. Frank Walpole was chairman of the Democratic Party's Executive Committee in Sarasota County as well as chairman of the Sarasota Board of County Commissioners and chair of the Good Roads Committee of the Sarasota Chamber of Commerce. He was also well known as a local businessman and one of the most important figures in the fight for county division. It would have been hard to find anyone better connected or politically more influential in Sarasota County. Despite all of these factors, Walpole lost the First District election by a mere thirteen votes to M.L. Wread. Wread, a general contractor, had played a minor role in the fight to improve the Bayshore Road in 1920 and was not a prominent figure in the county separation campaign. The outcome was certainly surprising and undoubtedly a sign of a discontented electorate.[139]

In District Two, Thomas A. Albritton of Bee Ridge ran unopposed. He had been appointed to the post a few months earlier after Lawrence L. May resigned and left the area. Albritton had been one of the original members of the Good Roads Committee appointed by A.B. Edwards in 1913. District Three incumbent Frank J. Hayden lost his election to M.I. Townsend, a strong supporter of completing the Tamiami Trail. In the Fourth District, Peter Buchan declined to seek reelection, leaving Joseph D. Anderson, a prominent local figure, without an opponent. Henry Hancock in the Fifth District faced no challenge and became the only original commissioner to survive the election. The makeup of the commission had almost completely changed, but as events would show, the new board shared the attitudes of the old one regarding objectives and policy, especially when it came to roads and bridges.[140]

Perhaps the most startling loser in the June 6 elections was A.B. Edwards, who campaigned for reelection as Sarasota County's tax assessor. If anyone could claim to be the father of Sarasota County, it would certainly be Edwards, one of the most important figures in the early history of the region. Yet challenger Thomas A. Hughes easily won election, 623 to 181. Hughes had been serving as supervisor of registration. Other than that, he had no lengthy record of leadership. Edwards may have been voted out of county government, but he remained head of the board of the Sarasota Chamber of Commerce, a position of considerable influence.[141]

Since neither contemporaries nor historians offered any explanation for this astonishing event, the explanation must be left to speculation. Edwards

did not become tax assessor until his term as mayor of the City of Sarasota ended on January 1, 1922. He had been in office but six months. Yet as tax assessor he was forced to base his calculations on the millage rates determined by the Manatee County Board of Commissioners and accepted by the Sarasota County commissioners. Using those rates led to large and uneven tax increases for many Sarasotans, who complained and appealed. There was tremendous public anger even though the millage was later significantly reduced by the Florida state government after the Sarasota Board of County Commissioners realized that the Manatee figures contained support for projects unrelated to Sarasota. None of this was Edwards's fault, but he was one of the officials associated with a very unpopular measure. This entire episode may explain most of the defeats of incumbents in the election, particularly Walpole and Edwards, as well as Augustus M. Wilson, the tax collector who finished last in a three-man race.[142]

In other results, Clerk of the Circuit Court O.E. Roesch had put his early troubles behind him and easily kept his job. Herbert S. Sawyer replaced Frank Redd as prosecuting attorney when the incumbent chose not to run for reelection. Sheriff B.D. Levi also did not seek reelection. L.D. Hodges, the former police chief of the City of Sarasota, took over the post. Judge William Perry ran unopposed but died in 1924 and was succeeded by Paul C. Albritton, son of County Commissioner Thomas Albritton. Professor Thomas W. Yarborough, the superintendent of instruction, and school board chairman Arthur Joiner faced no competition. This was significant in that the Sarasota County School system had faced problems of funding, lack of adequate school buildings, and a sizeable bonded debt inherited from Manatee County. Yarborough and Joiner had guided the system through these financial thickets and reported excellent progress during the year they had been in charge.[143]

The election of 1922 was important for several reasons. First, despite the outcome, it demonstrated the success of the original county officers in building a working government structure that represented the entire county and in adopting a broadly accepted policy agenda. Second, the substantial changes in personnel resulting from the election showed that the power structure of the new Sarasota County was in flux. New leaders were emerging, some of them part of a growing flood of new residents and others from small communities who now had a chance to develop their political skills as members of county government. The times were changing—Sarasota stood on the brink of one of the greatest growth eras in its history, known as the great Florida land boom. New titans of business such as Andrew McAnsch,

John and Charles Ringling, and many others would soon erect huge new buildings, initiate vast real estate empires, and build grand palaces for their families. However, the era of the pioneers who made Sarasota County was not yet over.[144]

The newly elected officers of the county government would take office in January 1923. Thus Walpole and the other original county commissioners continued to manage county affairs for another six months. It was in this period that Sarasota County set out to systematically evaluate all of its needs for roads and bridges and seek authority to issue bonds to finance construction of a comprehensive road transportation system. The impetus for this exercise, as usual, came from the Sarasota Chamber of Commerce. In early September, the chamber, which had been vigorously pushing the county commissioners to take action on funding the cross-state highway and the Tamiami Trail, decided to come up with a countywide roads and bridges plan. It intended to hire professional engineers to aid in the planning, prepare an estimated budget, and then submit everything to the county commission as a first step in gaining approval for a huge bond issue. The general idea was to connect all the communities in the county with each other and with state and federal road systems. In short, the chamber was proposing to do what had been promised when Sarasota County had been created: build a modern road system to spur population growth and economic development.[145]

The chamber specifically called for a road system that linked Sarasota County to adjacent counties on the south and east. It also wanted a road built between the towns of Fruitville and Bee Ridge as well as one connecting the villages of Fruitville and Miakka and a third road constructed from Miakka north to the settlement at Verna on the proposed cross-state highway. Finally, it wanted to build the section of the Tamiami Trail stretching from the Myakka River Bridge to the Charlotte County line. The board of governors of the Sarasota Chamber of Commerce instructed its president, A.B. Edwards, to appoint a committee to prepare detailed plans and cost projections. Edwards picked George B. Prime, a battle-tested veteran of fights over roads and county independence, to chair the committee. Other members selected were E.J. Bacon, soon to be the City of Sarasota's mayor; Arthur Joiner, now a county school board member; and state representative Joseph H. Lord.[146]

A week later, Prime reported back that his committee had received a proposition from the McElroy Engineering Company to undertake a survey of the suggested roads projects in the county. The company estimated that if built, the projects would add forty-three miles of hard-topped roads. Currently, Sarasota County had only fifty miles of such roads. The report

once again emphasized the importance of completing the Sarasota portions of the cross-state highway and the Tamiami Trail. Prime's committee report noted that the new roads would open up vast areas of eastern Sarasota County to new development. They may have been thinking of the Palmer Farms project covering eight thousand acres in Fruitville that would very much benefit from some of the proposed projects. Not until October 26 did the chamber of commerce approve hiring the McElroy Company. However, by then, a new project had been added to the listing, described as the Siesta Beach Road, to be built near where A.B. Edwards was contemplating a major investment on Siesta Key.[147]

The chamber of commerce road plan reached the Sarasota Board of County Commissioners in late 1922, just before the new county officers were installed. The new commissioners—M.L. Wread, T.A. Albritton, M.L. Townsend (chair), J.D. Anderson, and Henry Hancock—were no less committed than their predecessors to good roads, but there were reasons why they could not take immediate action on the chamber of commerce road plan. For one thing, great changes were taking place in road funding policy at the state and federal levels. Whatever Sarasota County officials thought about road priorities, national and state road agencies determined whether those roads met standards justifying subsidies. For another, the population of Sarasota County and Florida generally was rocketing upward at the height of the great Florida land boom. Between 1920 and 1930, the county gained 6,135 new citizens, an astonishing increase of 350 percent. While many of the newcomers moved into the City of Sarasota, others did not. As smaller communities grew, the demand for more roads expanded as well. The influx of wealthy people wishing to live on the keys created a growing demand for both bridges and roads on those islands. As a result of these rapid changes, the 1922 chamber of commerce roads and bridges plan was obsolete almost from the moment it reached the county commissioners.[148]

Seemingly every month, news reached Sarasota affecting the roads and bridges situation. In December 1922, John and Charles Ringling purchased 67,000 acres from the estate of Bradentown resident John A. Graham in the "Sugar Bowl," an enormous swath of land stretching from Bertha Palmer's old Meadowsweet Pastures on the Myakka River south to the Charlotte County line. There were few roads in the area, and the brothers would soon seek county assistance in addressing the roads and bridges transportation problem so vital to developing their land. In February 1923, the county commissioners received good news that the federal government was sending Sarasota County $75,000 in road-building assistance for the Tamiami Trail

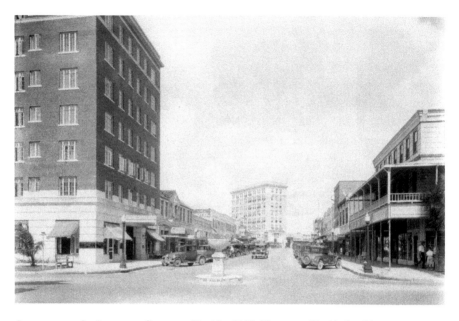

A street scene in downtown Sarasota, Florida, 192?. The great Florida land boom remade Sarasota in this decade. *State Archives of Florida.*

between the Myakka River Bridge and the Charlotte County line. But the news also meant changes had to be made in the chamber road plan that had assumed that project would be paid for from bond sales. Then, in March, the Tamiami Trail Association was formed to inject new life into a project stalled by the challenge of constructing a modern road in the Everglades. A month later, the Tamiami Trail Blazers, now a part of the trail association, pulled off the improbable feat of driving through the Everglades along the route of the planned Tamiami Trail all the way to Miami. The first member of the group to reach Miami was Sarasota's own George B. Prime, hardware merchant, good roads champion, and adventurer extraordinaire. This publicity stunt actually worked when a very rich man named Barron Collier offered Florida $1 million to complete the Tamiami Trail if in return Florida would name a county for him. As a result, the Florida Legislature carved Collier County out of Lee County, and work resumed on the Everglades portion of the project.[149]

The news about progress in constructing the Tamiami Trail across the Everglades was welcomed by people living along the planned route. But it led the Tamiami Trail Association and the Florida Highway Department to review the condition of the already built or nearly built north–south sections of the trail from Naples to Tampa. They found much to criticize, particularly

Governor Cary A. Hardee (*left*) and Barron G. Collier aboard Collier's yacht, 1924. Collier paid Florida $1 million to finish the Tamiami Trail and name a county for him. *State Archives of Florida.*

in Sarasota County, where a great deal of the roadwork had been done years earlier. They noted that the paving was inadequate to handle existing and anticipated traffic loads. At nine feet wide, the road did not meet modern specifications that called for eighteen feet as well as aprons on both sides of the road. Indeed, experts found the width of the entire roadway far too narrow. In sum, these experts concluded that the entire Sarasota portion of the Tamiami Trail road had to be remade. And of course that would be an unanticipated cost to Sarasota County even if the federal government paid half the cost, estimated at $800,000.[150]

The Sarasota County commissioners also received news regarding the cross-state highway. DeSoto County finally set up a bond election to defray the costs of building its section of the highway. Then, at a meeting in Bradentown of DeSoto, Manatee, and Sarasota Counties commissioners, all three counties agreed to finish their sections of the highway, which for Sarasota meant building some sixteen miles of hard-topped road. At almost the same time, a private investor in West Palm Beach, William J. Connors, completed construction of a fifty-two-mile toll road from West Palm Beach to Okeechobee City that opened on July 4, 1924. At Okeechobee City, the toll road connected up with the still incomplete cross-state highway. Connors's initiative showed that the cross-state road project had moved from being a theoretical possibility to a near certainty. It meant that together with the other pressures building on them, the commissioners had to act decisively to complete their part of the highway.[151]

This was the situation early in 1924. Pressed by internal forces demanding action on roads and bridges as well as by external circumstances requiring

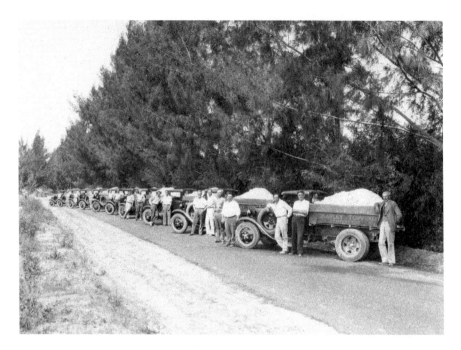

Trucks lined up to deliver road-building material on the Tamiami Trail in Sarasota County around 1924. *Coons Collection, image courtesy of Venice Museum & Archives.*

bold decision-making, the Sarasota County commissioners finally addressed the chamber of commerce road plan given to them more than a year earlier. In mid-January, they released a revised plan that was far more ambitious than the 1922 plan. It called for eight major road projects and two bridges to the keys. The total cost was $551,300. The bond issue for this plan passed easily at an election held on January 19, 1924.[152]

But having won the bond election, the county board once again took no action to sell the bonds or implement the construction program. The commissioners did not even advertise for bids on the project. The records of the time offer no explanations as to why the hard-pressed county commissioners refused to act. What is known is that, four months after the vote, the commissioners announced they were taking "testimony" on yet another revised road and bridge plan. This suggests that despite the positive vote, the commissioners were hearing complaints, likely from people who felt their interests had not been adequately addressed. The county commissioners may have felt they could not ignore these criticisms of their road and bridges plan. In mid-1924, money was not the problem for county government. As the *Sarasota Daily News* said in a headline, "Everything Is on the Boom in Sarasota." In fact, tax income

was so high that the county commissioners cut the millage rate. Even then, there was still funding available for significant infrastructure improvements. The commissioners found it politically easy to simply add more projects to yet another version of the roads and bridges plan.[153]

A new vote on a revamped and hugely expanded roads and bridges bond issue took place on June 16, 1924. It was preceded by a vigorous public campaign to assure passage, and Sarasota County voters gave the measure their strong support. This was hardly surprising, as the main reason for creating the county was to open the way for building a well-conceived road and bridge system. Moreover, the plan had something in it for almost everybody. The June 1924 plan was precisely the kind of aggressive, bold action the founders of the county had promised. Indeed, veteran road advocates like Edwards and Lord rushed forward to support the board's proposal. As the list of projects in Table 1 shows, the county had now taken a great step forward in meeting its current and future transportation infrastructure needs.

TABLE 1. ROADS AND BRIDGES PROPOSED IN JUNE 16, 1924 PLAN

Proposed Roads		Proposed Bridges
Bradentown Road (3 miles)	Sugar Bowl Road (13 miles)	Stickney Point Bridge (Siesta Key)
Venice-Englewood Road (11.5 miles)	Venice By-Way Road (3 miles)	Blackburn's Point Bridge (Casey Key)
Englewood–Myakka River Road (8.5 miles)	Stickney Road (.75 miles)	Two trestle bridges on Sugar Bowl Road
Fruitville-Miakka Road (13 miles)	Blackburn's Point Road (.5 miles)	Whittaker Bayou Bridge
Verna Road (3.5 miles)	Siesta Road (7.5 miles)	
Hancock Road (2 miles)	Crescent Beach Road (2.5 miles)	
Madison Road (2.5 miles)	Stickney Key Road (.25 miles)	
Bee Ridge Road (4 miles)		

The bridge and road plan was by far the best thought-out and most comprehensive road transportation scheme in Sarasota County's short history. Its estimated cost was $1,010,000, almost twice the price of the aborted January 1924 scheme. When implemented, it added seventy-eight miles of high-quality paved highways to Sarasota's growing system of modern roads. The plan contained most but not all of the road projects in the January 1924 proposal. Moreover, the bridge portion of the project list had been expanded, and the connecting roads to the new bridges had been added. The somewhat unpopular road and bridge projects for the Sugar Bowl were also new additions to the list. There was some feeling that circus magnates John and Charles Ringling should foot the bill for infrastructure improvements largely benefiting them alone. Nonetheless, the Ringling projects won approval along with the rest of the road and bridge proposals. [154]

Even as construction moved forward on the many projects approved by the public, pressure was again increasing for yet another massive bond issue to build even more roads and bridges. By early 1925, a third set of county commissioners had assumed power. The chair of the board in both 1925 and 1926 was one of the most dedicated supporters of good roads in this era, the man who led the Tamiami Trail Blazers into Miami in 1923, George B. Prime. A Minnesotan by birth, Prime and his wife had come to Sarasota in 1900, when he went into the hardware and grocery business. He served two terms on the Sarasota City Council and became a director of several local banks. He later emerged as a champion of good roads and county independence. As chairman of the Sarasota Board of County Commissioners, Prime was in a good position to shape the new road plan. He took full advantage of his opportunity to provide Sarasota County with an even greater expansion of its road system. [155]

The Sarasota Board of County Commissioners' roads and bridges plan of June 1925 was breathtaking in its scope. There were thirty-four major road extension and improvement projects and three new bridges on the list, as shown in Table 2.

George B. Prime, chairman of the Sarasota Board of County Commissioners and champion of building good roads. *By permission of Sarasota County Historical Resources.*

TABLE 2. ROADS AND BRIDGES PROPOSED IN JUNE 16, 1925 PLAN

Proposed Roads		Proposed Bridges
Lockwood Ridge Road	Hyde Park Avenue	Crowley Bridge
Verna Road	Swift Road	Manasota Bridge
Bradentown Road	Gocio Road	Siesta Bridge
Venice-Englewood Road	Albee Road	
Venice Byway Road	Wilkinson-McIntosh Road	
Englewood-Myakka Bridge Road	Clark Road	
Hancock Road	McCall Road	
Myakka Road	Woodmere-Manasota Roads	
Madison–Sugar Bowl Road	Siesta Bridge Road	
Bee Ridge Road	Fruitville Road	
Siesta Road	Bayshore Drive	
Crescent Beach Road	Old Miakka Road	
Stickney Bridge and Key Road	Osprey–Bee Ridge Road	
Stickney Point Road	Victory Avenue Loop	
Blackburn's Point Road	DeSoto Road	
Fruitville-Madison Road	Indian Beach Road	
Tuttle Avenue	Sugar Bowl Extension Road	

The price tag for these projects was $1,500,000, nearly three times the cost of the plan approved by voters in January 1924 and six times more than called for in the original 1914 Sarasota/Venice Special Roads and Bridges Bond District proposal. There is no way to know Prime's exact role in

developing this plan, but every veteran of the years-long fight for good roads and bridges surely rejoiced at what he and his colleagues conceived. On June 16, 1925, the voters of Sarasota County approved the bond issue, just as they had approved nearly every bond issue proposal put before them. The basic civic agreement among Sarasotans that good roads and bridges were indispensable to progress and economic development remained intact.[156]

The plans of 1924 and 1925, with a combined cost of $2,500,000 plus state and federal subsidies, did give Sarasota County the basic road and bridge system that it had so badly needed. New roads would continue to be built up to the present day as growing populations spread out beyond existing transportation arteries. But the 1924 and 1925 plans and the earlier road and bridge projects provided the fundamental road transportation structure. The communities of Sarasota County were now linked to one another and to major state and federal highways. The Tamiami Trail and the cross-state highway, when completed a few years later, positioned Sarasota County on two important transportation axes, one north–south and the other due east to the Atlantic Ocean. Those roads alone put Sarasota County in the mainstream of commerce and tourism and secured for it an excellent chance at a bright economic future. The founders of Sarasota County had fulfilled their promise of providing a system of good roads and bridges.

By the end of the 1920s, Sarasota County had been transformed in nearly every way. The creation of the county in 1921 came just in time for Sarasotans to exploit fully the opportunities of the great Florida land boom. Huge population growth, a building spree that filled the skyline with numerous skyscrapers, greatly enhanced rail service, new banks and hotels, and a sea of new residential developments were some of the achievements of that remarkable decade. Underlying it all was the road and bridge program. Without an adequate road transportation system, it is doubtful Sarasota County would have developed to the extent it did in the 1920s. And for this the founders of the county deserve great applause. Their vision and political acumen made it possible.

Would the Sarasota area have obtained the same benefits if it had remained part of Manatee County? By 1914 or so, the Sarasota district had already outgrown its association with the parent county. Sarasota, with its fast-growing population, comprised between a third and a half of the land mass of Manatee County, but it had only one representative on the board of commissioners. Moreover, tax income was distributed evenly across the five districts, regardless of how much a district paid in taxes. These inequities alone would have justified an effort to divide the county. However, the

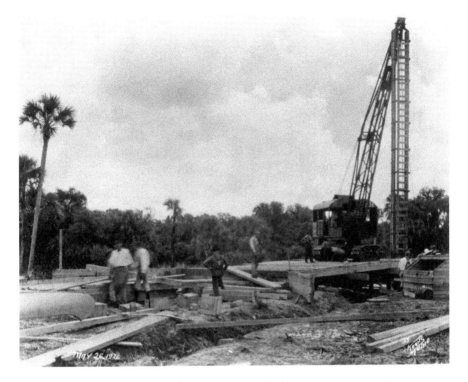

Bridge building on the Tamiami Trail at Nokomis, mid-1920s. *Coons Collection, image courtesy of Venice Museum & Archives.*

general incompetence of the Manatee County commissioners and their mishandling of the Sarasota district's efforts to tax itself to build needed roads made the situation intolerable. By 1920, the Bradentown business community concentrated its efforts on roads connecting it to Anna Maria Island, Tampa, and Arcadia. The community had come to see Sarasota, Punta Gorda, and Fort Myers as competitors for future revenues from tourists, settlers, and investors. The plan to reroute the Tamiami Trail and the cross-state highway so as to cut out Sarasota and communities south of it was an enormous threat. On top of other grievances, this plan made independence from Manatee County an immediate necessity. Only with the stature and powers of a county government could Sarasota County properly promote its interests and counter the manipulations of Bradentown. Sarasota became a county, built its roads and bridges, and never looked back.

Perhaps no single event better symbolized the transition from the pioneer period of the Sarasota region and the beginning of the modern era than the end of Rose Phillips Wilson's long tenure as owner, publisher, and editor

of the *Sarasota Times*. For eleven years, she helped her husband produce the paper and then assumed full control after his death in 1909. She became the chronicler of events throughout the area that would become Sarasota County. She was also an advocate for every progressive measure that advanced the area's economy and reputation. She always cheered, as she put it, "The MEN WHO DO THINGS." But she also made it a point to report the many achievements of Bertha Palmer, while giving prominent coverage to every meeting of the Sarasota Woman's Club, of which she was a founding member. When women won the right to vote, she tried hard to persuade them to use their votes for progressive causes.[157]

Her last journalistic words related to the recently completed tenure of Frank Walpole and the first Sarasota County Board of County Commissioners. She noted that Sarasota County was now a year and a half old. She saluted Walpole and his colleagues for the good job they did on building roads, arranging housing for the new government, and acquiring $70,000 in surplus military equipment to build even more roads. She praised the loyalty of the other commissioners to Walpole when they said he literally saved the "infant county" on several occasions. The new owner of the *Times* was T.J. Campbell, an east coast state senator seeking the governorship. His partner was none other than Joseph H. Lord, now serving in the Florida House of Representatives. The new owners made various changes in the *Times* and maintained its traditions as a local booster publication, but it was not the same. The *Times* would not last many years longer and soon was surpassed by a much more modern paper, the *Sarasota Herald*, in 1925. Rose Phillips Wilson had been indispensable to both the Good Roads Movement and county division. She, too, was part of that remarkable band of pioneer leaders who created Sarasota County.[158]

"The Million Dollar Courthouse"

The greatest physical symbol of the pride Sarasota County residents took in their county is the still impressive Sarasota County Courthouse at 2000 Main Street. Built between 1925 and 1927, the courthouse, with its soaring central tower, yet commands attention. Appropriately, the edifice was placed in the National Register of Historic Places on March 22, 1984.

The Sarasota County Board of County Commissioners had tried and failed in 1921 to hold a vote on where the permanent county seat would be located. This issue needed to be resolved before the commissioners could address the challenges of erecting a courthouse and jail. Even in the early months of the new county government, it became obvious that the space they shared with the City of Sarasota government in the old Hover Arcade Building on the bay front was inadequate for their needs. Since it would take years to build new facilities, the commissioners understandably felt they needed to get the process started as soon as possible. But strong public opposition to the county seat election plan soon arose. The commissioners had no choice but to cancel the balloting they had so recently announced.[159]

Three years passed before a new Sarasota Board of County Commissioners felt strong enough to once again raise the question of the permanent county seat. By then, the county government had moved out of city hall into a temporary structure located on Oak Street that had cost $13,000 to construct. In October 1924, the commissioners announced that an election to choose a permanent county seat would be held on November 18. Any

Sarasota County Courthouse campanile, a symbol of Sarasota County's pride and unity. *By permission of Sarasota County Historical Resources.*

community could seek the county seat designation but needed to register its interest in time to have its name on the printed ballot. The Palmers, who still owned much of Venice, asked that the village be considered as a candidate, probably hoping that hosting the county government would draw businesses and investors. As incentives to select Venice, they offered to pay for the construction of a courthouse and jail and throw in a $20,000 bonus. In just a few years, Venice would be transformed into a beautiful city by the investments of the Brotherhood of Locomotive Engineers and the inspiring urban plan for the community developed by John Nolen. But in 1924, Venice was still sparsely settled and largely undeveloped.

The City of Sarasota, by far the biggest community in the county with a population well over four thousand, fully benefited in the mid-1920s from the land acquisition and development mania that characterized the great Florida land boom. Among other advantages, the city could boast of a number of millionaires. One of them, Charles Ringling of circus fame, together with his spouse, Edith, owned a great deal of land just east of Five Points, the center of the City of Sarasota. Ringling dreamed of a huge development of hotels, business buildings, and residential areas. He realized that putting the new courthouse at the center of his planned real estate venture would spur economic development. As early as March 1924, nearly nine months before the county seat election, Charles and Edith pledged to sell the county the land it needed to erect a courthouse and jail for a nominal amount. Despite Venice's pretensions, the selection of Sarasota as the permanent seat of Sarasota County government was assumed by most citizens, and the November 24 election held no surprises. Just after Christmas 1924, Charles and Edith formally turned over the deed to the property as they had promised.[160]

On March 30, 1925, the county commissioners voted to offer a contract to Dwight James Baum of New York to design the courthouse and serve as "supervising architect" during construction. He would receive in return "6% of the total cost of construction and equipment designed and purchased by him." There was a caveat. Baum would receive nothing "until such time as the method of raising the necessary funds has been approved." George Prime, now chair of the Sarasota County Commission, directed Baum to prepare preliminary drawings and specifications that would permit the board to seek estimates of the cost.[161]

Dwight James Baum was forty-one years old and a rising star in the architectural world. Much of his national reputation would rest on his work in Sarasota and in Temple Terrace near Tampa. In 1925, Baum was already

Charles Ringling. *By permission of Sarasota County Historical Resources.*

under contract to design the great mansion Ca'd'Zan for John Ringling, Charles's brother. In the next four years, he would also design the El Vernona Hotel, the El Vernona Apartments, Herald Square, and the Sarasota Times Building, all in the City of Sarasota. Baum, a distant relative of L. Frank Baum, the author of *The Wizard of Oz,* specialized in the Mediterranean style of architecture that was the hallmark of boom-time Florida real estate development.[162]

On April 20, 1925, Baum presented to Prime and the other county commissioners his preliminary plans for the courthouse. They warmly praised his work and authorized him to prepare complete plans and specifications based on his original drawings. He was told to display them at their next meeting in August 1925. By then, the commissioners had arranged for a $450,000 bond sale to pay the estimated costs of the project. Baum handed over his final plans, and the commissioners presented him with a check for $10,000 for architectural services, his first income for the months of labor he had committed to design work.[163]

In the fall of 1925, the Sarasota Board of County Commissioners awarded the courthouse building contract to Stevenson and Cameron Incorporated, which bid $452,926 for the project. Baum soon knocked off about $45,000 from the bid when he found some cost-saving alternatives. In October, the commissioners issued Stevenson and Cameron another contract for $366,426 for equipping the jail. So far, matters had moved along at a brisk pace. Construction crews were now poised to begin work not only on the courthouse but also on dozens of new buildings and the Atlantic Coast Line rail terminal located at the end of Main Street, or Victory Avenue, as Main Street above Orange Avenue was called at the time. There were also dozens of road projects approved in the 1924 and 1925 bond issue elections now being built to the total value of $2,500,000. Everything did seem to be "on the boom" in Sarasota County. Then it all came to a screeching halt.[164]

As early as March 1925, there were signs that the incredible building boom affecting all parts of Florida, particularly the coastal areas, was overburdening the capacity of the state's railway systems to transport

materials essential to the construction of buildings and roads. On August 17, the Florida East Coast Railway, crippled by a labor strike, could no longer handle the volume of freight destined for Miami, where the rail yards were so jammed that freight cars could not be unloaded. More than thirteen hundred railcars sat idle on tracks north of Miami. Thousands more lay stranded around Jacksonville. There simply were not enough facilities or workers to handle the sea of materials pouring into Florida. The East Coast Railway Company stopped all shipments south save for fuel, livestock, and perishables. Other railroads followed suit on October 13, and Sarasota soon felt the effects of the spreading rail embargo. By November 26, 1925, the *Sarasota Daily Times* reported that the embargo had stopped shipments of building materials to Sarasota. Owen Burns, one of Sarasota's most active entrepreneurs, began bringing in building materials by barge. His company sent three barges to Sarasota from Tampa carrying Spanish tile for the courthouse, the Stanley Field mansion, and the Presbyterian church. Still, the paper said, "all building will soon stop," adding there was now no rock available for new road base.[165]

The strangling effect of the railroad embargo finally forced the firm of Stevenson and Cameron to inform Baum that it was shutting down the courthouse worksite until a sufficient supply of materials became available. Pessimistically, the company speculated it would be several years before any relief could be expected from the railroads. The *Sarasota Daily Times* bewailed the suspension of work "on one of the important building projects in Sarasota County." Attention immediately turned to massive dredging projects in Sarasota Bay that would allow large deep-draft vessels to carry bulk loads of building materials to Sarasota. Burns had demonstrated that barges could help the situation, but for economic efficiency far larger vessels had to be utilized. Joseph H. Lord became a leader of the deep-dredging movement, arguing it was the only way to keep Sarasota's prosperity growing.[166]

The embargo did not last years as many feared, but it was not lifted until May 1926, some seven months after it began. It was one of several factors that caused the great Florida land boom to crumple, bringing economic misery to many Floridians as well as outside investors who lost all or a substantial portion of their assets because of their involvement with the deceit and chicanery that characterized the real estate business during the height of the frenzy. But in the short run, Sarasota's light continued to burn brightly as work resumed on the massive makeover of the city and the great expansion of the road system approved by county voters.[167]

On May 12, 1926, the county dedicated the courthouse, even though only the outer walls had been erected. With a large crowd in attendance, the main business of the ceremonial event was filling the cornerstone with memorabilia and then laying it. Judge Cary B. Fish of Sarasota, grand master of Masonic Lodge No. 147, presided with one hundred other Masons in attendance. Laying cornerstones was certainly a traditional role for the Masons in communities, but it was particularly significant at this event. Those in the group leading the fight for roads and for county division had nearly all been members of the Democratic Party, but many were also Masons. Among them were the following: A.B. Edwards; chairman of the Sarasota County Commissioners George B. Prime; Franklin Redd, the county's first prosecuting attorney; John Burket, attorney for the county board; Otis F. Landers of the *Sarasota Daily Times*; and Dr. Jack Halton. With the exception of George W. Blackburn, all of them had supported county division. It was yet another link binding Sarasota County's progressive leaders, at least those who were male. Rose Wilson could not be a member, but her late husband, C.V.S. Wilson, had been part of the group.[168]

In his speech, Judge Fish, himself a veteran of the battles to create Sarasota County, praised county officials for building a courthouse that, when finished, "will surpass any on the west coast of Florida in architectural beauty and magnificence." Following the judge's remarks, Sarasota County Commission chair George Prime presented documents "containing the history of the county since its creation early in 1921." Fish then placed the papers within the large granite cornerstone, which was then covered and installed. County schools had cancelled classes for the day so that teachers and students could attend the dedication activities. A student chorus sang the opening hymn at the ceremony.[169]

A new newspaper, the *Sarasota Herald*, reported on the dedication ceremony and then marveled at the transformation of the eastern end of the city in the previous seventeen months as Charles Ringling developed his Courthouse subdivision. During that time, the paper noted, the area "went from sandy waste and rubbish area to the new Terrace Hotel, the Archibald Building, the Archibald-Crisp Building, the Ringling Building, the Atlantic Coast Line depot, and the new Courthouse plus smaller dwellings and home sites." The courthouse, the paper bragged, will have cost $1 million when completed and furnished. And it will stand "as a monument to the city's progress and endeavor." The paper praised the combining of Spanish and Italian motifs in the design of the courthouse, particularly the use of the roof tiles from Spain.[170]

Above: Sarasota County
Courthouse, midcentury. *By
permission of Sarasota County
Historical Resources.*

Right: Sarasota County
Courthouse, door detail. *By
permission of Sarasota County
Historical Resources.*

A few months later, the *Herald* returned to the subject of the courthouse, calling it "the most outstanding emblem of Sarasota County's prosperity during the year 1926." The article described the building as a "massive yet graceful structure in three units" and said the courtroom was its most beautiful space, with American black walnut beams spanning the ceiling. Modern visitors to the courthouse have only been able to appreciate the lush interior decoration after a major restoration in the 1990s. Sarasota historian Jeff LaHurd described the results of the $6 million effort, marveling at the "thick colorfully stenciled beams, marble floors, quaint glass skylights, heavy wooden doors, and ornately carved wrought-iron trim." He was delighted to see that the exterior had been repainted in its original "peachy shade" so popular in Sarasota's 1920s era buildings. The intricate and decorative metalwork of Samuel Yellin, a famous Philadelphia metalworker, also caught LaHurd's attention. A restoration of the exterior of the courthouse is underway and will involve surface repairs and repainting as well as repair of some of Yellin's ironwork. When that restoration is completed, today's Sarasotans will be able to see the courthoue much as their predecessors did nearly a century ago.[171]

Sarasota County has grown tremendously since 1921, and the government has had to grow as well to meet citizens' needs. The courthouse became too small to house all of the offices and functions that make up county government. As a result, only the clerk of the circuit court maintains her principal offices there, along with some judicial functions. The offices of county commissioners, judges, and the sheriff, as well as the jail and other offices, have moved to other quarters.[172]

Sarasota Herald Building, 539 South Orange Avenue, Sarasota. *By permission of Sarasota County Historical Resources.*

But in 1927, the Mediterranean Revival courthouse was truly the seat of government. Residents approaching the main entry saw before them a charming pond. Directly behind it was the imposing campanile. To the east and west of this soaring structure, an arcade led to two two-story buildings. The east building contained the courtroom, the jail, and judges' chambers. In the western building were located the clerk's office, the Sarasota Board of County Commissioners' offices and meeting rooms, as well as offices for other county officials. The courthouse was constructed of stucco-covered hollow clay tiles and masonry with a roof covered with the much-praised barrel tiles that came from Spain. While much of the original building has been or is being restored, some areas will probably never be reclaimed. Chief among these is the courthouse façade facing Ringling Avenue. In the 1950s and '60s, two large multistory structures were erected between the courthouse and the street that completely obscure views of the façade.[173]

Work on the Sarasota County Courthouse continued until February 24, 1927, when the county formally accepted possession of the facility. Actually, some county offices had been relocated from the temporary Oak Street courthouse a few weeks earlier, but after February 24, the entire move was swiftly completed, and the Oak Street building with its notoriously leaky roof was given to the City of Sarasota.[174]

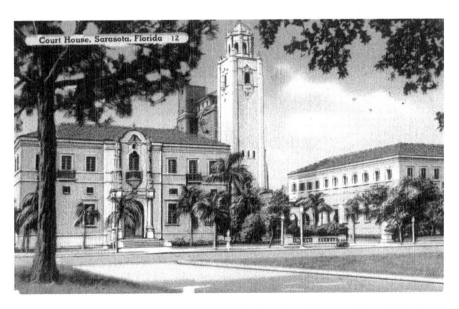

Postcard of Sarasota County Courthouse, souvenir of a trip to Sarasota. *By permission of Sarasota County Historical Resources.*

The construction of the Sarasota County Courthouse and the completion of the cross-state highway—officially called the Sarapalmbee Trail—in 1927, together with the opening of the Tamiami Trail in 1928, mark a logical conclusion of the story of why and how Sarasota County was established. While the Sarasota district might well have decided to become a county at some point, the specific cause in 1920–21 was the desperate fight for more and better roads and bridges and a growing belief that Manatee County was holding the area back to benefit Bradentown and other communities north of the Sarasota district. The battle for good roads forced the scattered communities of the district to cooperate and act together to promote their common objectives. Of necessity, much of the leadership in the Good Roads Movement and the county division campaign had come from the City of Sarasota, which held a majority of the district's population. Within the city, a talented group of men and women working through a thoroughly politicized chamber of commerce and its predecessor organizations as well as the city government, and Rose Wilson's *Sarasota Times* effectively mobilized people and money to get the roads and bridges built and then to fight for their independence from Manatee County. But without the contributions of men like August Wilson from Miakka, Peter Buchan of Englewood, Thomas Albritton of Bee Ridge, George Higel of Venice, and others from places like Nokomis, Miakka, and Fruitville, victory would not have been possible.[175]

It should be added that Bertha Palmer, her sons Honoré and Potter, and her brother Adrian Honoré—as a family, they owned vast stretches of land and paid 50 percent of the land taxes in Sarasota County—were critical to political success. They provided money, meeting facilities for the chamber of commerce, and a great deal of land for road building. Palmer corporate executives such as Lawrence May, Lamar Rankin, and Joseph Lord—although Lord remained one of the large landowners in the Sarasota district—were instrumental in advancing the road program and county division.[176]

Arthur Britton Edwards lived until 1969 and was known as "Mr. Sarasota." It is hard to overstate Edwards's importance in building a modern road system for Sarasota County and winning independence from Manatee County. He was a towering figure connected to all the other major leaders of 1910–28 Sarasota. He had met and charmed Bertha Palmer when she arrived in 1910. He was twice mayor of Sarasota, head of the chamber of commerce, chair of the Good Roads Committee, chief negotiator with Manatee County in 1921, principal spokesman for county separation at community meetings held all over the Sarasota district, and tax assessor for the new county. He

was also a close friend of Joseph Lord's as well as his business partner. Sarasota never had a better or more effective booster. Unfortunately, Edwards, Lord, Rose Wilson, Peter Buchan, George Prime, Frank Walpole, William Perry, Augustus Wilson, Harry Higel, John Burket, Thomas Yarborough, Thomas Albritton, Arthur Joiner, and many others have largely been forgotten despite their importance to he early history of the county.[177]

They all deserve to be remembered, particularly as Sarasota County approaches its centennial, for they are owed a debt of gratitude. They provided the governmental framework and the transportation infrastructure that allowed the county to flourish right up to the present day. They brought the people of the Sarasota district together, at least those who were white, into a political community united by roads,

Arthur Britton Edwards, hero of the Good Roads Movement and champion of the creation of Sarasota County. *By permission of Sarasota County Historical Resources.*

governmental institutions, and a common agenda of seeking growth and progress. African Americans in this period were barred from the political process and generally segregated in nearly all aspects of community life. Their plight and the injustice that enveloped them need to be remembered as well.

Whatever Sarasota County became is built on the foundations laid by these pioneers. The centennial year of 2021 offers the county's residents an excellent opportunity to review the historical record and to appreciate what these early leaders and those who succeeded them accomplished. All Sarasota County residents should schedule a visit to the Sarasota County Courthouse to admire its design and the opulence of its exterior and interior decorations. Certainly, the building symbolizes the excesses of the mid-1920s. But even more, it expresses the pride that generation felt in their struggle for independence and the huge economic boost that followed their victory in the legislature. And on the way to the courthouse, also admire the web of roads and bridges, much of it originally built between 1913 and 1928, which was both reason for the creation of Sarasota County and then a primary purpose of the new government.

CELEBRATING SARASOTA COUNTY'S FOUNDING

T he great excitement in Sarasota County in 1921 over winning the battle for independence from Manatee County did not last very long. Many anniversaries of the great event went entirely unmarked. This may have been due to the influx of new people into the county during the boom times of the 1920s. These newcomers had little knowledge and perhaps no real interest in the dramatic events leading up to July 1, 1921. But perhaps another factor was that even the people who had lived through these events simply moved on with their lives. New problems, issues, and opportunities commanded their attention. Memories faded, and many of the key figures left the area, or died or did not choose to relive old battles. Generations of new county leaders confronting the big issues of their times followed one another. In a sense, the pioneer generation of the founders of Sarasota County were victims of their own success. The county they established excelled in all the ways they dreamed. It became populous, wealthy, and widely known. It fulfilled its promise to become a center of culture and a gathering place for people from many parts of America and, indeed, the world. Sadly, the real story of how Sarasotans struggled to win their independence and secure a modern road system has largely been forgotten, let alone appreciated.

The result of all these factors has been a spotty record of observing the anniversary of Sarasota County's birth. Not until 1932 did the *Sarasota Herald-Tribune* run a brief story on the eleventh anniversary of the county division bill passing both houses of the Florida Legislature. Among key

citizens credited with securing this success were Augustus M. Wilson, Arthur L. Joiner, A.B. Edwards, Lawrence L. May, John F. Burket, Rose Wilson, and William Y. Perry. Some of these people were alive and residing in the county, but apparently no one thought to interview them. The twenty-fifth anniversary in 1946 passed without public or press comment. Interestingly, Karl Grismer published his path-breaking book, *The Story of Sarasota*, the first major history of the county, in 1946, but he made no reference to the anniversary. He even thanked A.B. Edwards for providing information and reading the manuscript prior to publication. Apparently, even Edwards did not alert Grismer to the fact that Saraota County was now a quarter-century old.[178]

In 1951, the thirtieth anniversary of the county, the *Sarasota News* printed a headline noting "County Quiet about 30th Year." The article went on to say that "some talk was circulating about making July 5 a county holiday." July 1, of course, was the actual date when Sarasota County became a legal entity. The story gave only a few historical details about the reasons behind forming a new county. The *Sarasota Herald-Tribune* in its magazine section of July 1, 1951, said the county had flourished since 1921. It made no mention of any celebrations, official or otherwise. Things went a bit better in 1961, when the *Herald-Tribune* announced that there would be a "pioneer barbecue and Sarasota Day" at Myakka State Park the following Saturday to mark the fortieth anniversary. The usual stock historical facts about the events of 1921 were once again repeated.[179]

It was not until 1971 and the fiftieth anniversary of the county's establishment that a major celebration was organized. The Sarasota County Historical Commission partnered with the Sarasota County Fair Board to plan the event. The date of May 14, 1921, was determined to be the official birthday of the county, since the enabling legislation passed on that date. However, the Sarasota County law specifically provided that the people of the proposed new county had to hold a referendum to ratify the law, which the governor scheduled for June 15. Even after public approval, Governor Cary Hardee had to certify the results of the election and then appoint the initial county officials, who took office on July 1, 1921. It appears May 14 was selected as the date for celebration not for reasons of historical accuracy but because it corresponded with the run of the fair. For its part, the historical commission identified papers, photos, and artifacts in its collections that told the story of the formation of the county and prepared them for public display. County historian Dottie Davis was placed in charge of organizing the exhibits. The county fair board gave the commission space in its Agricultural

Building. As a logo for the celebration, the organizers selected a covered wagon with a steer trailing behind. No one explained that in 1921 Fords, Chevrolets, and other types of automobiles rather than Conestoga wagons were the preferred means of travel.[180]

A few days before the county fair opened, the historical commission staff interviewed several people who had lived through the county division controversy. The most interesting of these, Mrs. Homer Hebb, at the time a student at the Florida State College for Women, had been invited to the state capitol in nearby Tallahassee to see Governor Hardee approve the Sarasota County legislation. As a descendant of William Whitaker, the earliest white settler in Sarasota, she was delighted to join fellow students in witnessing the signing of the bill authorizing the creation of Sarasota County. She recalled the sometimes contentious debate between those who wanted more roads and schools and those who feared higher taxes. She also talked about how the women's vote had contributed to a victory for dissolving the ties of the Sarasota district from Manatee County in the referendum vote held in June 1921.[181]

The Sarasota Board of County Commissioners apparently felt after some reflection that a history display at the county fair was not enough to mark the significance of the moment. So in May 1971, the commission announced that the new official date to celebrate the fiftieth anniversary would be July 4. Governor Reuben Askew was invited to attend the event along with state legislators and other officials. By June, planning had advanced considerably—a good thing, given the exceptionally short period of time available. The Historical Society of Sarasota County and other groups now committed themselves to making the celebration a success. Island Park on the bay front was named as the location for a daylong party. The public was invited to bring a picnic and listen to band music from 1921 during the afternoon.[182]

By July 1, the event began to take on near-epic proportions. The *Sarasota Journal* breathlessly proclaimed: "Entertainment galore will be in the offing for just about every member of the family Sunday when celebrations commemorate Sarasota County's 50th anniversary." The paper promised speakers, beautiful girls dressed in 1921 costumes, a fish fry, an open house aboard the Coast Guard cutter *Point Thatcher*, historical displays, music, and, of course, a fireworks display.

Taken as a whole, the fiftieth celebration was both an educational experience and a dazzling community party. But would it have been as successful had it not been scheduled on July 4? There were no tours of the

Sarasota County Courthouse, no programs informing people about the many responsibilities of county government and how those responsibilities had changed over the past half century and no effort to make the celebration countywide rather than only for the people of the City of Sarasota. It was a missed opportunity to emphasize that it took all the communities in the Sarasota district to create Sarasota County. Still, this was the most serious and most ambitious effort in the county's hstory to properly mark its founding up to that time.[183]

The seventy-fifth anniversary of Sarasota County took place in 1996. Once again, Sarasota County Historical Resources and the Sarasota County Historical Commission took the lead in presenting exhibits explaining the reasons the county broke away from Manatee County. A new generation of Sarasotans was introduced to Bertha Palmer, A.B. Edwards, J.H. Lord, Joseph Halton, Frank Walpole, Rose Wilson, and all the others who led the charge to secure the brightest possible economic future for Sarasota County. But, as in 1971, these displays said too little about the role of the chamber of commerce and its predecessor groups or the importance of all the other communities in the Sarasota district whose support for county division was crucial.[184]

Sarasota County Historical Resources also prepared a series of six interesting and informative historical displays on diffcrent aspects of Sarasota County history at nine sites throughout the county. The topics included transportation, agriculture, business, industry, tourism, arts and culture, sports, and government. On July 1, the day designated for the official observance of the anniversary, plans called for all the historical exhibits under the title "A Peek at Paradise: Sarasota County History" to be gathered together and displayed in the Edson Keith mansion at Philippi Estate Park on Philippi Creek. Historian Dr. Janet Snyder Matthews was commissioned by Sarasota County Historical Resources to write an introductory publication to the exhibits titled *Sarasota Over My Shoulder*. For a select few Sarasota leaders, historical resources and the Sarasota County Historical Commission offered a preview of the exhibits at an invitation-only reception at the offices of Historical Resources. Even twenty years later, the scope and thoughtfulness of the work done by Sarasota County Historical Resources and the Sarasota Historical Commision set a high standard for the planners of the centennial celebration.[185]

As part of the seventy-fifth celebration, Sarasota County created a special logo for the event. It consisted of a drawing of the courthouse surrounded by a circle with a banner across the bottom reading "75th Anniversary, 1921–

Logo of the seventy-fifth anniversary celebration of Sarasota County, 1996. *By permission of Sarasota County Historical Resources.*

1996." This logo appeared at the lower left-hand corner of Sarasota County's official letterhead stationery. There were also stickers produced bearing the logo. For the first time, the iconic Sarasota County Courthouse was given a prominent role as the integrating symbol of Sarasota County in a celebration of the county's establishment.[186]

On June 17, 1996, the county public relations office issued a press release detailing what would take place at the official celebration to be held at Philippi Estate Park on July 1 from 5:30 p.m. to 9:00 p.m., complete with a birthday cake, lemonade, and commemorative fans decorated with the seventy-fifth-anniversary logo. In addition, attendees would be treated to entertainment at the "Show Mobile" stage. County officials would speak, along with "members of the historical community." Besides the historical exhibits in the mansion, there would be a collection of antique automobiles. Everyone was encouraged to bring a picnic and chairs. On the morning of July 1, the *Sarasota Herald-Tribune* greeted the citizens of Sarasota County with the headline "Happy Birthday to Us."[187]

This, then, has been the history of how the citizens and government have marked the anniversary of Sarasota County's birth over nearly one hundred years. Now we are approaching the centennial year, and the question is whether we can do better than our predecessors in interpreting, communicating, and properly celebrating what happened here between 1910 and 1928. While those events hardly matched the magnitude of the American Revolution, the leaders of Sarasota in that era were certainly inspired in part by the principles of 1776. Dr. Joe Halton in his keynote address to the first mass meeting on county division noted that those supporting separation were battling an unjust government and that they were being taxed without fair and equal representation. And then there was Rose Phillips Wilson rallying the newly enfranchised women to pull their weight in fighting for county division.

The men and women who made this new county were passionate believers in its future. They worked tirelessly within the system to gain the benefits of good roads, bridges, and schools. And when they were stymied by what

they saw as bias and ineptitude, they organized the entire Sarasota district to fight for independence from Manatee County. Just as important, they then committed themselves to building a government that represented the people of Sarasota County and managed their public affairs competently. Would Sarasota County have exploded in wealth, population, and cultural achievement in the 1920s and beyond if it had remained part of Manatee County? Probably not if Manatee County had continued to pursue road and bridge policies that hobbled development in its southern district.

First and foremost, the centennial observance in 2021 should restore to public consciousness not only the names and deeds of those who made the county but also their sense of mission and the zeal they brought to their public service. Second, a proper centennial observance should stress that people and leaders from throughout the Sarasota district rallied to the causes of good roads, good schools, and county division. Previous celebrations have been too focused on the City of Sarasota because of its large population, great wealth, and influential press. It is proper and perhaps useful to remind everyone about the important role played by communities throughout the Sarasota district. The Sarasotans of 1921 only succeeded because they were a united force committed to a common agenda and inspired by a common vision of the future. And we must not fail to note the important role of women in the story of Sarasota County. African American citizens were politically, socially, and economically repressed in this era, but they were the people who largely built the road system either as free labor or as convict labor. They also made up much of the labor force that worked in Fruitville's Celery Fields and other large agricultural operations throughout Sarasota County. They were key actors in building Sarasota County, and they cannot be omitted from this story.

As in 1996, the centennial planners should arrange for exhibits that address the entire history and prehistory of the area now occupied by Sarasota County to take advantage of a relatively short period of time when many citizens may well have an interest in how this community evolved into what we see today. As part of this effort, special attention should be paid to historical architecture preservation. This would be an excellent time to review Sarasota's record in preserving structures that help define our past, celebrate our extraordinary record of architectural excellence, and give Sarasota County communities their special sense of place. We should ask our fellow citizens who devote themselves to preservation to tell us what individual structures and historical neighborhoods are under threat and what actions must be taken to save them.

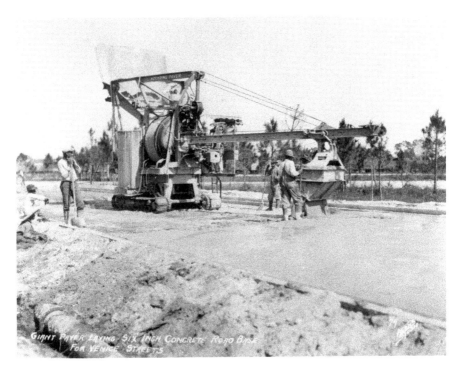

African American crew operating a giant paver laying six-inch concrete road base in the Venice area of Tamiami Trail. *Image courtesy of Venice Museum & Archives.*

Finally, 2021 provides an opportunity to showcase what county government has become over the last century. All parts of today's Sarasota County government trace their origins back to July 1, 1921, the day the county was born. Modern county government touches our lives in multiple ways, from the justice system to schools and libraries, to parks and recreation, to public safety, to community planning, and so much more. This might be a good time to open up county government and its facilities to the public, to give people a chance to learn about the breadth of public services offered by the many divisions and departments that compose that government. After all, the men and women of 1921 labored to give us this government, and we should try to appreciate all that it does.

SARASOTA DISTRICT AND COUNTY ROAD PROJECTS, 1911–1929

T he story of the formation of Sarasota County is closely tied to the growing demand for good roads and bridges not just in the Sarasota area but throughout the nation. The explosive growth of automobile ownership beginning around 1908 spurred this demand. For some car owners, the motive for urging construction of more and better roads related to pleasure driving, shopping, church attendance, and other mundane activities. But rather quickly, other motives came to the forefront. For example, farmers could see themselves benefiting from good roads that allowed them to transport their crops to railroad stations more rapidly whether by horse and wagon or by motorized trucks. Bad roads meant the loss of vulnerable cargoes that had to be shipped to market quickly. Another motive was to encourage tourists and investors to visit the area. Real estate markets, particularly in Florida, depended on a growing population and expanding numbers of tourists seeking sun and entertainment in the winter months. And as more and more travelers used cars rather than trains to reach Florida, local boosters and real estate developers recognized that not only good local roads but also a network of well-built state and later federal roads was essential to prosperity.

To assure future success, an area like the Sarasota district needed to be served by an ever-expanding network of local roads, which in turn meshed with roads leading to other parts of the state and ultimately to the entire United States. At the end of World War I, the inadequacies of the nation's railroads together with vast numbers of war-surplus cargo trucks meant

that truck traffic soon clogged the roads and did great damage to them. Better paving materials and more efficient methods of road maintenance became priorities.

Before and after Sarasota became a county in 1921, much of the money for roads and bridges came from local tax sources and bonds. However, in 1915, the state created the Florida State Highway Commission, which within a few years was planning a statewide system of roads. The state and counties shared costs for these projects, and the state established standards for construction and assumed responsibility for maintenance. In 1916, the federal government made its first appropriation for roads. By 1922, those appropriations became quite substantial. If a state highway commission showed that a state highway project (such as the Tamiami Trail) met federal standards, it could become eligible for federal funds.

As the story of the Sarasota district's roads and bridges demonstrates, before 1921, the area was left largely on its own to decide what roads and bridges to build and how to finance the projects. Moreover, Bertha Palmer, A.B. Edwards, Joseph Lord, Frank Walpole, George Prime, and the other leaders of the Good Roads Movement had to determine how wide the roads would be, how they would be drained, and, most important, how they would be paved. There were a few men in Sarasota such as William Tuttle who had engineering experience, but costs more than professional expertise drove technical decisions about road construction. In 1913 and 1914, the challenges of maintaining roads once they were built worried many leaders, but not enough to offend taxpayers by cutting out locally popular transportation projects. Edwards and Lord to their credit did try to learn about best practices of road building, including studies of which paving materials best stood up to heavy use. However, reliable information on such subjects remained hard to obtain in those early years and awaited further experimentation and scientific study. The first Sarasota district roads and bridges program of 1914–15 was hardly a great success. It was long delayed, the roads were too narrow, the bridges poorly built, the paving inadequate for heavy automobile traffic, and there were no provisions for maintenance. Still, the beginnings of a road system were put in place in those early years, thanks mostly to the drive and ambition of the citizens of the Sarasota district.

In 1922, a year after Sarasota won its separation from Manatee County, the Sarasota Chamber of Commerce put forward an ambitious road and bridge plan to the Sarasota County Board of Commissioners. Its proposal linked up all the major settlements in the county and connected Sarasota to

APPENDIX A

Banner headline of the 1928 *Sarasota Herald* celebrating completion of the Tamiami Trail. *By permission of Sarasota County Historical Resources.*

the Sarapalmbee Trail, a cross-state road running from West Palm Beach to Okeechobee, Arcadia, and finally to the Bradentown area. The City of Sarasota was joined to this road (now State Road 70) by Fruitville Road and the Verna Road at the eastern end of Sarasota County. It took years of serious political fighting to gain approval and funding for this project, but eventually it was completed in 1927. Just as important was the Tamiami Trail. Sarasota County poured money into its section of the trail, the county's chief connection to the growing national road system. The Tamiami Trail was finally finished in 1928, some thirteen years after the idea was first proposed. By the end of its first decade, Sarasota County government had committed some $4 million to road and bridge building in addition to millions more provided by state and federal government agencies. Helped by boom-time economic conditions, benefiting from state and federal subsidies and freed from the hostility of the Manatee County business community, the leaders of Sarasota County had totally transformed the transportation infrastructure of their area. Muddy lanes had given way to a strategically conceived system of increasingly well-built local, state, and federal roads that united the entire county, including the offshore keys with all parts of Florida and, indeed, the nation. This amazing achievement came about because of the sustained efforts of a talented and dedicated group of men and women who had a vision of the future and the political savvy to overcome substantial obstacles to make it a reality.

A combination of grievances drove the Sarasota district to seek independence from Manatee County. However, the issue of roads and bridges was the dominant reason local leaders decided to pursue separation. At first, the Sarasotans fumed at what they saw as ineptness by the Manatee County commissioners in road and bridge matters affecting Sarasota. Later, they came to feel the Manatee County government and the business community in Bradentown were actively working against their interests. With the creation of state and federal highway road agencies in 1915 and

129

1916, the role of county governments in selecting road routes and obtaining funding changed and expanded. To promote its road and bridge priorities, the Sarasota district needed to be a county in its own right so it could deal directly with the state highway authorities and float bond issues for road and bridge construction. Sarasota district leaders were not prepared to let Manatee County stand in the way of fulfilling their ambitions.

Timeline of Road and Bridge Development in the Sarasota Area, 1911–1929

1911 Manatee County sells bonds to build a road from the Hillsborough County line to Sarasota as part of the St. Petersburg–to–Sarasota Bayshore Road project. The Bradentown-Sarasota portion is finished in 1912 and soon falls apart.

1913 Manatee County funds initial development of Fruitville Road running east from the town of Sarasota.

 Manatee County commissioners propose a system of good roads for the entire county paid for with a bond issue. Most of the proposed roads are in northern Manatee County, although a road from Bradentown to Venice and an extension of Fruitville Road to Miakka are included. Sarasota district leaders object and gain an increase in the Sarasota district's road fund allocation.

1914 Voters reject the Manatee County road bonding plan. The Manatee County Board of Commissioners criticizes the shabby condition of existing roads.

 Former Sarasota mayor Harry Higel calls for a mass meeting to discuss a comprehensive road plan for the Sarasota district. In December, 150 Sarasotans attend the meeting and approve a plan asking the county and state governments to create a Special

Roads and Bridges Bond District in the Sarasota-Venice area to finance construction of an extensive system of hard-topped roads and bridges. This mechanism allows voters in a part of a county to determine what roads and bridges they wanted if they agreed to pay the interest on the bonds. Although Bertha Palmer and her family are the chief architects of the plan, the specific roads and bridges listed in it are the result of consultations with communities throughout the area extending from the town of Sarasota to Venice. The mass meeting also directs City of Sarasota mayor A.B. Edwards to appoint a representative Good Roads Committee to promote and carry out the idea of a special district.

1915 Edwards appoints a Good Roads Committee of members from all parts of the proposed bond district. The committee employs scientists and engineers to plan routes and recommend building materials.

The Good Roads Committee presents a petition for a $250,000 bond issue signed by 110 landowners, a quarter of the voters in the proposed Sarasota/Venice Special Roads and Bridges Bond District. The money is designated for thirty-four miles of new hard-topped roads and several bridges.

A road from Sarasota to Venice and a bridge to Sarasota Key (later called Siesta Key) are significant parts of this plan.

In March, the citizens living in the new Sarasota/Venice Special Roads and Bridges Bond District vote overwhelmingly in favor of the $250,000 bond issue.

In August, Manatee County commissioners reject bids for roadwork in the new bond district, as all of them exceed $250,000.

In November, the Manatee County commissioners call for a new election in the area covered by the special bond district permitting them to make drastic cuts in the scope of proposed construction to bring bids in under the $250,000 cap.

Joseph Lord and Lamar Rankin tour counties and towns in Florida that rely on sand-oil roads. They learn that these types of road are cheap but lack durability.

A large meeting in Chattanooga, Tennessee, in April proposes routes for the Dixie Highway and sets off local community competitions from Michigan to Florida to secure a location on one of the earliest national highways.

Businessmen from Miami, Naples, and Fort Myers meet with state officials about building the Tamiami Trail from Tampa to Miami as a cross-state road connecting the east and west coasts through the Everglades. Competition among Florida counties favoring competing routes to the Tamiami Trail begins almost immediately.

The Florida State Highway Department is created. Within a few years, it plays a big role in deciding which Florida roads receive state and federal financing.

1916 A second Sarasota/Venice Special Roads and Bridges Bond District election approves giving the Manatee County commissioners the ability to reduce the scope of the original 1914 plan. The commissioners then award construction contracts based on their modified plan. The Sarasota-Venice Road is reduced in width to nine feet. Cars going in opposite directions cannot pass each other. No provisions are made for road maintenance.

William M. Tuttle of Sarasota is named supervisor of road and bridge construction in the Sarasota/Venice Special Road and Bridge Bond District. The planned route of the Sarasota-Venice Road begins at the intersection of Main Street and Osprey in the City of Sarasota. At the village of Crocker (now the corner of the Tamiami Trail and Bee Ridge Road), the road divides, with the eastern branch leading to the community of Bee Ridge, while the southern branch, dubbed the "Velvet Road," reaches Venice. The road north from Sarasota starts at Palm Avenue and runs along Sarasota Bay to Indian Beach. Fruitville Road running due east from downtown Sarasota is extended one and a half miles. Additional work is planned for Lockwood Ridge Road and the

road from the village of Fruitville to the village of Miakka. Also, a road through the Hyde Park subdivision to the Bee Ridge hard road is planned.

The U.S. Congress passes the Bankhead Act, authorizing federal aid for post roads. State highway departments have the responsibility for creating state and state-aided highways as well as recommending roads and bridges eligible for federal support.

1917 The Manatee County commissioners let contracts for work on projects covered by the Englewood Special Roads and Bridges Bond District, including a connection to the Sarasota-Venice hard road.

The Bay Bridge to Siesta Key is dedicated.

The company building the Sarasota-Venice Road goes bankrupt, and work stops. It later resumes under the Fidelity and Deposit Company of Maryland.

In September, a meeting of the Central Florida Highway Division at Fort Myers refuses to reroute the Tamiami Trail to Arcadia as proposed by Bradentown businessmen. Instead, it votes to support the planned route along the southwest Gulf coast to Naples, then across the Everglades to Miami. The group also recommends that the road be entirely hard-surfaced. The decisions are major victories for Sarasota and other areas south of Bradentown that would have been cut off from the economic benefits of being located along the Tamiami Trail. However, the issue is not completely settled and arises again in a few years.

1918 Despite substantial progress on all aspects of the Sarasota/Venice Special Roads and Bridges Bond District projects, the Fidelity and Deposit Company announces it must wait for the end of World War I to complete work because of federal government rules and restrictions. The Sarasota-Venice Road, however, is to be completed immediately.

1919 The two-year-old Siesta Key Bridge is already in very poor shape.

In August, Manatee County receives $150,000 in state and federal road funds.

1920 Sarasota district leaders complain that there is an eight-mile gap in the Tamiami Trail between Venice and Englewood. They ask the Manatee County commissioners to obtain help from state officials to extend the trail.

The movement to create Sarasota County begins in June 1920.

Manatee County announces plans to build a road from Bradentown to the DeSoto County line. The Sarasota Board of Trade strongly opposes including part of the Sarasota district in the special bond district, claiming these citizens would be taxed only for the benefit of northern Manatee County. William Tuttle says the Bradentown businessmen are once again conspiring to reroute the Tamiami Trail away from the coast and to Arcadia and then south to Fort Myers. The effect would be to cut the entire Sarasota district off from the benefits of being on the Tamiami Trail.

The Sarasota Board of Trade organizes to oppose the Bradentown-Arcadia Road.

In September, a mass meeting in Sarasota unanimously favors creation of Sarasota County.

Manatee River Journal in November calls for a state-funded system of state roads that connect up county seats, another ploy to deny Sarasota access to key roads.

1921 On July 1, Sarasota County is officially established and the government organized.

In September, the Sarasota County commissioners lend Charlotte County equipment to clear twelve miles of road south of the Sarasota County line. The new section is to be part of the Tamiami Trail.

In September, the State Highway Commission officially designates the Tamiami Trail and the cross-state highway (future SR 70) as state highways. This is another blow to Bradentown's hopes of cutting Sarasota County off from both roads.

1922 In September, the Sarasota Chamber of Commerce appoints a committee to work out a countywide road and bridges plan.

One week later, the committee submits a plan formulated by the McElroy Engineering Company to undertake six major road projects:
1. Extending Fruitville Road to the village of Miakka.
2. Building a road from the village of Miakka north to the community of Verna to connect Fruitville Road with the proposed cross-state road.
3. Building a road from the Fruitville settlement to the Lockwood Ridge settlement.
4. Building a road from the town of Bee Ridge to the Fruitville settlement.
5. Building a road from Salt Springs to the Charlotte County line.
6. Extending the Myakka Road to the Tatum Ridge settlement.

The State of Florida runs out of funds to continue building the Tamiami Trail through the Everglades; work stops.

In December, the hard road from Venice to Englewood is completed and the Siesta Key Bridge strengthened.

1923 E.C. Warren builds a toll bridge to the southern part of Casey Key (also called Treasure Island.)

Sarasota County obtains $75,000 from the state highway department for a road between the Myakka River Bridge and the Charlotte County line.

In March, the Tamiami Trail Association is formed to rekindle interest in the project.

In April, a team of auto enthusiasts called the Tamiami Trail Blazers drives the planned route of the Tamiami Trail through the Everglades from Naples to Miami with the help of Seminole guides. George B. Prime of Sarasota is the first member of the group to set foot in the city. The exploit refocuses public attention on completing the Tamiami Trail.

Businessman Barron Collier offers to pay $1 million to build the Everglades section of the Tamiami Trail if a county is named for him. The state agrees and establishes Collier County out of Lee County.

Four competing routes vie to be the first to become the cross-state road: the Tamiami Trail; the route from Bradentown and Sarasota to Arcadia, Okeechobee City, and West Palm Beach; the route from West Palm Beach to Arcadia to Sebring to Tampa; and a route from Miami to LaBelle to Arcadia to Tampa. Eventually, all four routes will be completed.

1924 William J. Connors privately finances a toll road from West Palm Beach to Okeechobee City, thereby brightening prospects for the completion of the cross-state highway from West Palm Beach to Bradentown and the City of Sarasota

The Sarasota County Commission approves a vastly expanded version of the Sarasota Chamber of Commerce roads and bridge plan of September 1922 that calls for a huge addition to the county's road system, including the Siesta Key Road, the Stickney Point Bridge, and the Madison interior road. The county commissioners propose to cover construction costs by selling an additional $551,300 worth of bonds. However, the plan is never implemented as new circumstances and demands for additional roads cause the commissioners to hesitate and delay.

John Ringling's Sarasota Bay causeway is under construction.

In May, Sarasota County officials learn from the Tamiami Trail Association that the entire length of the trail in Sarasota is not up to federal standards. It cannot handle current traffic let alone

anticipated increases in tourist traffic and must be widened and better paved.

In June, the Sarasota Board of County Commissioners presents a significantly enlarged roads and bridges bond plan to the voters. It is approved on June 16 and authorizes the sale of $1,010,000 in bonds to cover construction costs. It represents the most comprehensive and carefully thought out road plan in Sarasota's history to date. See table 1 in chapter 5.

In October, the State Highway Commission begins work on widening and repaving State Road 5, the Tamiami Trail, in Sarasota County. The cost is $800,000, with the federal government paying half.

1925 In June, the voters of Sarasota approve a $1,500,000 bonding proposal for yet another new road and bridge plan. The total cost of the 1924 and 1925 roads and bridges projects is $2,500,000. See table 2 in chapter 5.

A rail embargo on nonessential cargoes including building materials seriously hampers road and building construction. The embargo lasts from October 1925 to May 1926.

1926 The Tamiami Trail is made part of U.S. 41.

1927 In March, the cross-state highway, now called the Sarapalmbee Trail (Fruitville Road to Verna to Myakka City, Arcadia, Okeechobee City, and West Palm Beach) is completed. George B. Prime, now chair of the Sarasota Board of County Commissioners, travels the new cross-state road in the first caravan of cars.

Stickney Point Bridge and Road are completed.

$450,000 bond issue for a bridge between Lido Key and Longboat Key is approved.

The new Siesta Key Bridge is completed and dedicated.

1928 In April, the Tamiami Trail is completed after thirteen years and a cost of $8,000,000. George B. Prime is part of the first road caravan to arrive in Miami on April 26.

1929 New Pass Bridge is completed in April between Lido and Longboat Keys.

BRIEF BIOGRAPHIES OF IMPORTANT LEADERS IN THE STRUGGLES FOR GOOD ROADS AND COUNTY DIVISION

IRA G. ARCHIBALD. Little is known of Archibald's background, but he was born in Lowell, Michigan, in either 1883 or 1884. By 1920, he was a well-established hardware store owner who sold, among many other things, Edison phonographs. Archibald built one of the earliest public bathhouses on Siesta Key. In 1925, he opened a 55,000-square-foot furniture and hardware store in Charles Ringling's Courthouse subdivision. He is given credit for helping to expand the City of Sarasota's business district to the east.

Archibald served as president of the Sarasota Board of Trade from 1918 to 1920. He was then selected as a member of the reconstituted board of trade in 1920. A year later, the chamber made him a member of the Committee of 10 sent to Bradentown to negotiate a settlement to the impasse over county division. As a result, the governor and state legislature approved the bill creating Sarasota County. Like many Sarasota leaders, Archibald was a Mason and past grand master of Sarasota Lodge no. 147. He died in 1943 and is buried in Manasota Memorial Park.

JOSEPH EMORY BATTLE. Battle was president of Sarasota's Adams Boat Company and a past grand master of Sarasota's Masonic Lodge no. 147. U.S. Census data from 1920 and 1930 also list him as the owner of a dry-goods department store. He was a board member of the Sarasota Board of Trade in 1920 and stayed in that position when the board of trade became the Sarasota Chamber of Commerce. His high standing in the community led to his appointment as chair of the first mass meeting on county separation

in June 1920. He later served on a committee with A.B. Edwards and W.Y. Perry to raise funds to finance the county division campaign. In April 1921, the chamber of commerce placed him on the Committee of 10 to negotiate with the Bradentown Board of Trade on issues related to separation. He died in 1966 in Sarasota at age eighty-eight.

PETER E. BUCHAN. Peter "Pete" Buchan was an enterprising businessman in Englewood and ran the local post office. Buchan was named by the second mass meeting in 1920 to the General Committee on County Separation that led the fight for independence from Manatee County. Buchan also helped fund the separation movement. After separation, he served one term on the Sarasota County Board of Commissioners in 1921. He later returned to the board of county commissioners and served a total of twenty-four years. As a commissioner, he worked to establish the airport in Englewood, which his fellow commissioners named for him and still is in use. Buchan long served on the Sarasota County Democratic Party Executive Committee. He died on January 12, 1968; he and his wife, Florence, are buried in Gulf Pines Memorial Park in Englewood.

JOHN F. BURKET. Born in Ohio on June 15, 1873, son of a judge, educated at Williams College and with a law degree from the University of Michigan, Burket served as city attorney for Sarasota from 1913 to 1927. At one time, for about a year, he held the post of attorney for the Sarasota Board of County Commissioners and the Sarasota County School Board. Burket also served as a director of the Sarasota County Board of Trade and handled much of the legal work related to the creation of the Sarasota/Venice Special Roads and Bridges Bond District in 1915.

Burket was one of the outstanding advocates of county independence and served on the General Committee on County Division. The Sarasota Chamber of Commerce named him in 1921 to the Committee of 10 to negotiate with the Bradentown Board of Trade about issues related to separation. Burket also had a hand in drafting the proposed legislation establishing Sarasota County and presented it to the Florida Legislature as part of a joint committee from Sarasota and Bradentown. His telegram to Rose Phillips Wilson was the first word received in Sarasota that the legislation had passed. He then campaigned tirelessly throughout the Sarasota district to persuade citizens to vote in support of independence. Burket died in July 1947 from the effects of a car accident.

OWEN AUGUSTUS BURNS. Owen Burns was one of the giants in early Sarasota history. Born in 1869 in Fredericktown, Maryland, and educated at Baltimore City College, Burns made a fortune marketing metal home savings banks. He migrated to Sarasota in 1910 and purchased all the land in the town of Sarasota still owned by the Florida Mortgage and Investment Company of Scotland. A dynamic entrepreneur, Burns started the Citizens Bank. He also served as president of the Sarasota Board of Trade in 1922, reorganized the yacht club, and helped launch a golf club in Sarasota and the Sarasota Woman's Club. In the mid-1920s, he built the El Vernona Hotel and Apartments and was closely associated with John Ringling in a number of initiatives.

Burns supported county separation and spoke out strongly at the first mass meeting in 1920. He was named to the twenty-five-member General Committee on County Division that led the fight for independence. Burns also had great interest in the Good Roads Movement, even providing stone at his own expense to fill potholes in the Sarasota district portion of Bayshore Road that the Manatee County Board of Commissioners failed to repair. Burns died on August 28, 1937, and is buried in the Burns family plot in Rosemary Cemetery in Sarasota.

FRANKLIN P. DEAN. Dean was president of the West Coast Realty Company and a founder of the first real estate association in the area. Census records show he lived at 87 Bayshore Road in 1920 and then in Indian Beach not far from the estates of John and Charles Ringling in 1930. In 1912, he purchased a Ford touring car, an investment that may explain some of his commitment to the local good roads and bridges movement. As a board member of the Commercial Club, Dean was named to a special committee to campaign for the 1915 Sarasota/Venice Special Roads and Bridges Bond District. In 1920, he was appointed to the General Committee on County Separation by the second mass meeting in Sarasota. He died in 1926 at age sixty-six.

ARTHUR BRITTON EDWARDS. Known to all as A.B., Edwards was born on October 2, 1874, just north of where the town of Sarasota would be founded in 1885. During his long life, he was involved in every major event in the Sarasota district and then Sarasota County, including welcoming Bertha Honoré Palmer to Sarasota in 1910. He served two terms as Sarasota's mayor and one year as county tax assessor. He was also a past grand master of the Sarasota Masonic Lodge no. 147. Edwards was involved in many economic ventures, but most people know him as a real estate dealer who sometimes partnered with Joseph H. Lord. He was married to Fanny Lowe.

Often called "Mr. Sarasota," at least in later years, Edwards was an original member and often president of the Sarasota Board of Trade and its successor organizations. He was the chief architect of the Sarasota district's efforts to obtain good roads and bridges, including the formation of the Sarasota/Venice Special Roads and Bridges Bond District, and he directly oversaw research efforts to identify the most durable but affordable paving substances. In June 1920, Edwards convened the first mass meeting on county division held at the Palmer Trust offices. At the second mass meeting, he was placed on the General Committee on County Division and made chair of the data committee that studied tax implications of independence. In April 1921, he testified on behalf of the county division bill before a Florida Senate committee and rebutted opposing arguments made by a Bradentown group. He then led a Committee of 10 named by the chamber of commerce to negotiate successfully a settlement with the Bradentown Board of Trade leaders. Early in May, Edwards, William Y. Perry, and John F. Burket joined with a committee from the Bradentown Board of Trade to return to Tallahassee with a modified bill that passed both houses unanimously. In June 1921, Edwards and other Sarasota leaders spoke at public meetings throughout the Sarasota district, urging voters to approve separation, which they did on June 15. Edwards was nominated by the chamber's Committee on County Division to Governor Hardee to become Sarasota County's tax assessor, a job he assumed after his term as Sarasota mayor ended. He later returned to his role as president of the Board of Governors of the Sarasota Chamber of Commerce, where he became involved in the 1924 and 1925 county road bond campaigns. In 1926, Edwards opened the Edwards Theater in downtown Sarasota, a beautiful Mediterranean Revival structure now called the Sarasota Opera House. He died on November 14, 1969, at the age of ninety-five.

ALICE MOREHOUSE GUENTHER. Born about 1865 in Wisconsin, Alice Morehouse married Frederick H. Guenther, a bookkeeper for the Palmer family. Alice Guenther became the first president of the Sarasota Woman's Club and provided dynamic leadership for many years. From organizing the first library to beautifying the bay front area, Guenther and her several hundred club members proved a powerful force promoting local improvements in Sarasota. At all times, Alice Guenther was in the forefront of women's progress. In 1919, she supported congressional passage of the Nineteenth Amendment to the U.S. Constitution enfranchising women. She and Rose Phillips Wilson were the first two women to register to vote in Sarasota. In 1921, they were also the first two women named to the board

of directors of the Sarasota Board of Trade, later renamed the Sarasota Chamber of Commerce. Guenther was also close to Bertha Palmer. Palmer, a charter member of the Woman's Club, contributed funds to help finance the clubhouse and gave the women a parcel of land on Main Street, where they built a children's park.

In June 1921, Alice Guenther presided at an important meeting of the Woman's Club to hear A.B. Edwards, John Burket, and William Perry lay out the arguments for county division. On behalf of the Sarasota Chamber of Commerce, E.S. Delbert then offered to pay the women's poll taxes, thus making it easier for them to vote in the upcoming referendum on creating Sarasota County. Alice Guenther died in 1955 in Sarasota and is buried in Manasota Memorial Park.

DR. JOSEPH HALTON. Halton, born near Liverpool, England, in 1881, migrated to America in 1888 with his brother Jack and their father. Joseph grew up in Indiana and Ohio and earned his medical degree at the University of Cincinnati. By 1905, he was in Sarasota along with Jack, who also had a medical degree. They built Sarasota's first hospital, called the Sanitarium, on North Gulfstream Avenue. Both brothers took an interest in public affairs. Joseph became an active member of the Sarasota Board of Trade and, by June 1920, was deeply involved in planning an effort to make the Sarasota district a county in its own right.

At the first mass meeting, he was selected to give the keynote address, in which he laid out a persuasive case for county separation. The meeting attendees then made him chair of an organization committee to propose a structure to lead the independence fight. His committee recommended to the second mass meeting that a twenty-five-member General Committee on County Division be appointed and divided into subject committees. Joseph Halton was named a member of this general committee. In April 1921, the Sarasota Chamber of Commerce placed Halton on the Committee of 10, sent to negotiate for county separation with the Bradentown Board of Trade. Dr. Halton died in 1963 and is buried with his wife, Mary Colt Halton, in Cedar Hill Cemetery, Hartford, Connecticut.

HARRY LEE HIGEL. Harry Higel was one of the most enterprising and energetic of Sarasota's early citizens until his brutal murder in 1921. Born in Philadelphia in 1867, Higel came to Venice with his family in 1884. Within a few years, he had relocated to Sarasota, where he operated a cargo boat, marketed real estate, ran a general mercantile establishment, and sold

gasoline and kerosene. By 1907, his major economic activity had shifted to Sarasota Key, where he launched a development called Siesta. Before long, that name became the official name of the island. In 1911, he built a hotel, Higelhurst, on the north end of Siesta Key. Unfortunately for Higel, the hotel burned down in 1917. Higel served five terms on the Sarasota Town Council and was mayor from 1911 to 1914. After Sarasota became a city, Higel succeeded A.B. Edwards as the second mayor (1916–17).

It was as town mayor in 1913 that Higel asserted that a so-called comprehensive road and bridge plan proposed by the Manatee County Board of Commissioners discriminated against the Sarasota district and favored the northern part of the county. A year later, he called for a mass meeting in the City of Sarasota to gain public support for good roads and bridges for the district. In 1915, he campaigned for the construction plan proposed by the Sarasota/Venice Special Roads and Bridges Bond District. That same year, he went to Washington, D.C., to discuss possible federal support for the special bond district. Higel had a personal interest in the outcome of the election on the bond district plan, as one of the proposed building projects was a bridge to Siesta Key, which would make his holdings on the island much more valuable.

Higel in 1920 strongly endorsed the idea of county separation and participated in the mass meetings. He was named to the General Committee on County Separation by the second mass meeting. Influential and politically astute, Higel would undoubtedly have played a major role in the new Sarasota County government. However, he died on January 6, 1921, the result of a brutal beating. Most people believed publisher Rube Allyn was responsible, but he was not convicted.

CLARENCE EDGAR HITCHINGS. Born in North Dakota in 1882, Hitchings is listed in the U.S. Census of 1910 as living in Sarasota on Lemon Avenue with his wife, Lutie, and two children. By 1913, he held the post of cashier of the Bank of Sarasota, later known as the John Ringling Bank. He also served as Sarasota's first scoutmaster for the Boy Scouts of America. In 1915, he became a board member of the Commercial Club, retaining his seat as the organization changed its name first to the Sarasota Board of Trade and then to the Sarasota Chamber of Commerce. In June 1920, the second mass meeting on independence from Manatee County appointed him to the General Committee on County Division. Later in his career, Hitchings became vice-president of the Bank of Sarasota, which collapsed during the Great Depression in 1935. Hitchings died in 1951.

Adrian C. Honoré. Born in 1847, Adrian was two years older than his famous sister, Bertha Honoré Palmer. With a law degree from the University of Chicago, Adrian Honoré helped manage his father's large real estate holdings in Chicago. Although a lifelong bachelor, he did have one well-publicized affair with the wife of a circus performer. Still, Bertha's husband, Potter Palmer, trusted A.C. Honoré's financial acumen and in his will made him joint trustee with his wife over a sizeable portion of his estate. When Bertha decided to establish herself in Sarasota in 1910, she brought her brother along as the chief manager of Palmer enterprises in Florida. He served as president of both the Sarasota-Venice Company and the Palmer Florida Company. In those enterprises, he was her closest advisor and carried out her wishes effectively and efficiently.

When Bertha died in 1918, she left her brother the fifteen-thousand-acre Meadowsweet Pastures beef and hog ranch along the Myakka River and a similarly sized tract near Tampa. In addition, Adrian Honoré possessed large amounts of land in the Sarasota district that he had purchased on his own.

Honoré had been closely involved in the negotiations with the Seaboard Air Line Railway Company to build the Venice extension from Sarasota to service his sister's vast landholdings. He also worked at her behest to persuade the federal government to dredge a deeper shipping channel between Venice and Sarasota. But by 1914, roads and bridges were the primary concern. Bertha Palmer wanted more and better roads built connecting up the different parts of her sprawling empire. Unhappy with the slow progress of road and bridge building, she increasingly blamed the poor performance of the Manatee County commissioners as the root cause of the problems. It was undoubtedly Bertha who urged Adrian Honoré and other allies to organize the Sarasota/Venice Special Roads and Bridges Bond District. To help things along at a critical point, Adrian found a Chicago bank willing to buy all the bonds for road construction. By 1920, Adrian and Bertha's two sons, Honoré and Potter Jr., were convinced that their needs for new and better roads could only be resolved through county division. Adrian helped orchestrate the first mass meeting on the subject and later agreed to accept a spot on the General Committee on County Division. A few years later, the Palmers threw their full weight behind connecting Sarasota to the cross-state highway by extending Fruitville Road and building the Verna Road. Adrian Honoré was among those who donated the land on which the Verna Road was built. He died in 1926 and is buried in Chicago. His eastern Sarasota County holdings, together with nine thousand acres of land donated by the Palmer brothers, became Myakka River State Park in the 1930s.

ARTHUR L. JOINER. Born in 1888 in Mississippi, Joiner was a relative newcomer to the City of Sarasota when the question of county division arose. He and his wife, Olivia, and their two children lived on Orange Avenue. In 1920, he was serving as cashier of the First National Bank in Sarasota, though Sarasota city directories of later years variously indicated his title was auditor, bank examiner, vice-president, director, and president. He certainly had the confidence of leading citizens, who at the second mass meeting on county division placed him on the General Committee. In April 1921, he was one of the men selected to testify before the state senate on a bill to create Sarasota County. He served for many years on the first Sarasota Board of Education representing the first district and also as chair of the board.

OTIS F. LANDERS. Born in 1886 in Alabama, Landers was a newspaperman affiliated with the *Sarasota Times* and later ran a printing establishment. Landers was both secretary and a past grand master of Sarasota Masonic Lodge no. 147. He was also a board member of the Sarasota Board of Trade. In 1921, he was named by the Sarasota Chamber of Commerce, a successor group to the board of trade, to serve as a member of the Committee of 10 to work out an agreement with the Bradentown Board of Trade on county separation. After the legislature and governor approved the compromise bill, Landers threw himself into the campaign to persuade Sarasota district voters to support independence. Along with A.B. Edwards and others, he traveled to communities throughout the district, urging a positive vote. Landers's services did not earn him a position in the new Sarasota County government. Indeed, he virtually disappeared from the public stage. The 1940 U.S. Census reported that he was a fifty-four-year-old widower living in a Sarasota boardinghouse. He died in 1943 in Marion, Florida.

THOMAS L. LIVERMORE. Livermore, born in 1872 in Massachusetts, graduated from Yale University, purchased land from the Palmers in Bee Ridge Farms, and established himself as a citrus farmer. He also joined the Masons, rising to the post of grand master. In 1925, he became an officer of the Sarasota County Fair in charge of citrus exhibits. He does not appear to have been overly active in the roads or county separation struggles, but the chamber of commerce nominated him to Governor Hardee for a position on the first Sarasota school board, representing the second district. He died in 1935; his widow, Sibbel H. Duff Livermore, moved back to Massachusetts.

JOSEPH H. LORD. Born in Maine in 1859, Lord graduated from Brown University in 1885. A year later, he was admitted to the Florida Bar and practiced law in Orlando. In 1889, he moved to the Sarasota area and purchased a large portion of the Florida Mortgage and Investment Company lands in Sarasota as well as land outside of the town, making him the largest landowner in Manatee County. His properties stretched to Venice, Bee Ridge, the Myakka River, and Fruitville. In Venice and Bee Ridge, he planted orange groves. Inside the Sarasota town limits, he bought four of the corners at Five Corners, the center of the community. Because of his land, his energy, and his intelligence, Lord was a major figure in the early history of the Sarasota district and later Sarasota County. His master stroke was to persuade Bertha Honoré Palmer to come to Sarasota in 1910, buy 140,000 acres—much of it from him—and establish her winter home in Osprey. Lord became vice-president of two Palmer corporations and maintained a strategic alliance with the Palmers for decades.

Lord was an early president of the Sarasota Board of Trade and returned to that post several times over the years. He supported all causes promising to improve the area and attract tourists and visitors. He was a leader in the fight for good roads and bridges, even traveling to other parts of Florida to study various types of road paving. He was a key figure behind creation of the Sarasota/Venice Special Roads and Bridges Bond District and an early supporter of county separation because of the inadequacies of the Manatee County Board of Commissioners on road and bridge issues. He was selected as a member of the General Committee on County Division by the second mass meeting in 1920 and headed the standing committee on data. The chamber of commerce nominated Lord to the governor for appointment as Sarasota's first representative in the Florida House of Representatives. Lord later became one of the owners of the *Sarasota Times*. He died in Chicago in 1936 but is buried in Manasota Memorial Park in Manatee, Florida.

LAWRENCE L. MAY. Born in Louisiana in 1894, May was an employee of the Palmer family in charge of the Palmer Trust headquarters in the City of Sarasota at the time of the fight for county separation. With the encouragement of the Palmer brothers and Adrian C. Honoré, he opened the Palmer corporate offices for mass meetings associated with county independence. He was named to the General Committee on County Division and then served on the Committee of 10 sent to carry on critical negotiations in Bradentown to resolve county separation issues. He served as the first county commissioner, representing Sarasota County's second district. While

a commissioner, he was part of a Sarasota delegation sent in September 1921 to an important meeting in Punta Gorda, Charlotte County, where the Central Florida Highway Association voted to derail Manatee County's ambitions to cut off Sarasota from direct access to the Tamiami Trail and the cross-state highway. May resigned from the county commission before his term was up and relocated to Shreveport, Louisiana. There, the 1930 U.S. census indicates he was working as a broker in real estate.

KATHERINE M. MCCLELLAN. McClellan was born in 1859 in Paterson, New Jersey, and graduated from Smith College in Northampton, Massachusetts. In 1892, she set up a photography studio in Northampton and in 1902 became Smith's official photographer. Never married, Katherine and her sister, Daisetta, came to Sarasota and, by 1915, had laid out McClellan Park along the bay shore south of the center of Sarasota. Katherine designed a pleasant subdivision with circular drives, access to Sarasota Bay, a clubhouse, tennis court, and other amenities. The sisters opened a real estate office on Main Street in Sarasota to sell lots. By 1918, Katherine had retired to Sarasota and continued her photographic business while marketing property in McClellan Park.

A longtime supporter of women's suffrage, McClellan gravitated into membership in the Sarasota Woman's Club. In 1921, she was chair of the club's legislative committee and organized a meeting in June to inform local women about the issues involved in county independence and the need for the recently enfranchised women to cast their votes in the June 15 referendum on county separation. After a successful business career and significant volunteer service to her community, Katherine McClellan died in September 1934.

BERTHA HONORÉ PALMER. The woman who transformed the Sarasota region into a dynamic center of business, tourism, and culture with a global reputation was born on May 22, 1849, in Louisville, Kentucky. Her parents, Eliza and Henry Hamilton Honoré, soon resettled in Chicago. Henry Hamilton Honoré became a successful real estate investor and developer. Bertha, the elder of two daughters, was educated in private Chicago schools and at the Convent of the Visitation just outside Washington, D.C. In 1870, she married real estate developer Potter Palmer, who presented her with his recently opened Palmer House Hotel as a wedding gift. After the Great Chicago Fire, he rebuilt the Palmer House, and the couple lived there for some years until Potter constructed the largest home in Chicago north of

downtown. Called "the Castle," the edifice became the social center of the city as Bertha quickly established herself as a society queen. In 1893, she headed the Women's Division of the World's Columbian Exposition and earned an international reputation as she and her board put together a great international exhibit of women's achievements.

After the world's fair, Bertha resumed her role as arbiter of Chicago society but extended her reach to purchasing an estate in Bar Harbor, Maine, and leasing a "cottage" amid the wealthy of New York in Newport, Rhode Island. After her husband died, Bertha inherited millions of dollars and began to spend more time in Paris and London, where she owned homes. She soon came to the attention of King Edward VII and became part of his social circle. Edward died in 1910, and Bertha began searching for a new challenge at age sixty-one. She saw an ad in the *Chicago Tribune* for citrus lands in the Sarasota district.

After visiting Florida, guided about by J.H. Lord and A.B. Edwards, Bertha began buying land, eventually owning 140,000 acres, nearly 220 square miles. For herself she developed a beef and hog ranch called Meadowsweet Pastures as well as a 350-acre estate she dubbed Osprey Point. She named her mansion the Oaks. But Bertha's ambitions went much further. With her sons, Honoré and Potter Jr., and her brother A.C. Honoré, she formed two corporations—the Sarasota-Venice Company and the Palmer Florida Company—to develop and sell her lands. She conceived the idea of agricultural communities of 10- and 20-acre farms where nonfarmers sick of city life could live by growing and selling vegetables and citrus. The Palmers did everything possible to help these settlers succeed. Among other things, they put in drainage systems, artesian wells, experimental farms and groves, roads every half mile, and a company town with a hotel, stores, and a sawmill. Bertha helped build churches and other structures that made former city dwellers more comfortable with the rural setting. In addition to all of this, Bertha launched the Boulevard Addition, a subdivision north of Sarasota, and Eagle Point Camp in Venice for rich families to get a chance to "rough it" without giving up too many luxuries.

As a result of Bertha's initiatives, thousands of new residents poured into the Sarasota district. Communities in the district grew in size, and new businesses opened to serve an expanding population. But this growth could not be sustained without new roads and bridges to accommodate the huge number of cars purchased after 1908, when the mass-produced Ford Model T was introduced. Almost from the moment Bertha arrived in Florida, she began to fight for more and better roads to connect her far-flung blocks of

land. In 1914 and 1915, she was very clearly behind the effort to create the Sarasota/Venice Roads and Bridges Special Bond District. She had become frustrated with the plodding and inept approach of the Manatee County Board of Commissioners to road needs in the Sarasota district. In 1915, when the commissioners continued to impede implementation of the bond district road-building program, Bertha asked one of her attorneys to find out how Sarasota could become a county in its own right. Nothing came of her inquiry, but she was among the first to suggest county division.

Bertha Palmer passed away several years before the movement for county separation really began. But her sons and her brother as well as allies like Edwards and Lord helped propel the drive for creating Sarasota County. Indeed, the plan for a Sarasota County freed from the interference of an increasingly jealous Manatee County was hatched in the Palmer Trust office in the City of Sarasota. Bertha died on May 5, 1918, at the Oaks. She lay in state at the Castle in Chicago before a procession through the streets of Chicago to Graceland Cemetery.

HONORÉ PALMER AND POTTER PALMER JR. These two men, the sons of Bertha and Potter Palmer, played important roles in the development of the Sarasota district and Sarasota County. Honoré was born in Chicago on February 1, 1874, educated at St. Mark's School, and graduated from Harvard in 1898. A man of wealth, he traveled abroad and belonged to the most exclusive clubs in Chicago He had early training as a banker but spent most of his life administering the vast real estate holdings amassed by his parents. He became particularly involved in managing the great Palmer House Hotel erected by his father. In 1903, he married Grace Greenway Brown of Baltimore.

In 1910, he accompanied his mother on her first trip to Sarasota. Like her, he made the area his winter home and with his brother built the estate called Immokalee near the mouth of Philippi Creek. He became an officer in both the Sarasota-Venice Company and the Palmer Florida Company and was actively involved in the development of Bertha's 140,000-acre empire.

Potter Palmer Jr. followed in the footsteps of his brother. Born in 1875, he also graduated from St. Marks and Harvard. He trained as a banker and then served as a director of the First National Bank of Chicago. He and his wife, Pauline Kohlsaat Palmer, were deeply interested in the Art Institute of Chicago, where he was a member of the board of directors for many years.

After Bertha died in May 1918, the Palmer brothers took full control of the Palmer estate, although they continued to rely heavily on the advice of their uncle Adrian until his death in 1926. Potter Jr. and his family left Immokalee to

his brother and took up residence in the Oaks, Bertha's home in Osprey. Potter also assumed control over the Castle on Chicago's Gold Coast, from where Bertha had presided over Chicago society for decades. The brothers, like their mother, understood the close connections between their real estate holdings and the need for good roads and bridges as well as railroads. However, their names never appeared on good roads committees. Rather, they worked through employees and allies such as J.H. Lord, Lamar Rankin, and A.B. Edwards to promote their goals. Usually, only Adrian C. Honoré's name appeared in the newspaper as representing Palmer corporate interests.

In the 1920s, the Palmer brothers initiated three important projects in the Sarasota area: the twelve-hundred-acre Hyde Park orchard, the eight-thousand-acre Palmer Farms development, and the Palmer Bank. These operations were in addition to the well-established Bee Ridge Farms and Osprey Farms developments, as well as the ongoing effort to sell land in Venice. Except for the bank, all of these operations relied on roads and railroads to bring settlers and investors to the area and to ship out crops of vegetables and citrus. The railroad issue was worked out when the Palmers negotiated a deal with the Atlantic Coast Railway Company to build an extension from Sarasota to Palmer Farms in Fruitville and then on to the Arcadia area to link up with other rail connections. But in the age of cars and big trucks, the Palmers knew that their properties would not achieve full value until they had access to a growing national road network. The Tamiami Trail and the cross-state highway were the roads they needed, and they supported all efforts to have them completed. Since the Palmers paid 50 percent of the real estate taxes in the Sarasota district and, later, the county, they had enormous influence on transportation decisions.

Honoré's and Potter's names also did not appear on the committees working for county separation. Once again, they used employees and allies to help make independence possible. They provided a place for the committees to meet as well as money and logistical support to the board of trade and its successor groups.

Potter Palmer Jr. died in 1943 of heart problems. Honoré took over the Palmer empire, although it continued to shrink in size as large parcels were sold off. In the 1950s, Honoré and Grace launched Meadowsweet Pastures Ranch north of the Tamiami Trail and south of Clark Road, named in honor of Bertha. They raised prizewinning purebred cattle. They also contributed handsomely to the recently established New College in Sarasota. Honoré died in 1964 at age ninety. After his death, the ranch was sold to developers, who created hundreds of homesites and dubbed the area Palmer Ranch.

WILLIAM YULEE PERRY. Although born in 1869 in Key West, Florida, Sarasota County's first judge lived in Chicago and pursued an interest in yachting. In 1910, he was commodore of the Columbia Yacht Club based at Randolph Street and the Chicago River. A few years later, he became president of the Chicago Yacht Club. He also was president of the Illinois Athletic Club, an exclusive men's association. In 1917, at age forty-eight, he graduated from Chicago-Kent College of Law and soon relocated to Sarasota, where he set up a law practice. In 1920, he became a board member of the Sarasota Board of Trade. Not long after that, the group reorganized as the Sarasota Chamber of Commerce, and Perry was named as its attorney. He became a member of the General Committee on County Division and in April 1821 was responsible for reviewing and assessing the bill on county independence that group intended to submit to the Florida Senate.

When the bill stalled because of opposition from northern Manatee County interests, Perry was appointed to the Committee of 10 to negotiate with the bill's opponents in Bradentown in April 1921. At a mass meeting in that city, Perry gave a powerful address forcefully laying out the Sarasota district's grievances and its unshakeable intent to be a separate county. As a result, Perry played a key role in reaching a settlement with the Bradentown businessmen. As a principal author of the revised Sarasota County bill, he led a three-member Sarasota group, who, with three Bradentown leaders, traveled to Tallahassee to present the new draft bill to the legislature, which swiftly approved it. Perry then returned to Sarasota and joined A.B. Edwards, Otis Landers, and John Burket in touring the Sarasota district, urging citizens to approve the plan for separation. The chamber of commerce Committee on County Division recommended to Governor Hardee that Perry be named Sarasota County's first judge. In that role, he was responsible for organizing the court's operations but faced problems in getting the Manatee County judge to transfer key information on current legal cases. Perry died in 1924 while still in office. He was replaced by Paul C. Albritton. Perry and his wife, Elizabeth, who continued to live in Sarasota until her death in 1942, are buried in Rosemary Cemetery.

GEORGE B. PRIME. Furniture and hardware merchant George Prime was born in Albert Lea, Minnesota, on March 12, 1880, grew up in Bradentown, and attended Rollins College in Winter Park. In 1900, he and his new wife, Kate, moved to Sarasota, where he became a partner in a general mercantile business. Later, he gave this up to operate a coastal schooner, but by 1909, he was again in retail selling groceries and hardware. In the 1920s, he added

real estate sales to his list of activities while also serving as a director of three local banks. Prime was a Mason and a former grand master of Lodge no. 147 as well as a trustee of the First Presbyterian Church. He was also a member of the Sarasota County Democratic Party Executive Committee and served three terms on the Sarasota town council.

Prime always had a fascination with cars and roads. In 1912, he purchased a Ford Touring Car with a twenty-horsepower engine. Eight years later, he was part of a Sarasota-Bradentown delegation that went to Tampa to ask the Tampa Wholesale Grocers to lobby its county commission to repair the nearly impassable Hillsborough portion of the Bayshore Road. Prime was a passionate supporter of good roads and also threw himself into the fight for county independence, perhaps hoping county separation would lead to faster progress on building the Sarasota district's road system. He was appointed a member of the General Committee on County Division by the second mass meeting in 1921 and then became part of the Committee of 10, sent by the Sarasota Chamber of Commerce to find a way to end Bradentown's opposition to county separation. After the governor signed the Sarasota County bill, Prime actively campaigned throughout the Sarasota district on behalf of public approval of independence.

Prime was one of the few major leaders of the county division movement not appointed to one of the new county offices. However, from 1921 to 1925, he worked tirelessly to have the Tamiami Trail and the cross-state highway completed. In 1923, he was a member of the Tamiami Trail Blazers, a group of twenty-five men with ten automobiles. With the help of two Seminole guides, the caravan followed the proposed route of the Tamiami Trail across the Everglades. Prime was the first of the group to make it through the swamps to reach Miami, although he did so on foot. Later, he went back, freed his car from the mud, and completed the trip. The audacity of the Trailblazers rekindled interest in the Tamiami Trail project, and work soon resumed. In 1925, Prime was elected to the Sarasota Board of County Commissioners and served as chairman in both 1925 and 1926. During his term, plans for the new courthouse were adopted and construction began. As chairman, he secured public approval of the 1925 $1.5 million comprehensive road and bridge plan for Sarasota County. Prime also used his position to push his two favorite road projects, the Tamiami Trail and the cross-state highway. In 1927, he was one of the first motorists to drive the cross-state highway, or Sarapalmbee Trail as it was known, from Sarasota to West Palm Beach. In 1928, he was part of the first caravan of cars to drive the entire length of the Tamiami Trail

from Tampa to Miami. George Prime left Sarasota in 1928 for Clayton, Georgia, where he worked as a realtor until his death in September 1953. He is buried in Roane Cemetery there.

HENRY LAMAR RANKIN. Rankin, who usually preferred his middle name, was born in 1882 in Atlanta, Georgia. A 1902 Harvard graduate, he became Bertha Palmer's ace real estate salesman. His great achievement was a successful national campaign to sell ten- and twenty-acre farms in Bee Ridge Farms, Bertha's path-breaking eight-thousand-acre planned agricultural community. She later used him in a vain effort to salvage her Tampa development efforts and her even less successful plan for Venice. He represented her in developing a golf club in Venice. By 1914, she had asked him to work with A.B. Edwards and Harry Higel to create the Sarasota/Venice Special Roads and Bridges Bond District. As part of this assignment, he joined Joseph H. Lord in touring other communities in Florida to study the effectiveness of various types of paving materials. In 1915, he was placed on the Special Committee on Roads established by the Commercial Club, successor to the first Sarasota Board of Trade, to work with the Manatee Board of County Commissioners on gaining approval for the special bond district. After Bertha's death in 1918, Lamar and his wife, Jesse, moved to Tampa, where he became president of Lamar Rankin and Company Real Estate. That he was successful in this enterprise is perhaps revealed by the estimated $45,000 value of his home in Hyde Park, Hillsborough County. He died in 1953 and is buried in Oakland Cemetery in Atlanta.

FRANK REDD. The Redd family roots were in Bee Ridge and Fruitville, but Redd himself was a lifelong resident of Sarasota. Like so many other leaders of the good roads and county division battles, Redd was a Mason and a past grand master of Lodge no. 147. He was an attorney who also dabbled in real estate. He joined the Sarasota Board of Trade and became secretary of its successor organization, the Commercial Club, in 1915. In 1920, Redd was named to the General Committee on County Division. The chamber's Committee on County Separation nominated him to Governor Cary Hardee for the post of Sarasota County's first prosecuting attorney in 1921. He held the job for only a year or so, not choosing to run in the 1922 election. In the 1930s, Redd brought national attention to himself when he represented Pluma Palmer, the estranged wife of D'Orsay Palmer, son of Honoré Palmer and grandson of Bertha Palmer, in a messy estate case. Redd died in October 1958.

VICTOR A. SAUNDERS. Vic Saunders owned a store and managed the local post office in Osprey, a short distance from Bertha Palmer's magnificent estate, Osprey Point. Saunders was a respected member of the small community and very involved in civic improvement projects. In 1915, the Commercial Club in Sarasota asked Saunders to represent Osprey in supporting the campaign for the Sarasota/Venice Special Roads and Bridges Bond District, an assignment he accepted. Because of his local influence, Saunders was also invited in 1921 to join the General Committee on County Division by those attending the second mass meeting in Sarasota. He took an active interest in the committee's work and journeyed to Sarasota to join in the great celebration when the legislature approved the county separation bill. Saunders died in 1940.

WILLIAM MILTON TUTTLE. Tuttle has a Sarasota thoroughfare named in his honor but otherwise seems to have largely disappeared from Sarasota history. Yet he was a noted figure in the fight for good roads and bridges as well as county independence. Born in Monticello, Kentucky, in 1869, he was educated as a civil engineer. He first appears in the *Sarasota Times* as a vice-president of the West Coast Realty Company, of which Franklin Dean was president. Dean was also a key leader in Sarasota. Tuttle was given the job of inspecting and supervising the work of constructing the roads and bridges authorized by the Sarasota/Venice Special Roads and Bridges Bond District plan.

In June 1920, Tuttle became a member of the General Committee on County Division appointed at the second mass meeting. He was immediately made chair of the boundaries subcommittee charged with defining the areas to be included in the new Sarasota County. Tuttle's committee proposed a northern boundary between Townships 35 and 36 that later became the primary matter of dispute with Manatee County and nearly derailed the county separation movement. In September 1920, Tuttle was a member of the joint Bradentown-Sarasota delegation dispatched to Tampa to lobby business leaders to seek improvements in the Hillsborough portion of the Bayshore Road. Around this time, he became a board member of the Sarasota Board of Trade. After Sarasota became a county, the county commissioners named Tuttle to a delegation to persuade State Highway Commission officials to designate the currently planned routes of the Tamiami Trail and the cross-state highway as state roads. The highway commission agreed, thus frustrating Bradentown's dreams of altering the routes of those roads to its advantage and Sarasota's disadvantage. This was

an important victory for Sarasota and a vindication of the decision to split from Manatee County. Despite his many important services to Sarasota, Tuttle was not named to one of the new county offices. He died in Sarasota in 1925 and is buried in Kentucky.

FRANCIS A. "FRANK" WALPOLE. Frank Walpole provided the Sarasota district with important experience in county government, a broad association with Florida political leaders, and general political "smarts." Born in Richland, Tennessee, in 1872, Walpole enjoyed a long career in journalism, including stints as editor of the *Tampa Herald*, *Palmetto Journal*, and *Manatee Record*. Walple brought passion to his newspaper work and was called the "fiery red-haired editor."

In 1907, he served as Manatee County treasurer. By 1916, he and his wife, Ruby, had relocated to Sarasota and were running the Red Cross Drug Store on lower Main Street. He also held the post of chair of the Manatee County Democratic Party Executive Committee at a time when there was no Republican Party to speak of and Democratic Party primary elections were the only ones that counted. Walpole was also a Mason and a board member of the Sarasota Board of Trade and later of the Sarasota Chamber of Commerce, where he chaired the Good Roads Committee.

In June 1920, Walpole was not one of the original members of the General Committee on County Division but was subsequently added to the roster and immediately became quite active both on road and bridge issues and county division. In January 1921, he ran for and won the seat on the Manatee County Board of County Commissioners representing the Sarasota district, thus becoming the last individual to hold that position. It was certainly an odd arrangement in which a leader of the separation movement now served on the governing board of the county he was trying to break apart. Walpole was not selected to be a member of the Committee of 10 dispatched to negotiate a settlement with Manatee County or the subcommittee sent to present a modified county separation bill to the legislature. But he was in Tallahassee, likely lobbying behind the scenes. After Governor Cary Hardee signed the Sarasota County bill, he gave the pen to Walpole, who witnessed the event. Walpole also sent first news of the signing by telegram to Rose Phillips Wilson, the *Sarasota Times* editor.

When Hardee made his appointments of temporary officers for the new county, he named Walpole to the first district seat of the Sarasota County Board of County Commissioners upon recommendation of the Sarasota Chamber of Commerce Committee on County Division. At the

first meeting of the county board, Walpole, as the only commissioner with experience, was made chair. Under his leadership, the county commission established a working government; overcame opposition from Manatee County to providing court documents, tax records, and many other essential documents; dealt with the aftermath of the Great Hurricane of 1921; and made progress on road and bridge planning and building. Walpole worked particularly hard on moving the Tamiami Trail and cross-state highways to completion. But there were problems and missteps by the new government, and Walpole, among others, was rejected by the voters in the election of 1922. He remained active in business and the Democratic Party until his death in 1927 at age fifty-six. He is buried in Manasota Memorial Park in Manatee County.

AUGUSTUS MARION WILSON. A.M. Wilson was born in Thorn County, Georgia, on December 26, 1850. He married Caledonia Crum in December 1868 and a few years later migrated to Miakka, a small community near the Myakka River in Manatee County. He grew citrus and became a major cattleman in the area. He also established a general store and served as the local postmaster for some thirty years. Despite these commitments, as well as raising twelve children with his wife, Wilson was very active in governmental affairs, serving three terms in the lower house of the Florida Legislature and one term in the senate. He also was elected to one term on the Manatee County Board of Commissioners and four terms on the Manatee County School Board. In addition, he was Manatee County tax collector for two years and a federal Indian agent for one year.

At the time of the organization of the movement for county division, Wilson was nearly seventy years old, but he threw himself into the fight to create the new Sarasota County, where his hometown of Miakka would be located. In June 1920, he was already a director of the board of trade and then was selected as one of the twenty-five members of the General Committee on County Division by the second mass meeting. The committee sent him to Tallahassee to begin lobbying the legislature in April 1921. After the committee's bill was drafted and approved by another mass meeting in Sarasota, four copies were sent to Wilson with instructions to submit the bill in the senate. Wilson did this and then reported back to his Sarasota colleagues that his communications with legislators suggested there would be little opposition to the bill. It appears he had not been talking to the right people. A ferocious opposition quickly materialized in northern Manatee County, particularly in the Bradentown area. Carloads of leading citizens

from both Bradentown and Sarasota immediately left for Tallahassee to lobby against or for the bill. In the hearing before the state senate committee, Wilson and other Sarasotans testified for the bill, but the senator representing the Manatee County area refused to endorse the legislation, while the state representative from the county flatly opposed it. The senate committee reported the bill out but with no recommendation. This, in effect, left the issue in limbo with time running out and the legislature about to disband. Wilson was not part of the negotiations between the Sarasota Chamber of Commerce and the Bradentown Board of Trade to work out their differences, as he had remained in Tallahassee. When the joint committee of the two trade organizations arrived at the state capital with a revised bill on county division, Wilson shepherded it through both houses, where no one voted against it.

The chamber of commerce nominated him to Governor Hardee for appointment as Sarasota County's first tax collector, a job he had once held in Manatee County. He served until 1922. During his brief term, he was sent, along with Lawrence L. May and William Tuttle, to meet the Florida Highway Commission in September 1921. The three, along with a delegation from Charlotte County, convinced the highway commission to resist efforts by Manatee County to change the routes of the Tamiami Trail and the cross-state highway. The commission endorsed the existing plans and made both roads state highways. A.M. Wilson died at age eighty on October 8, 1931, and is buried at Old Miakka.

ROSE PHILLIPS WILSON. Mrs. C.V.S. Wilson never publicly used her first or maiden names until she became the first woman in Sarasota to register to vote, and then only because the voter registration law required her to do so. Rose Wilson was an interesting and dynamic woman who deeply influenced the world around her. She was the second wife of Cornelius Van Santvoord Wilson, who had been born in 1837. He married Rose in 1898 after his first wife died of yellow fever. Rose was expected to raise his six children and assist him in publishing the *Manatee County Advocate*. C.V.S. Wilson moved his family to Sarasota in 1899 and began issuing a new paper, the *Sarasota Times*. Wilson was a civic-minded publisher who used his newspaper to support progressive ideas in the small fishing village that was Sarasota at the end of the nineteenth century. Rose Wilson worked hard to fulfill her duties as a stepmother and as her husband's partner in getting out the weekly publication. Cornelius died in 1910, and Rose became the sole proprietor of the *Sarasota Times*. She assumed full ownership at the very

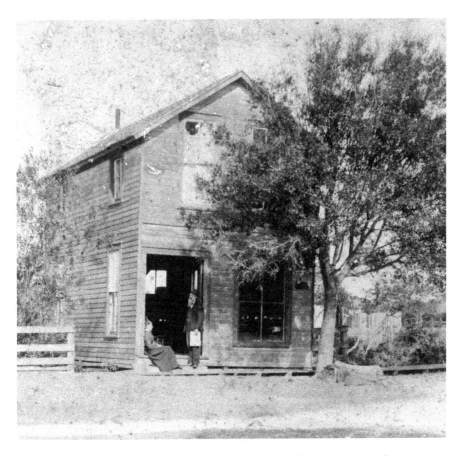

Rose and C.V. Wilson pictured in front of the first Sarasota Times Building in Sarasota, circa 1905. *By permission of Sarasota County Historical Resources.*

moment that perhaps the greatest news story in Sarasota's history to that time occurred. In February 1910, Mrs. Potter Palmer of Chicago stepped off her private Pullman car at the Seaboard Air Line Railway station in Sarasota. The millionairess and global personality was greeted by A.B. Edwards. Bertha Palmer was known to kings, queens, European nobility, and American political and social leaders because of her role as president of the Board of Lady Managers at the World's Columbian Exposition held in Chicago in 1893.

Rose Phillips recognized instantly that Bertha Palmer was going to be Sarasota's greatest asset. She covered in great detail the great lady's purchase of 140,000 acres, the building of her 350-acre estate called Osprey Point, the innovative developments at her planned agricultural communities, and

her transformation of the Sarasota district's transportation infrastructure. Wilson also appreciated the importance of Bertha Palmer as one of the world's leading supporters of women's rights, particularly the right to equal pay for equal work. Like Bertha Palmer, Rose Wilson was a charter member of the Sarasota Woman's Club.

The famous and rich Bertha Honoré Palmer infused money, energy, and vision into the Sarasota district. Rose Wilson understood that Palmer had lifted Sarasota to a new level and opened thrilling possibilities for the future. She embraced the electric environment created by Palmer's investments and her ceaseless international boosting of the Sarasota region. Economic and population growth remade Sarasota and all the other communities in the Sarasota district. And Rose Wilson and the *Sarasota Times* were the heralds of this new age. It was an expansive time, and Rose championed every progressive idea she came across and cheered, as she put it, "THE MEN WHO DO THINGS." Her paper from beginning to end was an advertisement for the Sarasota district, inviting tourists, settlers, and investors to become part of the evolving Sarasota story.

Aside from the short-lived *Sarasota Sun* edited by Rube Allyn, there were no other newspapers in the Sarasota district, so Rose's voice and views had an outsized influence on policy. Wherever one lived in the Sarasota district, a subscription to the *Sarasota Times* was the only way to find out what was happening. Rose enlisted correspondents in many of the smaller communities to write weekly columns on people and events. One of these contributors for many years was George Higel, brother of the slain Harry Higel. Writing under the pseudonym Nemo, Higel reported on the Venice/Nokomis area with wit and insight.

Rose reached the peak of her influence when she backed the plan to establish the Sarasota/Venice Special Roads and Bridges Bond District. When the Manatee County Board of Commissioners dithered and delayed construction of the roads and bridges, she was caustic in her criticism. Her news and editorial columns stressed to her readers the importance of good roads and bridges if Sarasota was to reach its full potential. She was delighted to report in June 1920 that plans were afoot to seek independence from Manatee County. In this period, she not only became the first woman to register to vote under the newly adopted Nineteenth Amendment but also one of the first two women chosen for director positions on the Sarasota Board of Trade, which was soon renamed the Sarasota Chamber of Commerce. Very soon, she was promoted to the executive committee of this powerful organization. In issue after issue of the *Sarasota Times*, Rose

pressed women to register, to learn about the issues, and, above all, to vote. She made no secret of how she thought women, and men as well, should vote on June 15, 1921, on the question of ratifying the legislation creating Sarasota County.

After the Sarasota district voted for independence, Rose celebrated by renaming her paper the *Sarasota County Times* and printed the headline "HURRAH FOR SARASOTA COUNTY!" She defended the new Sarasota County government against criticism and publicized its triumphs. But as Sarasota County entered the period of the great Florida land boom, when new buildings soared and new titans of commerce and real estate emerged, Rose obviously concluded that her work was completed; she sold the paper in 1922. She died in 1964 and is buried in Manasota Memorial Park beside her husband.

THOMAS W. YARBOROUGH. Yarborough, Sarasota County's first superintendent of public instruction, was born in Oxford, Georgia, in 1869. Yarborough graduated from Atlanta's Emory University and later attended the University of Florida. He taught school in Georgia, Alabama, and Louisiana before becoming principal of Sarasota High School in 1907. He joined the board of trade and chaired an important public meeting in 1913 dealing with the need to complete the Bayshore Road. From 1918 to 1921, he worked in the schools of Mulberry, Florida.

Yarborough was not involved in the political contest over county separation, but the Sarasota Chamber of Commerce Committee on County Division nominated him to be the superintendent of public instruction in Sarasota County. Yarborough accepted and returned to Sarasota in time to take up his duties on July 1, 1921. He and the members of the school board faced important challenges. There were generally too few schools in the county, particularly for black students. Moreover, Yarborough inherited a $100,000 debt as part of the arrangement to free Sarasota from Manatee County. By careful management and some outside help from the Julius Rosenwald Fund to construct the first school for African American students in Sarasota, Yarborough was able to put the school system on a solid footing. Yarborough was elected as superintendent every two years until his retirement on January 1, 1945, thus holding the office for nearly twenty-four years. He died on February 26, 1946.

NOTES

CHAPTER 1

1. Telegram, John F. Burket to Rose Wilson, March 18, 1921, and telegram, Francis Walpole to Wilson, May 5, 1921. Vertical File, Sarasota County Historical Resources; *Sarasota Times*, May 12, 1921; *Sarasota County Times*, June 16, 1921.
2. La Hurd, *Sarasota: A History*, 33–34.
3. Grismer, *Story of Sarasota*, 86; Janet Snyder Matthews, *Venice: Journey from Horse and Chaise* (Sarasota, FL: Pine Level Press, 1989), 119–120.
4. Grismer, *Story of Sarasota*, 92–100; La Hurd, *Sarasota*, 13–23.
5. Grismer, *Story of Sarasota*, 101–154; La Hurd, *Sarasota*, 24–32; Cassell, *Suncoast Empire*, 72–73.
6. Matthews, *Venice*, 141–143; Grismer, *Story of Sarasota*, 47–57; Cortes, *History of Early Englewood*, 7–91.
7. Cassell, *Suncoast Empire*, 69–74; La Hurd, *Sarasota*, 21–23; Grismer, *Story of Sarasota*, 101–154.
8. Matthews and Mansberger, *Mrs. Potter Palmer*, 7, 14; Ross, *Silhouette in Diamonds*, 40–66; Weimann, *Fair Women*, 10.
9. Cassell, *Suncoast Empire*, 33; Weimann, *Fair Women*, 16.
10. Weimann, *Fair Women*, 96–107, 139; Ross, *Silhouette in Diamonds*, 59–60; Cassell, *Suncoast Empire*, 45–47.
11. Ross, *Silhouette in Diamonds*, 190–196, 211–221; Kalmbach, *Jewel of the Gold Coast*, 81–82.

12. *Chicago Sunday Tribune,* January 23, 1910; Ross, *Silhouette in Diamonds,* 220–221; Cassell, *Suncoast Empire,* 63.

13. Grismer, *Story of Sarasota,* 305–306; La Hurd, *Sarasota,* 146–147.

14. La Hurd, *Sarasota,* 24–26.

15. Grismer, *Story of Sarasota,* 300–302; La Hurd, *Sarasota,* 142.

16. Cassell, *Suncoast Empire,* 76–77; Matthews, *Venice,* 179–181.

17. *Sarasota Times,* December 14, 1915; reprinted from *Tampa Tribune*; Grismer, *Story of Sarasota,* 170–176.

18. Grismer, *Story of Sarasota,* 273–274.

19. Ibid.

20. Cassell, *Suncoast Empire,* 194; Matthews, *Venice,* 189–190.

21. Cassell, *Suncoast Empire,* 101–103; *Sarasota Times,* July 19, October 22 and November 5, 1914.

22. There were 78,000 automobiles in the United States in 1905. By 1915, that number had grown to 2.33 million and three years later rocketed to 5.5 million. See *America's Highways,* 51–53.

23. *America's Highways,* 40–42, 91–97.

24. Kendrick, *Florida Trails to Turnpikes,* 8–11.

25. *Sarasota Times,* October 9, November 6, 1913; Cassell, *Suncoast Empire,* 89–90.

26. Cassell, *Suncoast Empire,* 133–155.

27. *Sarasota Times,* November 13 and December 14, 1913.

28. Ibid., November 13 and December 14, 1913, and March 30, 1915.

29. Ibid., March 17, 20, 30 and May 26, 1914.

30. Ibid., May 12, 19, 1914.

CHAPTER 2

31. Matthews, *Venice,* 192.

32. *Sarasota Times,* August 13, 1914; Grismer, *Story of Sarasota,* 300–306; Cassell, *Suncoast Empire,* 173–174, 188; Copy of "Broadside to the Voters of the Sarasota Roads and Bridges District" by Lamar Rankin, Member of the Good Roads Committee, March 1915, in Bertha Honoré Palmer Papers, Sarasota County Historical Resources (hereafter SCHR); Adrian C. Honoré to Bertha Honoré Palmer, March 10, 1915, in Bertha Honoré Palmer Papers, SCHR.

33. John H. Allen to A.B. Edwards, January 16, 1915, A.B. Edwards Papers, SCHR; *Sarasota Times*, September 3 and 10, August 14, and October 22, 1914.

34. *Sarasota Times*, October 22 and December 3, 1914.

35. Ibid., December 3 and 17, 1914.

36. Franklin P. Dean to A.B. Edwards, December 15, 1914; Thomas A. Albritton to Edwards, December 21, 1914; Dr. F. William Schultz to Edwards, December 1914; W.B. Webb to Edwards, December 17, 1914; Charles T. Curry to Edwards, December 16, 1914; Lamar Rankin to Edwards, December 17, 1914, A.B. Edwards Papers, SCHR.

37. LaHurd, *Sarasota*, 92, 123; Grismer, 301, 309; *Sarasota Times*, March 11, 1915, June 24, 1920.

38. *Sarasota Times*, January 7, 21, February 4, 11, 18, and March 4, 11, 15, 18, 1915; *Manatee River Journal*, February 14 and March 1, 1915.

39. *Sarasota Times*, August 19 and November 4, 1915.

40. Ibid., November 4, 1915; James W. Ponder to Bertha Honoré Palmer, March 18 and April 10, 1915; A.C. Honoré to Bertha Honoré Palmer, March 10, 1915, Bertha Honoré Palmer Papers, SCHR; Matthews, *Venice*, 193; "Broadside to the Voters of Sarasota Roads and Bridges District," Lamar Rankin, March 1915, op. cit.

41. *Sarasota Times*, November 18 and 25, 1915.

42. Ibid., November 25 and December 8, 1915.

43. Ibid., January 6 and 20, 1916.

44. Ibid., January 11 and 20, February 24, 1916; Matthews, *Venice*, 193–194.

45. *Sarasota Times*, May 25, 1916.

46. Ibid., June 15, July 20, and October 5, 26, 1916; January 25, 1917; *America's Highways*, 80; Kendrick, *Florida Trails to Turnpikes*, 8–11, 15.

47. *America's Highways*, 91–92.

48. *Sarasota Times*, June 21 and September 16, 20, 1917.

49. *Sarasota Times*, November 21, 1918, and January 9, 1919. African Americans composed a significant percentage of the workforce building the roads. Moreover, an African American inventor, Henry Clifford Webb of Bradentown, patented a special plow in 1918 that cut through tough palmetto roots, thus easing the task of clearing the route of the Sarasota-Venice Road. See Matthews, *Venice*, 203–204.

50. *Sarasota Times*, August 14, 21 and November 20, 1919, January 22 and February 12, 1920.

51. *America's Highways*, 103–104.

CHAPTER 3

52. Grismer, *Story of Sarasota*, 199.

53. The seven counties formed in Florida in 1921 were Charlotte, Dixie, Glades, Wauchula, Highlands, Union, and Sarasota. Sarasota was designated as the sixtieth county. See Sarasota County historian Ann Shank, "The Creation of Sarasota County," typescript, February 16, 2006, SCHR.

54. *Sarasota Times*, June 17, 1920.

55. Ibid., June 17, 1920; Shank, "Creation of Sarasota County"; Grismer, *Story of Sarasota*, 199.

56. *Sarasota Times*, June 17, 1920.

57. Ibid., June 24, 1920.

58. Ibid.

59. Ibid.

60. Ibid.

61. *Sarasota Times*, July 1, 8, 1920.

62. Ibid., July 29, 1920.

63. *Manatee River Journal*, August 19, 1920; *Sarasota Times*, August 19, 1920.

64. *Sarasota Times*, August 19 and September 2, 1920.

65. Ibid., September 19, 1920.

66. Grismer, *Story of Sarasota*, 300–302; Cutler, *History of Florida*, 301–302; La Hurd, *Sarasota*, 142.

67. *Sarasota Times*, September 9, 1920.

68. Ibid.

69. Ibid.

70. Ibid., September 16, 1920.

71. Ibid., September 4, November 4, and 25, 1920.

72. Ibid., November 25, 1920.

73. Ibid., October 29, 1920; January 6, 1921; *Manatee River Journal*, January 13, 1921.

74. *Sarasota Times*, January 20, 27, March 3, and April 4, 8, 1921.

75. Grismer, *Story of Sarasota*, 303.

76. *Sarasota Times*, March 10, 31, 1921.

CHAPTER 4

77. *Sarasota Times*, March 21, 1921.

78. Ibid., April 14, 1921.

79. *Manatee River Journal*, April 21, 1921.

80. Ibid.; La Hurd, *Sarasota*, 150–151; Cassell, *Suncoast Empire*, 111–112; Grismer, *Story of Sarasota*, 151; *Manatee River Journal*, June 23, 1921.

81. *Sarasota Times*, April 21, 1921.

82. Ibid., April 28, 1921.

83. Ibid.

84. Ibid.

85. Ibid., May 5, 1921; *Manatee River Journal*, May 5, 1921.

86. Ibid.

87. *Manatee River Journal*, May 5, 1921.

88. *Sarasota Times*, May 12, 1921.

89. Ibid.; Western Union Telegrams, John Burket to Rose Wilson, 7:00 p.m., May 12, 1921, and Frank Walpole to Wilson, May 12, 1921. Vertical File, SCHR.

90. *Sarasota Times*, May 12, 1921.

91. Ibid., May 12, 19, 1921.

92. John McCarthy, Speech on Bee Ridge history to the Manasota County Historical Society, November 19, 1997, Collection MCHS-3-0398, Manatee County Public Library Systems Digital Collection. See also Shank, "Creation of Sarasota County", op. cit.; Grismer, *Story of Sarasota*, 200; La Hurd, *Sarasota*, 54.

93. *Sarasota Times*, June 17 and August 26, 1915; *Manatee River Journal*, June 17 and July 1, 1915.

94. *Sarasota Times*, April 21 and June 2, 1921.

95. M.T. McInnis, "Forgotten Communities of Manatee County," speech to Manatee Historical Society, February 23, 1967. Systems Digital Collection, Manatee County Public Library. According to McInnis, James Waterbury platted and recorded his tract in 1919, while the town of Waterbury was laid out and platted in 1920. His ten thousand acres covered six square miles in Township 35. See also a pamphlet, *A Waterbury Grapefruit Grove for Investment* in the University of Florida George Smathers Library Digital Collections; pamphlet, *The Waterbury System Schools* by the Waterman-Waterbury Company of Minneapolis, Minnesota, in *Minnesota Reflections*, historical collections, Hennepin County Library; Historical Records,

Library of Manatee County, Plat Book 2, page 37 of the Public Records of Manatee County; letter to the editor of *Medical World* 35 (February 1917), Philadelphia, Pennsylvania, 37.

96. *Sarasota Times*, May 19, 26 and June 2, 1921.

97. Ibid., May 19, 26, 1921. The Florida Legislature set the poll tax rate at two dollars in 1888.

98. Ibid., May 19, 1921.

99. Ibid., May 26, 1921.

100. Ibid., June 2, 1921.

101. Ibid.

102. Ibid., June 9, 1921.

103. Ibid.

104. Ibid.

105. Ibid.

106. Ibid.

107. *Manatee River Journal*, June 16, 1921; *Sarasota County Times*, June 16, 1921.

108. *Sarasota County Times*, June 16, 25, 1921.

Chapter 5

109. Cary Augustus Hardee, Florida Governors, Florida Department of State, dos.myflorida.com.

110. *Sarasota County Times*, June 23, 1921.

111. Grismer, *Story of Sarasota*, 323; *Sarasota Times*, September 9 and November 16, 1920; *Sarasota County Times*, June 23, 1921.

112. *Sarasota Times*, June 24, September 16, and November 4, 1920, April 28, 1921; *Sarasota County Times*, June 23 and 30, September 9, 1921; Cortes, *Early Englewood*, 89–90.

113. *Sarasota Times*, June 24, 1920; April 21, 1921; *Sarasota County Times*, June 23, June 30, 1921; Grismer, *Story of Sarasota*, 262.

114. *Sarasota Times*, November 4, 1920, and April 14, 1921; *Sarasota County Times*, June 16, 1921; Grismer, *Story of Sarasota*, 262.

115. *Sarasota Times*, October 9, 1913; *Sarasota County Times*, June 23, 30, 1921.

116. *Sarasota Times*, November 4, 1920 and April 14, 1921; *Sarasota County Times*, June 16, 23, 1921; Grismer, *Story of Sarasota*, 262.

117. *Sarasota Times*, June 24, 1920, and April 1, 1921; *Sarasota County Times*, June 23 and September 9, 1921; Grismer, *Story of Sarasota*, 299.

118. *Sarasota Times*, March 11, 1915, and June 24, 1920; *Sarasota County Times*, June 23, 1921: Robert M. Snell, *From Shield to Star* (Sarasota, FL: Coastal Printing, 1999), 2–10.

119. Grismer, *Story of Sarasota*, 305; *Sarasota Times*, November 24, 1914, January 14, 1915, November 16, 1916, June 24 and November 4, 1920; *Sarasota County Times*, June 21, 1921.

120. Sarasota County Commissioners Minutes, June 23, 1921, microfilm, Office of the Clerk of the County Court, Sarasota County Administration Building, City of Sarasota. Hereafter referred to as County Commissioners Minutes.

121. Ibid., June 29 and July 2, 1921.

122. Ibid., July 5, August 21, and October 3, 18, 20, 1921; *Sarasota County Times*, August 11, 1921; Grismer, *Story of Sarasota*, 203–205.

123. County Commissioners Minutes, October 3, 1921 and November 11, 1922; *Sarasota County Times*, January 15, 1922.

124. County Commissioners Minutes, November 7, 23 and December 12, 21, 1921.

125. Ibid., November 7 and December 5, 21, 1921.

126. Ibid., November 10, 1921, and January 22, 1922.

127. *Sarasota County Times*, November 10, 1921.

128. Ibid., August 11, 18, September 8, 1921; January 5, 12, 26, February 2, 9, March 2, 9, and April 6, 12, 1922.

129. County Commissioners Minutes, July 5, 28, August 8, 18, and September 5, 1921.

130. Ibid., November 14, 1921.

131. *Sarasota County Times*, September 8, 1921 and April 12, 1922.

132. Ibid., September 8, 1921.

133. Ibid., February 2 and March 2, 1922.

134. Ibid., April 12 and May 1, 1922.

135. Ibid., April 27, 1922.

136. Ibid., May 7, 1922.

137. County Commissioners Minutes, March 22, 1921.

138. *Sarasota County Times*, July 6, 1922.

139. Ibid., June 8, 1922.

140. Ibid.; Grismer, *Story of Sarasota*, 230.

141. *Sarasota County Times*, June 8, 1922.

142. County Commissioners Minutes, September 16, October 10, and December 21, 1921.

143. *Sarasota County Times*, June 8, 1922.

144. Ibid., January 24, June 19 and October 16, 1924; County Commissioners Minutes, October 30 and December 3, 1923.

145. *Sarasota County Times*, August 24 and September 7, 1922.

146. Ibid., September 7, 14; Grismer, *Story of Sarasota*, 308–309.

147. *Sarasota County Times*, September 14, October 26, 1922; Cassell, *Suncoast Empire*, 207–237.

148. La Hurd, *Sarasota*, 183–197.

149. *Sarasota County Times*, December 28, 1922, February 8, March 15, and April 12, 1923.

150. Ibid., May 8 and 22, 1924.

151. Ibid., October 16, November 6, 1924.

152. Ibid., January 17, 21, 24, 1924.

153. Ibid., May 8, 1924.

154. Ibid., June 19, 1924.

155. Ibid., June 19 and September 14, 1925; La Hurd, *Sarasota*, 183; Grismer, *Story of Sarasota*, 308–309.

156. Sarasota County Board of Commissioners Minutes, June 20, 1925.

157. *Sarasota County Times*, January 14, 1922.

158. Ibid.

CHAPTER 6

159. *Sarasota County Times*, October 23, 1924.

160. Ibid., August 27 and October 16, 1924; Matthews, *Venice*, 233–248; La Hurd, *Sarasota*, 52; the Board of County Commissioners Minutes for 1924 have been lost. See Lane, "Tracking the Sarasota County Courthouse," 63–78.

161. County Commissioners Minutes, March 30, 1925; Sarasota County Courthouse Nomination Proposal (1984): National Register of Historic Places, 7: In State of Florida Department of State, Division of Archives, History, and Records Management; *Sarasota County Times*, December 31, 1924.

162. La Hurd, *Sarasota*, 52, 74.

163. County Commissioners Minutes, April 20, June 25, August 17 and 19, and September 23, 1925; Sarasota County Board of County Commissioners, Resolutions, microfilm, Offices of Sarasota County Clerk of the Circuit Court, September 25, 1925.

164. County Commissioners Minutes, September 23, 1925; *Sarasota County Times*, April 12, 1925.

165. La Hurd, *Sarasota*, 53; William W. Rogers, "Fortune and Misfortune, the Paradoxical 1920s" in Gannon, *History of Florida*, 303.

166. *Sarasota Daily Times*, December 16, 18, 21, 1925.

167. Wynne and Moorhead, *Paradise for Sale*, 141–150; *Sarasota Daily Times*, December 6, 1925.

168. *Sarasota Herald*, May 13, 1926.

169. Ibid.; Lane, "Tracking the Sarasota County Courthouse," 73.

170. *Sarasota Herald*, May 13, 1926.

171. Ibid., December 15, 1926; Jeff La Hurd, "Sarasota Courthouse" in *Sarasota Magazine* (May 2000): 207–209.

172. *Sarasota Daily Times*, October 16 1924.

173. Sarasota County Courthouse Historical Marker, Sarasota County Historical Commission, 2002; *Sarasota Herald-Tribune*, June 17, 2017.

174. *Sarasota Herald*, February 25, 1927.

175. *Sarasota Times*, April 28, 1921.

176. Cassell, *Suncoast Empire*, 200–201, 210–211.

177. Grismer, *Story of Sarasota*, 300–302.

Afterword

178. *Sarasota Herald-Tribune*, May 5, 1932.

179. Ibid., July 1, 1951, and May 31, 1961; *Sarasota News*, July 6, 1951.

180. *Sarasota Herald-Tribune*, February 14, 23, 1971.

181. Ibid., March 14, 1971.

182. Ibid., May 6 and June 25, 1971.

183. *Sarasota Journal*, July 1, 1971; *New York Times*, October 11, 1971, noted Sarasota's fiftieth birthday but suggested that a bigger story was Sarasota Bay becoming so polluted that swimming in it was unhealthy.

184. *Sarasota Herald-Tribune*, January 2, 1996.

185. Ibid., April 1 and July 15, 1996; Invitation to Historical Resources Reception, Vertical File, 1996, SCHR; Matthews, "Sarasota Over My Shoulder."

186. Vertical File, 1996, SCHR.

187. Ibid.; *Sarasota Herald-Tribune*, July 1, 1996.

BIBLIOGRAPHY

BOOKS, ARTICLES, PRINTED HISTORICAL RECORDS

America's Highways, 1776–1976: A History of the Federal-Aid Program. Washington, D.C.: U.S. Department of Transportation, Federal Highways Administration, 1977.

Benshoff, P.J. *Myakka*. Sarasota, FL: Pineapple Press, 2002.

Bickel, Karl A. *The Mangrove Coast*. New York: Coward-McAnn, 1942.

Black, Hope L. "Mounted on a Pedestal, Bertha Honoré Palmer." M.A. thesis, University of Florida, 2007.

Bradentown, Florida, City Directory Including Manatee, Manatee County, Palmetto, and Sarasota. Richmond, VA: R.L. Polk and Company, 1910.

Cassell, Frank A. "A Confusion of Voices: Reform Movements and the World's Columbian Exposition of 1893." In Alan D. Corré, *The Quest for Social Justice II: The Morris Fromkin Memorial Lectures, 1981–1990*. Milwaukee: The Golda Meir Library of the University of Wisconsin–Milwaukee, 1992, 59–76.

———. *Suncoast Empire: Bertha Honoré Palmer, Her Family, and the Rise of Sarasota*. Sarasota, FL: Pineapple Press, 2017.

Cortes, Josephine. *The History of Early Englewood*. Englewood, FL: Lemon Bay Historical Society, 1971.

Cutler, Henry Gardner. *History of Florida: Past and Present, Historical and Bibliographical, Vol. II*. Florida: Lewis Publishing Company, 1923.

Dwight, Eleanor, ed. *The Letters of Pauline Palmer, 1908–1926: A Great Lady of Chicago's First Family*. Italy: MTT Scala Books, 2006.

Early Florida Auto Registrations, 1905–1917. Division of Library and Information Services, Florida Department of State, *Florida Memories*.

Early Florida Maps. Division of Library and Information Services, Florida Department of State, *Florida Memories*.

Edwards, A.B. "History." In *The Look-Out*, Sarasota, Florida, April 1, 1960.

Esthus, George I. (Pete). *A History of Agriculture of Sarasota County*. Sarasota, FL: Sarasota County Agricultural Fair Association and the Sarasota County Historical Commission, 1976.

Gannon, Michael, ed. *The History of Florida*. Gainesville: University Press of Florida, 1996.

Graham, Thomas. "The First Developers." In *The History of Florida*, edited by Michael Gannon, 276–295. Gainesville: University Press of Florida, 1996.

Grismer, Karl H. *The Story of Sarasota*. Sarasota, FL: M.E. Russell, 1946.

History of the Tamiami Trail and a Brief Review of the Road Construction Movement in Florida. Miami: The Tamiami Trail Commissioners and the County Commissioners of Dade County, Florida, 1928.

Hoffman, Glenn. *Building a Great Railroad: A History of the Atlantic Coast Line Railroad Company*. CSX Corporate Communications and Public Affairs, 1995.

Ingram, Tommy. *Dixie Highway: Road Building and the Making of the Modern South, 1900–1930*. Chapel Hill: University of North Carolina Press, 1914.

Kalmbach, Sally Sexton. *The Jewel of the Gold Coast: Mrs. Potter Palmer's Chicago*. Chicago: Ampersand, 2009.

Kendrick, Baynard. *Florida Trails to Turnpikes, 1914–1964*. Gainesville: University of Florida Press, 1964.

Korwek, Dorothy, and Carl Shriver. *John Nolen Plan of Venice, Florida*. Venice, FL: Triangle Inn Association, 2011.

LaHurd, Jeff. *John Hamilton Gillespie: The Scot Who Saved Sarasota*. Sarasota, FL: Friends of the Sarasota County History Center, 2011.

———. *Owen Burns: The Man Who Bought and Built Sarasota*. Sarasota, FL: Friends of the Sarasota County History Center, 2011.

———. *Quintessential Sarasota: Stories and Pictures from the1920's—1950's*. Sarasota, FL: Clubhouse Publications, 1990.

———. *Sarasota: A History*. Charleston, SC: Arcadia Publishing, 2000.

Lane, Myrtle. "Tracking the Sarasota Courthouse." *Sarasota Origins* 1 (Summer 1988). Sarasota, FL: Historical Society of Sarasota County.

Letter to the editor. *Medical World* 35 (February 1917). Philadelphia, PA.

Long, Timothy A. *Bertha Honoré Palmer*. Chicago: Chicago Historical Society, 2009.

Marquis, Albert N. *The Book of Chicagoans: A Biographical Directory of the Leading Men and Women of Chicago*. Chicago: A.N. Marquis, 1917.

Marth, Del. *Yesterday's Sarasota, Including Sarasota County*. Miami, FL: A.E. Seaman Publishing, 1973.

Matthews, Janet Snyder. *Edge of Wilderness: A Settlement History of Manatee River and Sarasota Bay, 1528–1885*. Tulsa, OK: Caprine Press, 1983.

————. *Journal to Centennial Sarasota*. Revised edition. Sarasota, FL: Sesquicentennial Production, 1991.

————. *Sarasota Over My Shoulder*. Sarasota, FL: Sarasota County Department of Historical Resources, 1976.

Matthews, Janet Snyder, and Linda W. Mansperger. *Mrs. Potter Palmer, Legendary Lady of Sarasota*. Osprey, FL: Gulf Coast Heritage Association, 1999.

McCarthy, John. Speech to Manatee County Historical Society, November 19, 1997. Manatee County Library System Digital Collection.

McClellan, Katherine D. *McClellan Park, Sarasota, Florida*. Pamphlet. Sarasota, FL: Vertical File of the Sarasota County Historical Resources Center, n.d.

Mohl, Raymond and Gary R. Mormino. "A Social History of Modern Florida." in *History of Florida*, edited by Michael Gannon. Gainesville: University Press of Florida, 1996.

Pascal, Guy. "Speech to Manatee County Historical Society on Why Sarasota Separated from Manatee County," April 15, 1973. Bradenton, FL: Manatee County Library System Digital Collection.

Prince, Richard E. *Seaboard Air Line Railroad*. Bloomington: Indiana University Press, 1967.

Report of the Secretary of State of the State of Florida. Part I: For the Period Beginning January 1, 1921, and Ending December 31, 1922. Tallahassee, FL: T.J. Appleyard, Printer, 1923.

Robie, Virginia. "The Oaks, Osprey on Little Sarasota Bay." *House Beautiful* 67, no. 1 (January 1920): 34–58.

Rogers, William W. "Fortune and Misfortune: The Paradoxical 1920s." In *History of Florida*, edited by Michael Gannon. Gainesville: University Press of Florida, 1996, 296–312.

Ross, Ishbel. *Silhouette in Diamonds: The Life of Mrs. Potter Palmer*. New York: Harper Brothers, 1960.

Sarasota City and Sarasota County Directory for 1924. 2 vols. Asheville, NC: Florida-Piedmont Publishers, 1924. Found in the library of Sarasota County Historical Resources.

Sarasota County Courthouse Historical Marker. City of Sarasota, Sarasota County Historical Commission, 2002.

Shank, Ann. "The Creation of Sarasota County." Typescript. Sarasota, FL: Sarasota County Historical Resources, 2006.

Snelzer, Robert M. *From Shield to Star*. Sarasota, FL: self-published, 1999.

Strange, William B. *The Sunshine Economy: An Economic History of Florida Since the Civil War*. Gainesville: University Press of Florida, 2008.

Sulzer, Elmer. *Ghost Railroads of Sarasota County*. Sarasota, FL: Sarasota County Historical Commission, 1971.

Talbot, George M. "The Rise and Fall of the Sarasota Celery Industry, 1895–1995." *Proceedings of the Florida State Horticultural Society* 114 (2001).

Tebeau, Charlton W. and William Marina. *A History of Florida*. Coral Gables, FL: University of Miami Press, 1999.

United States Federal Census, 1910, 1920, 1930, 1940.

Warner, Joe. G. *Biscuits and Taters: A History of Cattle Ranching in Manatee County*. St. Petersburg, FL: Great Outdoors Printing Company, 1980.

A Waterbury Grapefruit Grove for Investment. Pamphlet. George Smathers Library Digital Collections, University of Florida.

The Waterbury System Schools. Pamphlet. The Waterman-Waterbury Company of Minneapolis, Minn. In *Minnesota Reflections*, Historical Collections, Hennepin County Library, 1918.

Weeks, David C. *Ringling: The Florida Years, 1911–1936*. Gainesville: University Press of Florida, 1993.

Weimann, Jeanne Madeline. *The Fair Women*. Chicago: Academy, 1981.

Wynne, Nick and Richard Moorhead. *Paradise for Sale: Florida's Booms and Busts*. Charleston, SC: The History Press, 2010.

ARCHIVES

Chicago History Museum

Bertha Honoré Palmer Papers
Bertha Palmer and Palmer Research Collection
Palmer Photographs
Potter Palmer and Palmer Estate Papers

Hennepin County (MN) Library

Minnesota Reflections, Historical Collections

Historic Spanish Point Archives

Map of Osprey Point Estate
Webb Papers

Manatee County Historical Society Collection, Eaton Room, Manatee County Public Library

Manatee County Historical Records Library

Bertha Palmer Folder
General Index to Deeds
Plat Book

Manatee County Library System Digital Collections

Sarasota County Historical Resources

A.B. Edwards Papers
A.B. Edwards Interview by County Historian Dottie Davis
Bertha H. Palmer Papers
Lillian G. Burns Collection
Map Collection
Photograph Collection
Sarasota County Plat Books
Vertical File

Newspapers

Chicago Tribune
Manatee River Journal
New York Times
Sarasota County Times
Sarasota Daily Times
Sarasota Herald
Sarasota Herald-Tribune
Sarasota Journal
Sarasota Times

INDEX

A

Adams, W.J. 39, 42
African American citizens 14, 124, 163
Albee, Dr. Fred 62
Albritton, Paul C. 38, 95, 154
Albritton, Thomas A. 13, 37, 38, 94, 95, 97, 116, 117
Allyn, Rube 58, 59, 146, 162
Amendment, 19th 57, 144
Anderson, Joseph D. 94, 97
Anna Maria Island 18, 105
Archibald, Ira G. 64, 141
Arnold, T.F. 63, 64
Art Institute of Chicago 24, 152
Askew, Reuben 121
Atlantic Coast Line Railroad terminal 112

B

Bacon, E.J. 96
Bankhead Act of 1916 30, 43, 134
Bank of Sarasota 39, 61, 146
Bar Harbor, Maine 25, 151
Battle, Joseph E. 50, 64, 141
Bayshore Road 30, 31, 32, 45, 57, 58, 81, 94, 131, 143, 155, 157, 163
Bee Ridge Farms 30, 36, 148, 153, 156
Bee Ridge, Florida 23, 30, 35, 37, 38, 41, 50, 62, 81, 93, 94, 96, 116, 133, 136, 149, 156
Bee Ridge Road 31, 101, 103, 133
Bee Ridge Woman's Club 57
Bendus, Robert 11
Blackburn, Albert 41
Blackburn, Benjamin Franklin 62
Blackburn Point Road 101, 103
Board of Lady Managers 24, 25, 161

Bradentown 12, 17, 18, 21, 22, 31, 44, 46, 49, 50, 51, 52, 54, 58, 64, 71, 81, 84, 86, 87, 97, 99, 101, 103, 116, 129
Bradentown Board of Trade 62, 64, 142, 144, 148, 160
Brotherhood of Locomotive Engineers 109
Buchan, Peter E. 13, 50, 64, 80, 84, 94, 116, 117, 142
Burket, John F. 39, 50, 51, 54, 64, 66, 67, 76, 112, 117, 120, 142, 144, 145, 154
Burns, E.O. 51
Burns, Owen 44, 50, 51, 111, 143

C

Ca'd'Zan 110
Campbell, T.J. 106
Cassell, David Daniel 5
Cassell, Elizabeth Weber 15
Cassell, Jonathan Frank 7
Celery Fields 124
Chapman, C.N. 62
Charlotte County 87, 89, 96, 97, 135, 136, 150, 160
Chicago History Museum 15
Chicago, Illinois 23, 24, 28, 37, 62, 83, 147, 150, 152, 154
Chicago World's Fair. See World's Columbian Exposition
Collier, Barron 98, 137
Collier County 98, 137
Commercial Club 27, 38, 39, 40, 41, 42, 44, 143, 146, 156, 157
Committee of Ten 64, 67
Connors, William J. 99, 137

Cooper, Frank M. 62, 63
Courthouse subdivision 112
cross-state highway 13, 53, 54, 58, 69, 72, 73, 88, 92, 96, 97, 99, 104, 105, 116, 133, 136, 137, 147, 150, 153, 155, 157, 159, 160
Curry, Charles T. 37

D

Daughters of the American Revolution 57
Davis, Dottie 120
Dean, Franklin P. 37, 38, 41, 51, 143, 157
Delbert, E.S. 60, 61, 145
Democratic Party 14, 27, 94, 112, 142, 155, 158, 159
DeSoto County 22, 54, 89, 135
DeSoto Hotel 22
Dixie Highway 18, 53
Duggins, L.R. 62
Dunn, W.L. 50

E

East and West Railway 70
Edwards, Arthur Britton 13, 26, 27, 36, 37, 39, 40, 41, 45, 46, 48, 51, 52, 54, 55, 63, 64, 65, 66, 71, 76, 80, 83, 86, 87, 94, 96, 97, 101, 112, 116, 120, 122, 128, 132, 143, 145, 146, 151, 153, 154, 156
Edward VII, king of England 25, 151

Election of 1920 57, 58
Elliott, Howard 41
Englewood 23, 41, 42, 45, 50, 53, 64, 74, 76, 80, 87, 88, 93, 101, 103, 116, 134, 135, 136, 142
Eustis, Florida 36, 40
Everglades 18, 41, 89, 90, 98, 133, 134, 136, 155

F

Field, Stanley 111
Fish, Cary B. 37, 112
Florida 12, 13, 28, 30, 42, 98, 128
Florida East Coast Railroad 111
Florida Highway Department 30, 98
Florida House of Representatives 106
Florida land boom. *See* great Florida land boom
Florida Mortgage and Investment Company 22, 25, 143, 149
Florida State College for Women 121
Florida State Legislature 21, 30, 36, 38, 47, 59, 61, 62, 65, 67, 74, 80, 119, 142, 159
Fort Myers, Florida 18, 53, 89, 90, 105, 133, 134, 135
Fort Pierce, Florida 45, 49, 53
Freemasons 27, 112, 155, 156, 158
Fruitville, Florida 23, 37, 50, 93, 96, 101, 116, 124, 134, 136, 149, 153

G

General Committee, County Division 38, 50, 51, 52, 53, 54, 55, 57, 59, 60, 61, 72, 83, 142, 143, 144, 145, 146, 147, 149, 154, 155, 156, 157, 158, 159
Georgetown 23
Gillespie, John Hamilton 22, 25
Good Roads Associations 29
Good Roads Committee 19, 37, 38, 80, 87, 90, 94, 116, 132, 153, 158
Good Roads Movement 29, 33, 48, 51, 58, 59, 80, 83, 87, 116, 128, 143
Graham, John A. 51, 65, 73, 97
Grant, Frederick 24
Grant, Ida 24
Grant, Ulysses S., President 24
Great Depression 14, 20, 146
great Florida land boom 14, 95, 97, 104, 109, 111, 163
Gulf Stream Avenue 22

H

Halton, Jack, Dr. 48, 50
Halton, Joseph, Dr. 7, 48, 49, 51, 58, 64, 122, 145
Hancock, Henry 80
Hancock, William F. 50, 94, 97
Hardee, Governor Cary 19, 21, 67, 72, 75, 79, 81, 84, 121, 158, 160
Harmer, George F. 66
Harris, W.S. 62

Hayden, Frank J. 80, 84, 94
Hebb, Mrs. Homer 121
Higel, George 76, 116, 162
Higel, Harry 13, 36, 39, 44, 46, 55, 58, 59, 117, 131, 145, 156
Higel, Mrs. Wesley 81
Hillsborough Board of County Commissioners 55, 155
Hillsborough County 22, 131
Historical Resources, Sarasota County Department of 11, 15, 122, 177, 178, 179
Historical Society of Sarasota County 121
Hitchings, Clarence Edgar 39, 51, 146
Hodges, L.D. 95
Honoré, Adrian C. 13, 26, 35, 48, 51, 73
Hughes, Thomas A. 94
Humphries, J.H. 65, 66
hurricane of 1921 20, 86, 92, 159

I

Indian Beach 37, 38, 41, 51, 133, 143
Island Park 121

J

Johnson, J.M. 62
Joiner, Arthur L. 50, 51, 63, 81, 95, 96, 117, 148

K

Keene, J.W. 62
Kelleher, Larry 15

L

LaHurd, Jeff 114
Lake Shore Drive (Chicago) 24
Landers, Otis F. 64, 76, 112, 148, 154
Laurel, Florida 62
League of Women Voters 57
Lettly, H.H. 62
Levi, B.D. 83, 86, 95
Lincoln Highway 18
Livermore, Thomas L. 81, 148
Lockwood Ridge Road 37, 103, 133
Lord, Fran Mabel Webber 25
Lord, Joseph II. 13, 25, 26, 27, 31, 33, 39, 40, 46, 73, 83, 96, 101, 106, 111, 116, 117, 122, 128, 133, 149, 151, 153
Louisville, Kentucky 23

M

Mackintosh, H.W. 41
Manasota Key 49
Manasota Lumber Company 49
Manatee County 11, 12, 17, 18, 21, 22, 27, 30, 32, 33, 36, 39, 41, 45, 46, 47, 48, 49, 50, 51, 52, 54, 55, 61, 62, 64, 69, 70, 74, 75, 76, 81, 82, 83, 85, 89, 92, 95, 104, 116, 122, 131, 132, 134, 135, 147, 152

Manatee County Commission 17, 18, 45

Manatee County Historical Records Library 15

Martin, Thomas Reed 62, 76

Maryland 18

Masonic Lodge no. 147 112, 141, 143, 148

Mason, J.R. 50

Matthews, Janet Snyder 122

May, Lawrence L. 50, 51, 80, 94, 120, 149, 160

McClellan, Katherine 71, 150

Meadowsweet Pastures 26, 97, 147, 151, 153

Miakka, Florida 23, 32, 41, 51, 53, 54, 61, 76, 80, 93, 96, 101, 116, 131, 134, 136

Miami, Florida 18, 41, 53, 89, 98, 102, 111, 134, 137, 155

Model T, Ford motor car 28, 151

Moore, Ellwood 39

Myakka City, Florida 69, 70, 138

Myakka River 23, 26, 32, 70, 147, 149, 159

N

Naples, Florida 18, 53, 133, 134, 137

Newport, Rhode Island 25, 151

Nokomis, Florida 50, 62, 76, 80, 93, 116, 162

Nolen, John 109

O

Oaks, The 27, 62, 151, 152, 153

O'Brien, M. 62

Ogles, Lindsay 15

Okeechobee City, Florida 45, 89, 99, 129, 137, 138

Ormiston Colony 22

Osprey, Florida 23, 37, 41, 50, 62, 76, 93, 103, 149, 153, 157

Osprey Point 26, 151, 157, 161

P

Palmer, Bertha 13, 14, 24, 25, 26, 27, 28, 30, 35, 39, 40, 42, 46, 48, 57, 62, 97, 106, 116, 122, 128, 132, 145, 147, 149, 161, 162

Palmer Florida Company 26, 35, 147, 151, 152

Palmer, Honoré 152, 156

Palmer, Mrs. Potter. *See* Palmer, Bertha

Palmer, Potter 23, 147, 150

Palmer, Potter, Jr. 26, 48, 147, 152

Palmetto, Florida 45, 62, 65

Pearce, Frank 51

Pearce, George B. 55

Perry, William Y. 51, 64, 65, 66, 71, 73, 76, 81, 95, 117, 120, 142, 144, 145, 154

Philippi Creek 23, 32, 37, 44, 122, 152

Phillips, Clem 62

Pine Level 22

Point Thatcher, Coast Guard cutter 121

Pomelo, Florida 71
Ponder, J.W. 40, 41
Prime, George B. 13, 51, 64, 87,
 96, 97, 98, 102, 103, 109,
 110, 112, 117, 128, 137, 138,
 139, 154
Punta Gorda, Florida 53, 89, 105,
 150

R

Ragan, Gary M. 62
Rankin, Lamar 35, 37, 40, 116,
 133, 153, 156
Reaves, O.K. 65
Redd, Frank 51, 82, 95, 112, 156
Republican Party 14, 94, 158
Ringling, Charles 96, 97, 102, 109,
 112, 141, 143
Ringling, Edith 109
Ringling, John 96, 97, 102, 110,
 137, 143, 146
Roesch, O.E. 81, 84, 86, 95
Rosemary Cemetery 143, 154

S

San Francisco 18
Sarapalmbee Trail 129, 138, 155.
 See cross-state highway
Sarasota Bay 22, 27, 30, 61, 111,
 133, 137
Sarasota Board of Trade 14, 27,
 28, 32, 33, 36, 38, 44, 45, 50,
 51, 52, 53, 57, 58, 60, 81, 82,
 135, 141, 142, 143, 144, 145,
 146, 148, 149, 153, 154, 156,
 157, 158, 159, 162, 163
Sarasota Chamber of Commerce
 27, 58, 60, 61, 62, 63, 67, 68,
 70, 71, 73, 74, 75, 77, 79, 80,
 81, 85, 90, 94, 96, 97, 100,
 116, 122, 128, 136, 137, 141,
 142, 144, 145, 146, 154, 155,
 160, 162, 163
Sarasota City Council 36, 49, 51,
 59, 102, 146, 155
Sarasota, City of 19, 20, 21, 27,
 30, 31, 35, 37, 38, 39, 41, 46,
 47, 48, 49, 51, 61, 63, 64, 66,
 67, 69, 72, 73, 76, 80, 83, 84,
 86, 87, 93, 95, 96, 97, 107,
 109, 110, 115, 116, 122, 124,
 129, 133, 137, 141, 152
Sarasota County Clerk, Office of
 15
Sarasota County Courthouse 13,
 116, 122
Sarasota County Fair Board 120
Sarasota County Historical
 Commission 11, 120, 122
Sarasota County Library System
 15
Sarasota district 12, 43, 49, 128, 129
Sarasota Over My Shoulder 122
Sarasota Times 35, 36, 39, 40, 41,
 51, 57, 68, 73, 74, 75, 76,
 110, 116, 148, 149, 160
Sarasota, town of 22, 23, 25, 26,
 27, 28, 59, 143
Sarasota-Venice Company 26, 31,
 35, 36, 39, 42, 147, 151, 152
Sarasota-Venice Road 40, 42, 44,
 134

Sarasota/Venice Special Bond
	District 37, 39, 42, 52, 53,
	59, 74, 80, 103, 132, 133,
	134, 142, 143, 144, 146, 147,
	149, 152, 156, 157, 162
Sarasota Woman's Club 14, 57, 58,
	71, 106, 143, 144, 150, 162
Sault Ste. Marie, Michigan 18
Saunders, Victor A. 41, 50, 157
Savarese, John 51
Sawyer, Herbert S.. 95
Schultz, Dr. F. William 37
Seaboard Air Line Railway 22, 27,
	59, 147
Senate Committee on County
	Organization 63
Siesta Key (Sarasota Key) 59, 134,
	135, 136, 137, 138
Smith, Hamden S. 60
Spanish-American War 26
Stephens, W.E. 50
Stevenson and Cameron 110, 111
Stewart, J.J. 62
St. Petersburg, Florida 30, 131
Stuart, O.L. 65

T

Tabor, H.F. 65
Tallavast Station 37
Tamiami Trail 18, 20, 41, 45, 53,
	58, 69, 87, 88, 90, 92, 94, 96,
	97, 99, 104, 105, 116, 128,
	129, 133, 134, 135, 136, 137,
	138, 139, 150, 153, 155, 157,
	159, 160
Tamiami Trail Association 98

Tamiami Trail Blazers 90, 98, 102,
	137, 155
Tampa, Florida 18, 22, 30, 31, 41,
	45, 53, 55, 57, 61, 90, 105,
	133, 137, 155
Tatum Ridge, Florida 23, 136
Taylor, Bryant 50
Townsend, M.L. 94, 97
Tucker, Ernest 50
Tuttle, William M. 13, 42, 51, 52,
	53, 55, 89, 103, 128, 133,
	135, 157, 158, 160
Tyler, John S. 62
Tyler, Lee H. 62

U

United States Congress 28, 57, 74,
	134, 144

V

Venice Extension rail line 30, 147
Venice, Florida 23, 30, 37, 41, 42,
	45, 49, 50, 76, 81, 87, 88, 89,
	93, 101, 103, 109, 116, 131,
	132, 133, 135, 136, 145, 147,
	149, 151, 153, 156, 162
Venice Museum & Archives 15
Verna, Florida 73, 89, 96, 101,
	136, 138, 147

W

Walpole, Frank 13, 55, 67, 71, 77,
 79, 84, 87, 90, 92, 94, 96,
 106, 117, 122, 128, 158
Washington, D.C. 23
Waterbury, James 70
Waterbury tract 70, 71, 89
Webb, Henry Clifford 167
Webb, William B. 37
White, H.V. 62
Wilson, Cornelius Van Santvoord
 160
Wilson, Mrs. C.V.S. *See* Wilson,
 Rose Phillips
Wilson, Rose Phillips 13, 36, 39,
 41, 42, 50, 51, 55, 57, 58, 62,
 66, 67, 68, 71, 72, 73, 74, 75,
 105, 112, 117, 120, 122, 123,
 142, 144, 160
Women's Building 24, 25
World's Columbian Exposition 24,
 161
World War I 13, 18, 29, 43, 127,
 134
Wread, M.L. 55, 94, 97

Y

Yarborough, Thomas W. 81, 95,
 117, 163
Yellin, Samuel 114

ABOUT THE AUTHOR

Frank A. Cassell is President Emeritus and Professor Emeritus of History at the University of Pittsburgh at Greensburg. He earned his BA at Wabash College in Crawfordsville, Indiana, and his MA and PhD at Northwestern University. He taught and served as an administrator at the University of Wisconsin–Milwaukee and Roosevelt University in Chicago before taking the presidency at Pitt-Greensburg. The board of trustees of the University of Pittsburgh named a new academic building at Pitt-Greensburg in his honor in 2012.

Cassell has published books and articles on the colonial and early national periods of American history, the Columbian Exposition of 1893, social history in Indiana in the nineteenth century, and his experiences as a university president. The Florida Book Awards presented *Suncoast Empire: Bertha Honoré Palmer, Her Family, and the Rise of Sarasota* the 2017 silver medal for nonfiction.

Cassell has been a member and an officer of the Sarasota County Historical Commission and of the History and Preservation Coalition of Sarasota County for some years. He is also chair of the Sarasota County Centennial 2021 Steering Committee. He and his wife, Beth, will celebrate their 60th wedding anniversary in 2021 as Sarasota County celebrates its 100th anniversary.

OTHER BOOKS BY FRANK A. CASSELL

Suncoast Empire: Bertha Honoré Palmer, Her Family,
and the Rise of Sarasota, 1910–1982 (2017)

Josie and Salem: An Indiana Love Story (2011)

We Made No Little Plans: A Memoir (2007)

Seeds of Crisis: Public Schooling in Milwaukee Since 1920. John L. Rury and
Frank A. Cassell, eds. (1993). Winner of the Gambrinus Prize, Milwaukee
Historical Society, as best book on Milwaukee History published in 1993.

The University of Wisconsin–Milwaukee: A Historical Profile (1992). Frank A.
Cassell, J. Martin Klotsche, and Frederick I. Olson.

Merchant Congressman in the Young Republic:
Samuel Smith of Maryland, 1752–1839 (1971)

CPSIA information can be obtained
at www.ICGtesting.com
Printed in the USA
LVHW070213230221
679702LV00018B/538